Between the Wingtips

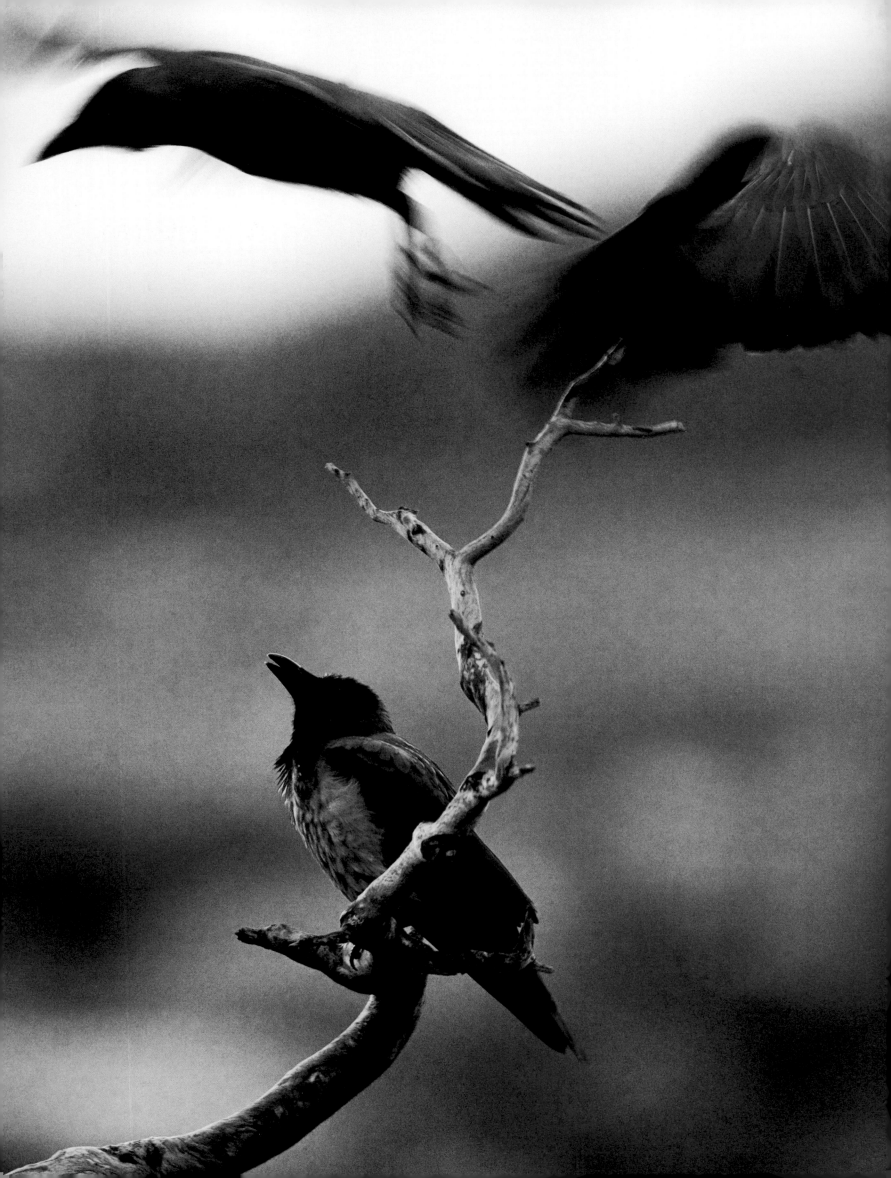

Photographs Brutus Östling Text Magnus Ullman

Between the Wingtips

The Secret Life of Birds

Collins

An Imprint of HarperCollinsPublishers

Between the Wingtips is something unusual: a work of non-fiction that captures the reader from the very first page and is impossible to put down. After only a couple of pages, it is easy to understand why. The author, Magnus Ullman, and the photographer, Brutus Östling, take us on a spellbinding journey of words and images, introducing us to the most intriguing bird species on earth.

This book contains a wealth of fascinating facts about the appearance and behavior of a number of bird species. Why do some boast colorful displays while others are so dull that you can hardly see them against the bark of a tree? How does the Whooper Swan manage to fly at an altitude of 25,000 feet where the temperature is minus 40? *Between the Wingtips* provides most of the answers to these questions, but also presents several interesting theories offering possible solutions to problems still unsolved by science.

The photographic material is nothing less than fine art, offering glimpses of the astounding variation in color and behavior of birds that during the course of several thousand years have developed their own niches in terms of nesting places and diet.

Opening the cover of *Between the Wingtips* is like opening the door to a new world that will stimulate the senses and create a better understanding for how important it is to safeguard our amazing natural landscape – from the freezing Antarctic to the sweltering tropics.

Lars Kristoferson
Secretary General
The World Wildlife Fund,
Sweden

BETWEEN THE WINGTIPS. Copyright © 2006 by Brutus Ostling and Magnus Ullman.

English language translation © 2006 by Katarina Sjöwall Trodden. All rights reserved.

Printed in Italy. No part of this book may be used or reproduced in any manner whatsoever without written permission except in the case of brief quotations embodied in critical articles and reviews. For information, address HarperCollinsPublishers, 10 East 53rd Street, New York, NY 10022.

Originally published in Swedish as *Mellan Vingspetsarna* by Norstedts

Published by agreement with Pan Agency

Design: Jens Andersson

HarperCollins books may be purchased for educational, business, or sales promotional use.

For information, please write:

Special Markets Department, HarperCollinsPublishers, 10 East 53rd Street, New York, NY 10022.

FIRST U.S. EDITION

ISBN-10: 0-06-113685-9

ISBN-13: 978-0-06-113685-6

06 07 08 09 / 10 9 8 7 6 5 4 3 2 1

Contents

Introduction

MOST PEOPLE HAVE some kind of relationship with birds. Many of us are happy simply to enjoy the sight of any small bird we see through the kitchen window, in the backyard, or while out walking the dog, and to hear the exhilarating sound of birdsong in the spring. On the other hand, if you are one of those people who tend to carry a pair of binoculars around your neck when you go out walking and call yourself a bird-watcher, you are likely to be more aware of other people's general interest in birds than most.

If you happen to be watching a flight of geese through your telescope, for example, it never seems to take long before someone comes up and asks what those birds are, crossing the sky like a string of rosary beads. You may manage to say, "They are geese. They are flying to…", but then you are invariably interrupted with the words, "I must tell you about this strange bird I saw once…" Then will follow a long, excited account of some memorable encounter. Similarly, relatives will phone you up for help identifying birds they have seen, and coworkers will tell you about a bird that was perched on a television aerial, singing so beautifully it just had to be a Snow Bunting. But when you gently explain that it probably wasn't a Snow Bunting because that isn't how they perch when they sing, the reaction is often skeptical, not to say aggressive: "How do you know? You weren't even there!"

Because birds are characterized by a strange combination of regular habits and perplexing irrationality, how could you possibly know these things? The answer is you can always try to find out more about birds, constantly improving your knowledge and satisfying your curiosity.

Thomas Alerstam, a Swedish research scientist specializing in bird migration, was once asked what particular aspect out of everything he had learned about migration surprised him most. Dr. Alerstam, however, did not pinpoint any single detail. Instead, after some serious deliberation, he replied that what astonished him most was the miracle of how such tiny organisms function at all, their patterns of behavior combining to work in harmony. These diminutive passerines, weighing only 1/3oz (10g), are capable of preparing themselves for migration and surviving the entire flight to the tropics, including having to find suitable food in suitable places along the way. They navigate in the right direction, and are able to pick up a vast number of different signals in order to manage their dangerous 6,000-mile (10,000km) journey. And then they know when it is time to return. As Dr. Alerstam said, what is most amazing about migrating birds is their whole incredible story.

You could simply consider a bird to be a small, efficient machine that reacts to different stimuli and performs various relevant actions. There are those who reject this view and who wonder what then happens to our respect for this little creature? Who is going to care about nature conservation and the protection of birds? The fact remains, however, that birds do function in the same way as machines to a greater extent than mammals, for example, in the way they react to stimuli. They do this more instinctively than consciously, and with less forward planning and less afterthought. But why should this fact make them less precious and less worthy of protection? Birds are, quite simply, little miracles, and as such they require care and consideration.

There are so many intriguing connections and remarkable facts to consider about birds that you do not necessarily have to be in the least bit interested in them to be fascinated by them. All you need is a curiosity about life and an open mind. After all, the migration of the arctic tern from pole to pole and the reflection of the sun in a dewdrop are both equally fascinating and equally wonderful to behold.

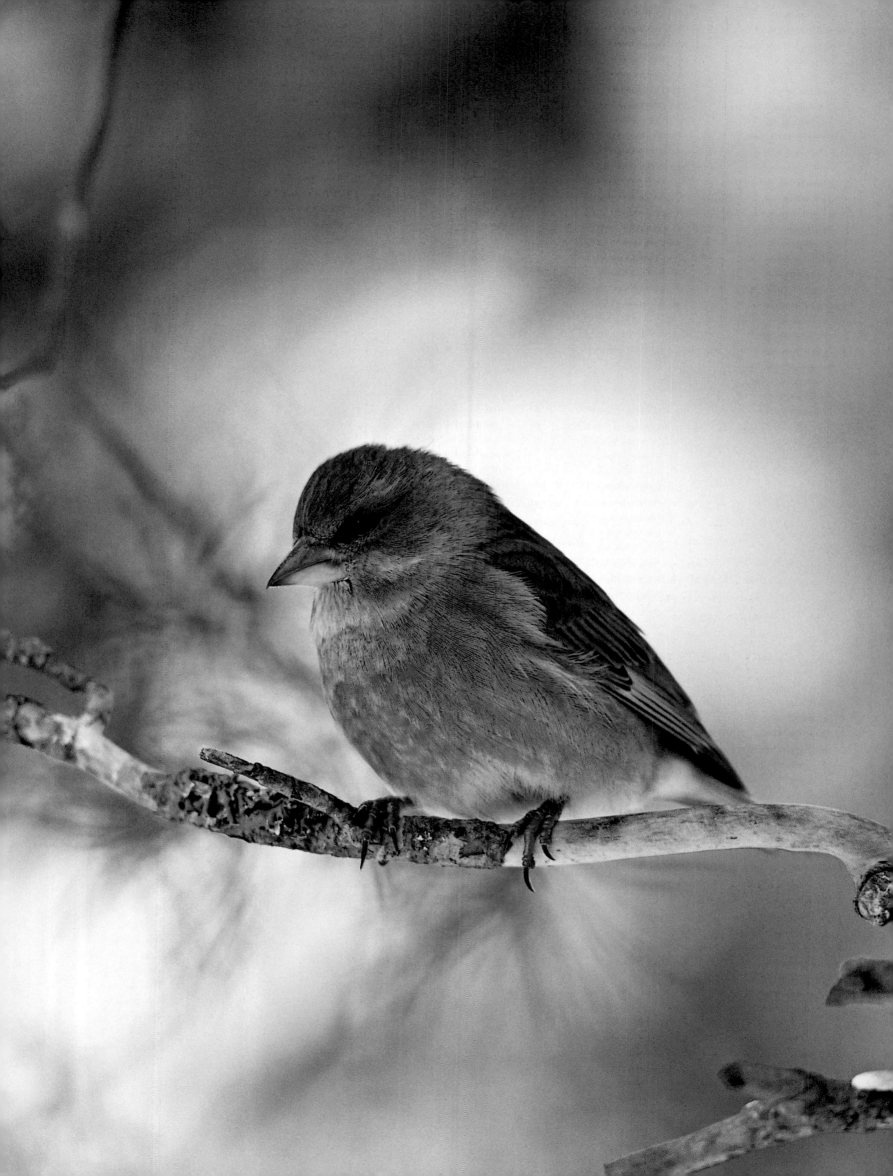

The Flying Machine

WHAT IS THE most distinguishing feature of birds? The majority of people would probably say it is their ability to fly. But while it is true that this is important, it is not their main identifying feature. Species other than birds can also fly, including bats and most insects—and there are many more insects than there are birds. There is no doubt, however, that being able to fly is a quality we associate intimately with birds. There can't be many people who remain unmoved by the sight of a flotilla of cranes floating across the sky or the symmetrical outline of geese flying in formation in the fall.

The fact that birds form such a prominent part of our lives does have something to do with their song, a sound that heralds the arrival of the spring. But their flight is equally important. Just compare a flock of croaking starlings, confidently invading an entire meadow, with a frightened rabbit anxiously hiding in the far corner, afraid of being noticed.

Birds are able to conquer the laws of gravity by having a body structure that is extremely well adapted to this purpose. In many ways, they are the perfect flying machine: front limbs transformed into wings; a spool-shaped trunk; low weight; and, not least, specially designed feathers. The fact is that a bird's most prominent feature is its feathers, unique to the class Aves. That feathers are designed with flying in mind is obvious—apart from being light and resilient, the bird's plumage also contributes to its aerodynamic qualities. This can be illustrated simply by imagining a plucked goose. Deprived of its feathers, it would not be very well adapted to a life on the wing.

There are other reasons why we view birds as elegant flying machines. They have hollow bones to lower their weight, and their respiratory system is designed to allow every breath of air to pass through their lungs in two stages to achieve maximum oxygenation of the blood. And what reason can there be for the female to lay eggs other than as a means of avoiding having to carry a heavy fetus until it is ready to be born?

Our fondness for birds also has a lot to do with their migration cycle. Some see their return at the end of winter as a major event, a sure sign that spring and summer are on their way. There are other animals—mammals, fish, and insects—that migrate between seasons, but no group has a more structured migration than the birds. Their colonization of arctic regions, for example, is based on their ability to adapt to spending the winter in other continents. And flying is the key that makes all this possible.

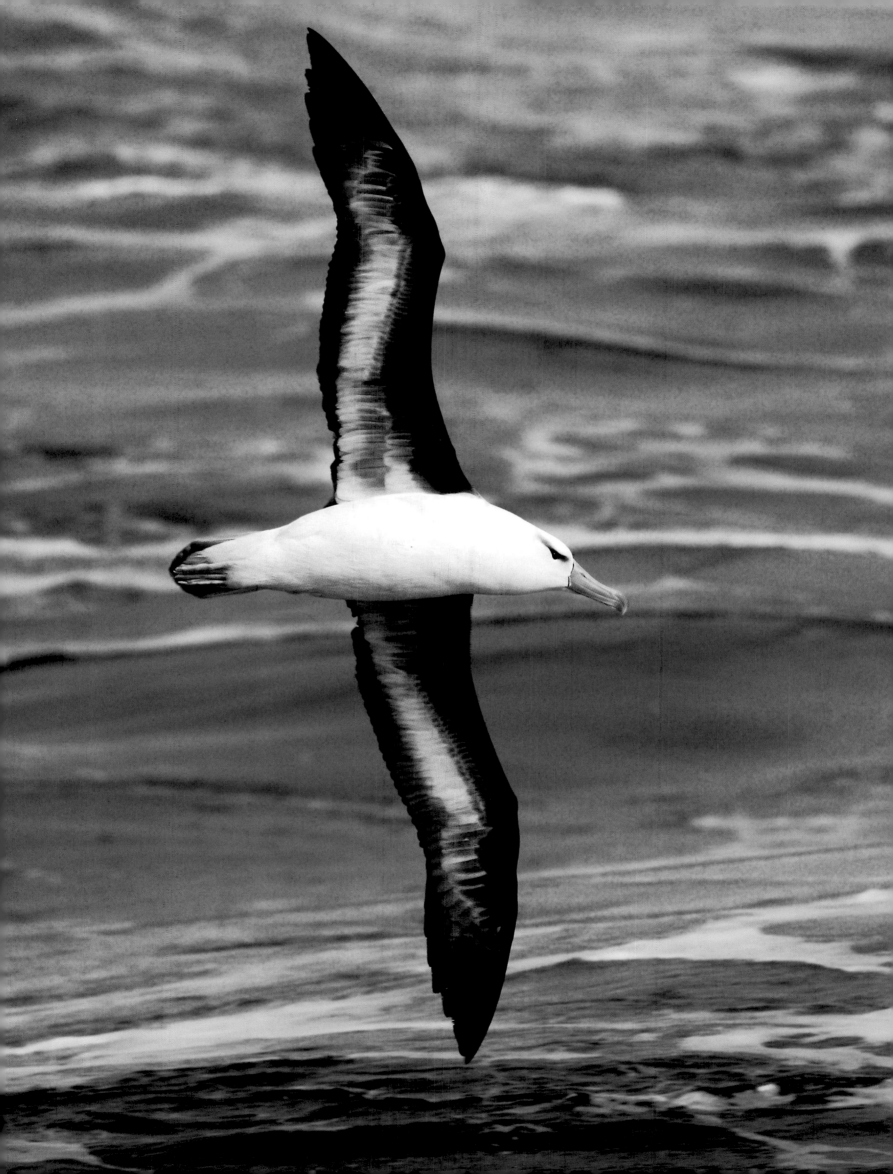

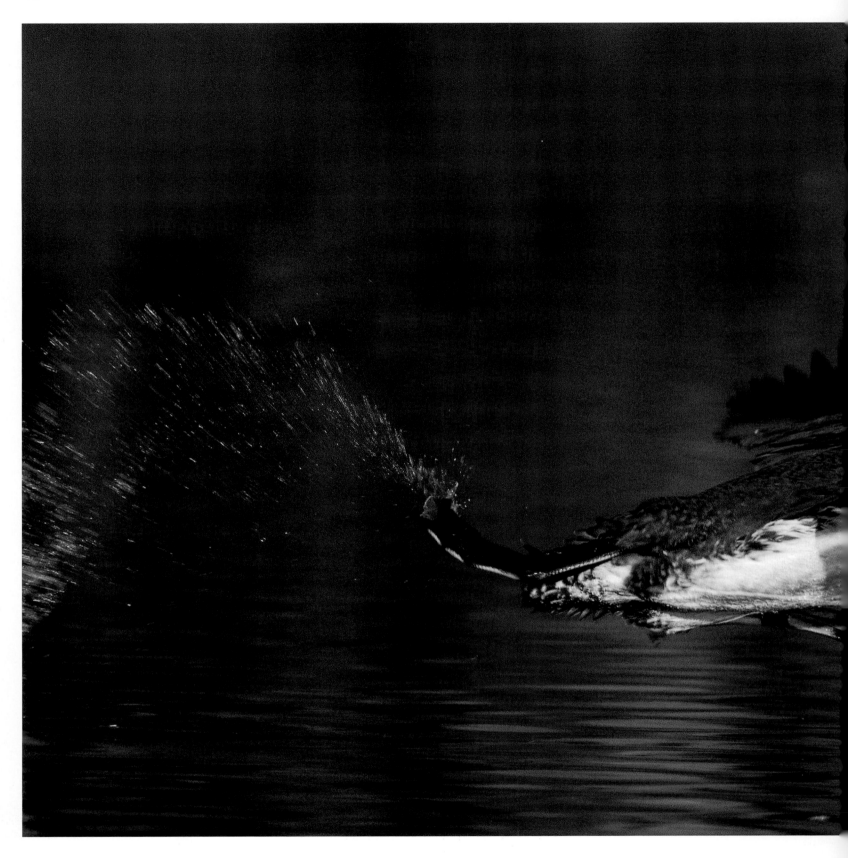

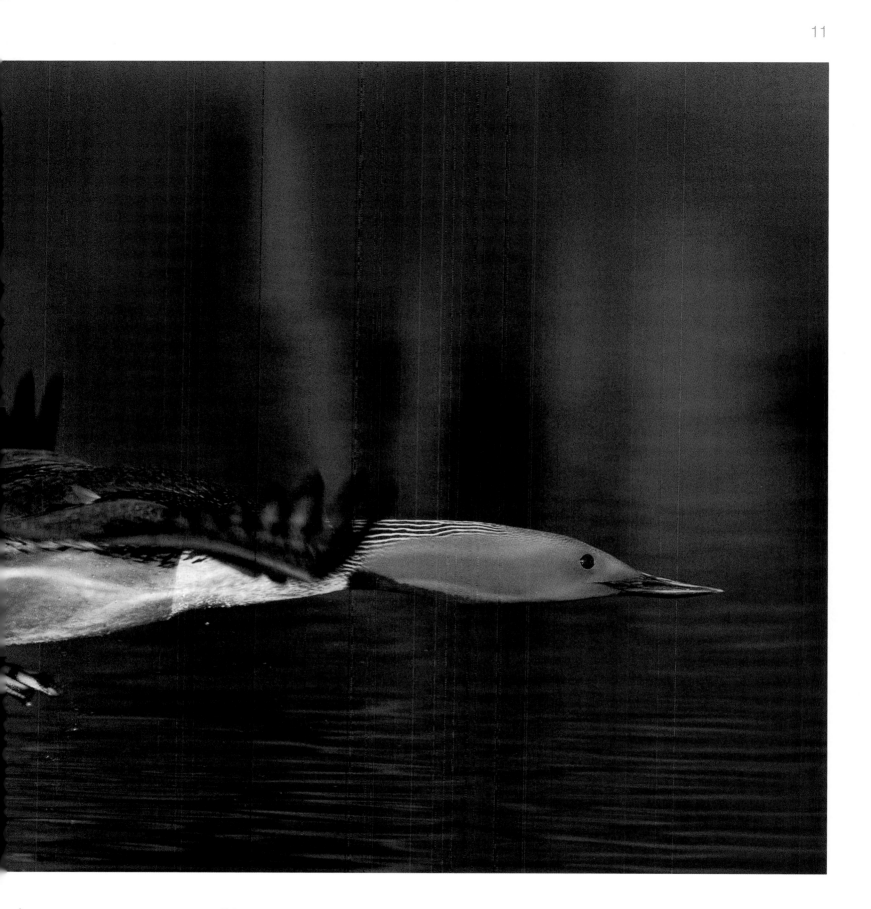

Takeoff. Most animals use their legs and feet as a means of locomotion, but this is not necessarily the most important function of these limbs. Loons, for example, can hardly walk at all—and they seldom need to. The only reason for them ever to step ashore is to visit their nest. Their legs are somewhat weak and are placed so far to the rear of their bodies that the birds would find it hard to keep their balance if they tried to walk upright. This is why they tend to slide up to their nests, which are built just above the waterline. Their feet are used mainly for swimming instead, or when taking off. Loons are heavy birds and need a long runway, so on takeoff they accelerate by running along the surface of the water until they acquire sufficient lift.

Red-throated Loon * Sweden * April

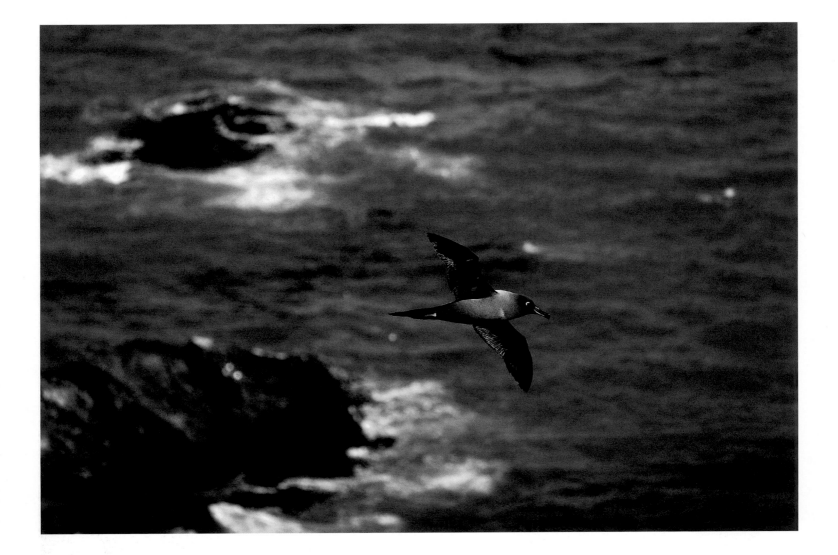

Narrow-winged gliders. Albatrosses are able to glide through the air by means of dynamic soaring, which is just as complicated as it sounds. It means that the bird exploits the wind gradient at higher altitudes above the ocean—the wind is stronger here, because lower down the water surface creates friction and so slows wind blowing over it. To gain momentum, the bird propels itself upward into the wind, initially unconcerned about its direction of travel. The headwind gives it the lift it needs to get airborne, and as the wind velocity increases with altitude so the bird's velocity also increases. The albatross exploits this to reach its maximum altitude at approximately 60ft (20m) above the crest of the waves. The bird then picks up more speed by gliding down-ward, this time in the direction of its destination, until it reaches the water surface. It then starts the puzzling yet fascinating process all over again.

Light-mantled Sooty Albatross * South Georgia * January

Flippers and wings. Unlike many diving birds, which use their feet to propel themselves underwater, puffins and other auks pursue fish by diving deep into the ocean and swimming using their wings. But auks also use their wings for flying, which, because of their dual function, have evolved into a compromise design: They are rather small and narrow, allowing these heavy birds both to swim underwater and to fly. It is not unusual in birds to see designs that suit a combination of different needs.

Atlantic Puffin * Iceland * July

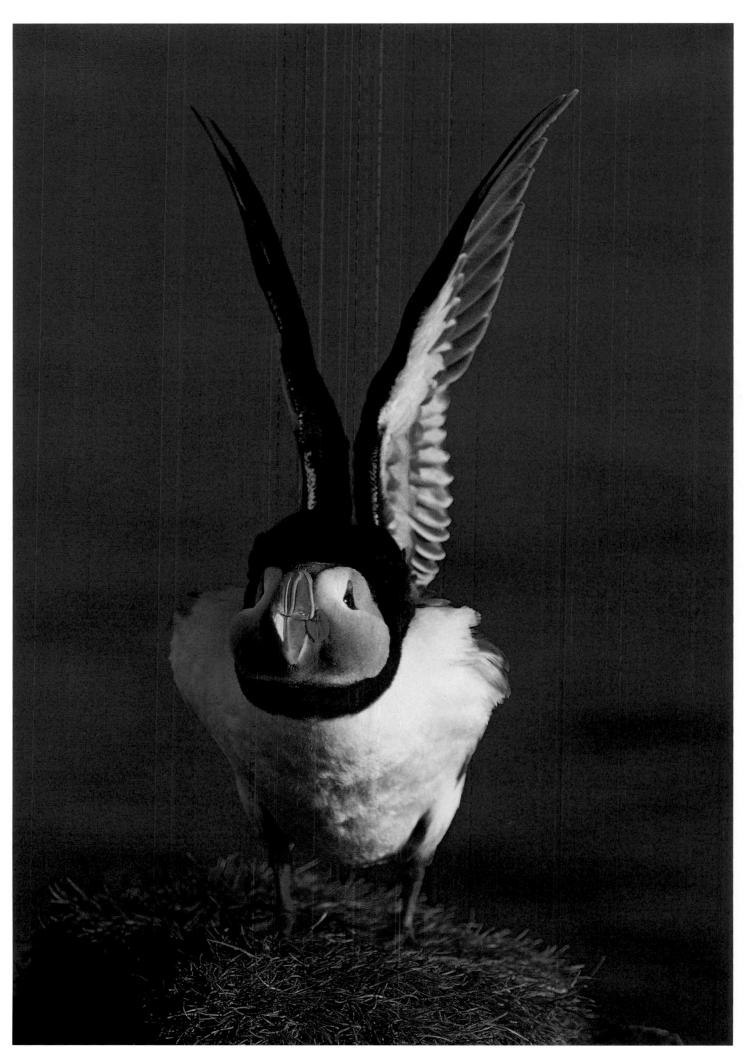

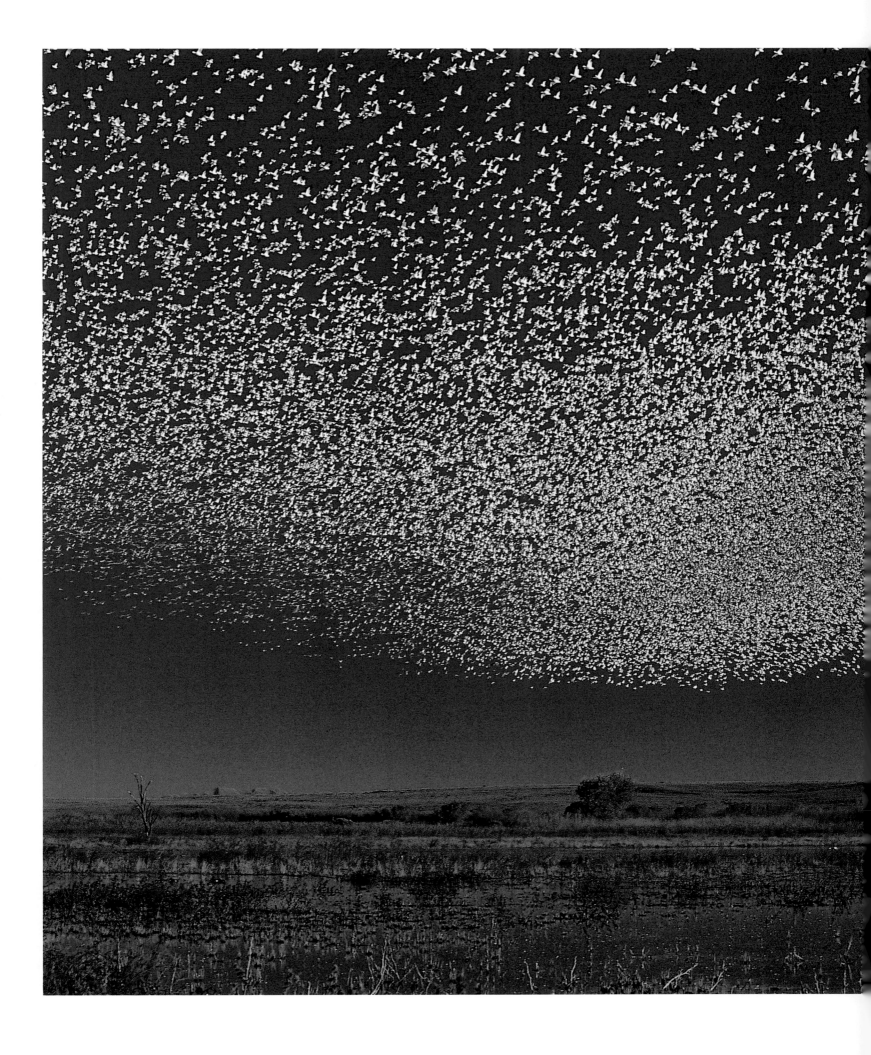

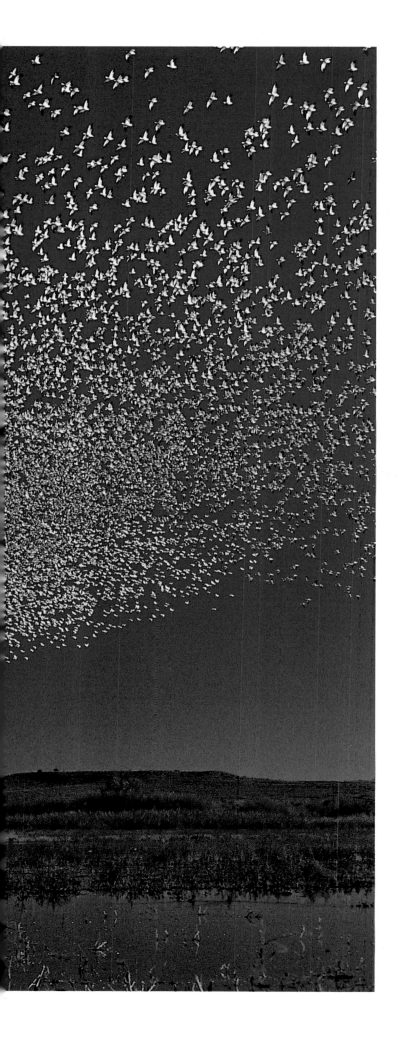

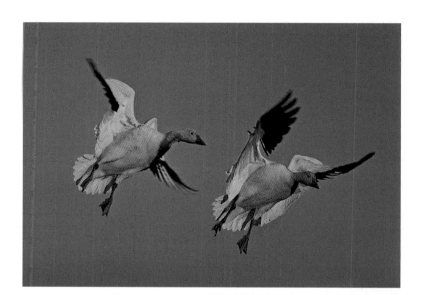

The leader of the flock. We have all seen it—the most experienced bird of the whole team, the one all others follow, leading a skein of geese. Where the leader flies, so flies the rest of the team. But is this what is really happening? Those observers who have not tired of watching flying geese after 20 seconds or so are less likely to be convinced of the existence of a team leader, because after this lapse of time the bird at the head of the formation will have slipped to the back.

The truth is that the lead goose exists only in the human mind—geese are unaware of this phenomenon. No goose is happy to fly at the head of the formation, because in doing so it will be unable to save energy by taking advantage of the slipstream that forms behind it and the other birds. As a result, the order of birds changes constantly.

Geese retain their family bonds after the breeding season. The young stay with their parents throughout the winter, even when the family joins a larger flock. While the young do follow their parents, there is no overall leader.

Snow Geese ∗ New Mexico ∗ December

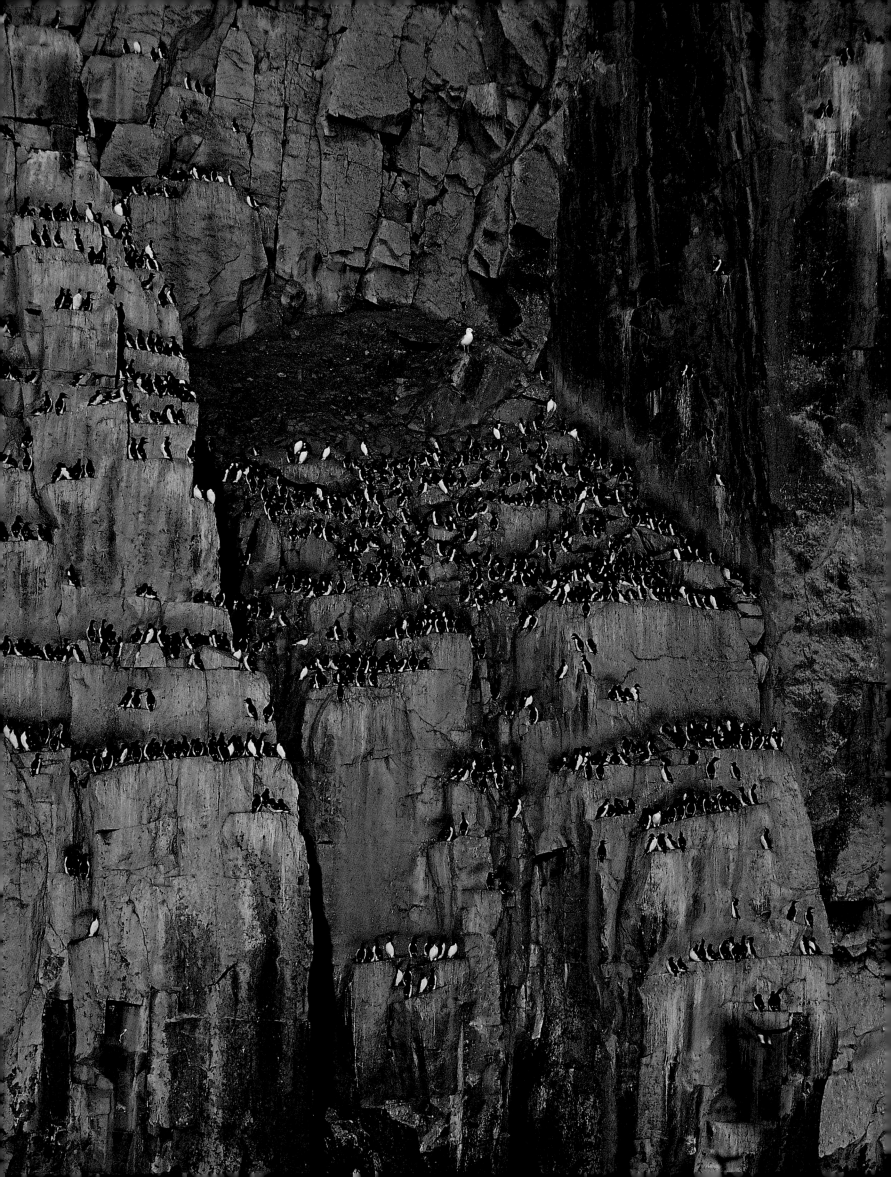

Paying the price for saving energy. The elongated, pointed wings of auks have one disadvantage: They make it more difficult for the bird to maneuver in flight compared with a rounded wing. When it comes to such complicated operations as landing on a nesting cliff, the birds could certainly do with more finely tuned motor skills. There is virtually no other avian species on Earth that has as small a living space as the Common Murre and the Thick-billed Murre. These birds stand on a narrow ledge, incubating a single egg. Next to them is another bird doing the same. An incoming bird must therefore choose a suitable landing place in good time, aim for it from a great distance and hope for the best as it prepares to come in at high speed.

Thick-billed Murre ⋆ Spitsbergen ⋆ July

Long and pointed. The advantage of an auk's elongated, pointed wings is that they are more energy efficient during long flights from the colony to the fishing grounds out at sea. Saving energy is vital because auks fish for food several times a day during the breeding season.

Common Murre ⋆ Norway ⋆ July

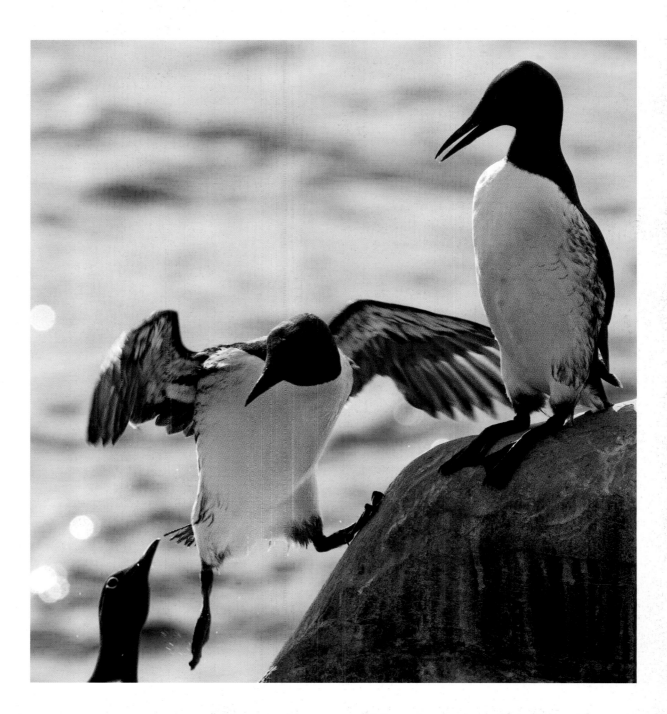

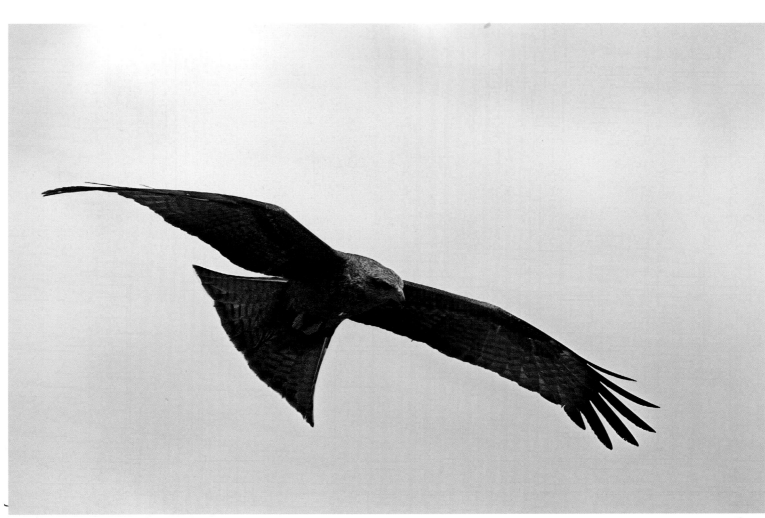

Lifting capacity. Many bird species—especially raptors—soar in order to avoid having to expend energy by using muscle power. To facilitate this, they often have extremely broad wings like those of vultures. However, the shape of a bird's wing is a compromise between different needs, and not all birds have the same leisurely lifestyle as the mighty vultures. Kites, for example, need to be quick and agile, which is why they have a more streamlined build, including rather narrow wings. They can, however, increase their lifting capacity during flight by spreading their tail feathers. Their tail is elongated with extra-long outer feathers to counteract every little gust of wind, keeping the birds airborne and stable.

Black Kite * Spain * March

Experience. A feature that distinguishes birds from mammals is that much of their behavior, including most skills, is innate. A tiger cub has a "fledgling" period that lasts many months, during which time its mother teaches it to hunt for prey. In contrast, young birds have little time for extended periods of learning. When they leave the nest they are usually meant to be able to fend for themselves.

But even birds may need a period of adjustment in order to refine their hunting or flying skills. A young pelican targeting a moving fish, for example, may well lose its balance before it has gained full control over the complete set of actions needed.

Brown Pelican * Florida * February

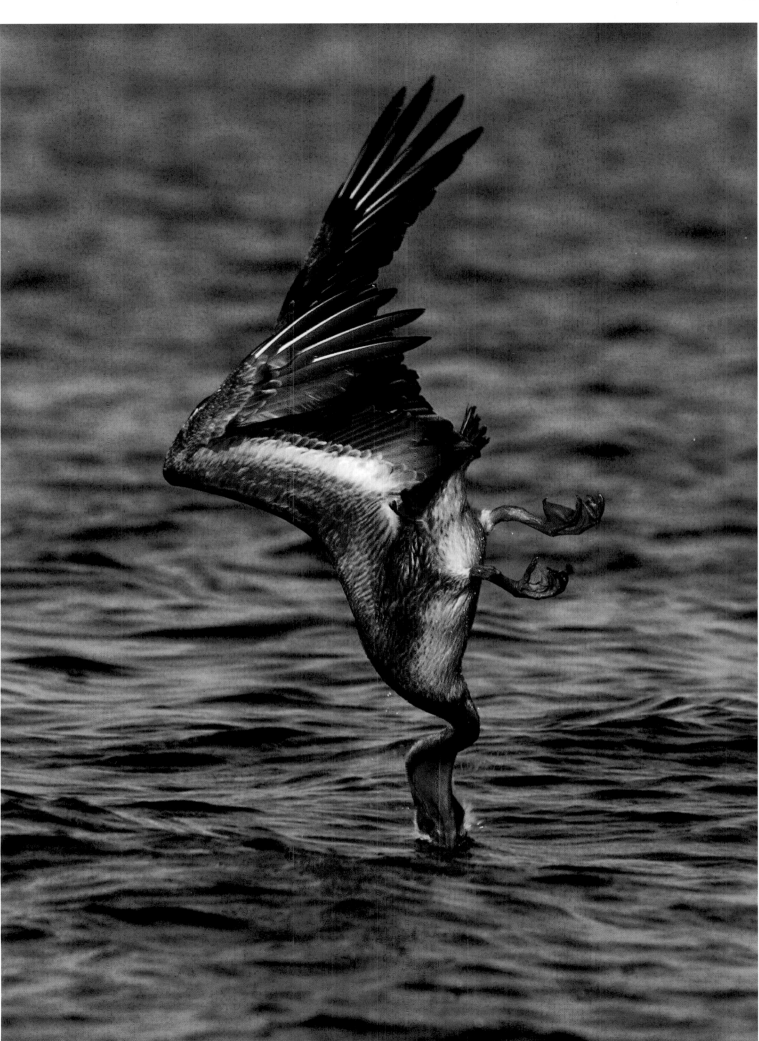

Alula. Flight is a complicated affair, requiring the presence of a stable airflow around the upper as well as the lower surface of the wings. Vortices can form in certain situations and will interrupt the high-velocity air currents flowing over the upper surface of the wing that are essential to flight. The bird can stabilize its flight by raising its "thumb," or alula, a small set of feathers located by the carpal joint. This is the only digit that is not fused to the others, and so is flexible. During takeoff and landing in particular you may notice that birds raise their alula slightly to increase stability, whereas during flight the alula rests invisibly on the upper surface of the wing.

Whooper Swan ★ Finland ★ April

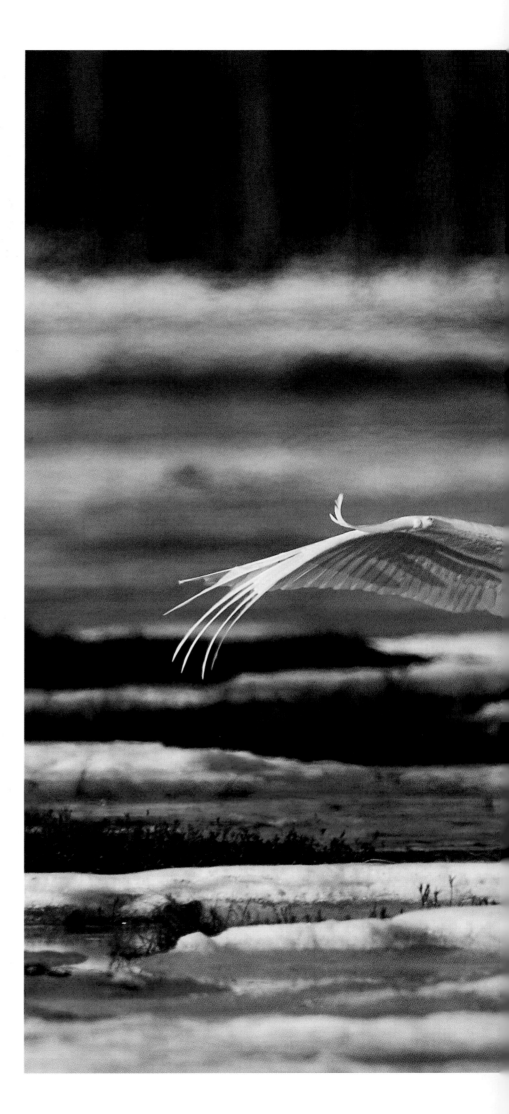

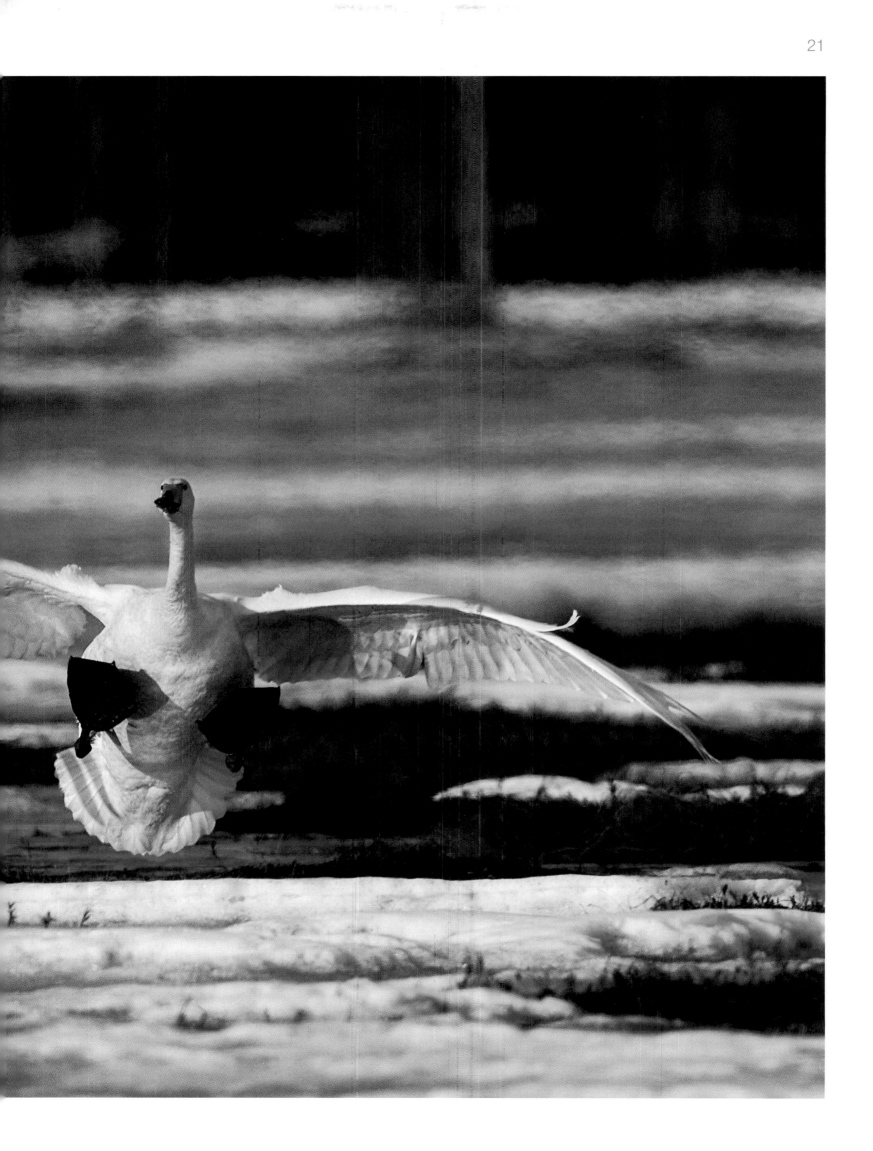

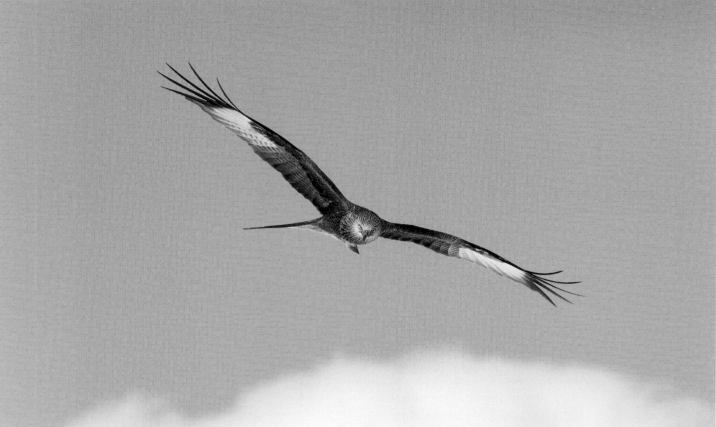

Light aircraft. The more time a bird spends in the air, the less it uses muscle power to fly. Harriers and kites have very low weight in relation to the surface area of their wings. A good example of this is the Red Kite, which weighs just over two pounds and has a wing span of 5 feet. It can soar gracefully for hours, gently beating its wings. It is obvious even to such poor earth-bound creatures as us that it is the air currents that keep them aloft.

Red Kite * Sweden * March

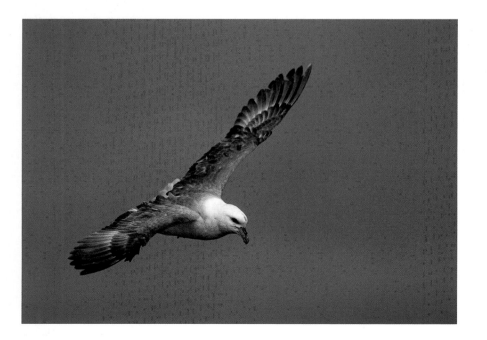

Soaring. The use of dynamic soaring by albatrosses enables them to travel for thousands of miles across the ocean. But soaring is not common to all ocean wanderers, and there is another technique available to, for example, albatrosses and fulmars. Thermal air currents are formed on the windward side of the waves, and the harder the wind blows, the stronger these upward currents are. It is estimated that updrafts generated at a speed of 20 knots (23mph) can lift an albatross 65ft (20m) above sea level and a fulmar something in the region of 30ft (8m). The bird can then propel itself downward and forward without having to resort to energy-expending muscle power.

Northern Fulmar * Iceland * July

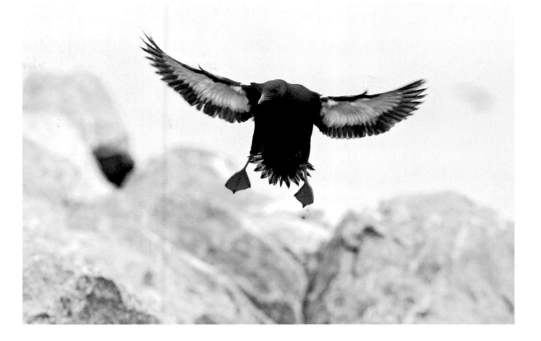

Landing. The process of landing is partly achieved through a reversal of takeoff, by increasing air resistance in order to slow down. Most birds need to maintain a certain momentum in order to stay aloft, so landing sees them coming in at full speed ahead, then braking sharply to slow down lift. By spreading their tail feathers and splaying their feet, auks increase their air resistance to slow themselves down before landing.

Black Guillemot ∗ Åland, Finland ∗ July

Broad-winged active fliers. A Black Grouse on the ground needs to be able to accelerate with lightning speed when threatened by a fox. A Sparrowhawk hunting for prey through the forest must be able to fly fast and also negotiate tree trunks skillfully. Birds such as these, with short, broad, rounded, and "fingered" wings, are distinguished by their speed, powerful acceleration, and unbeatable maneuvering skills. This large group includes gallinaceous birds, hawks, owls, and woodpeckers. Their flight places their muscles under heavy strain, which is no problem for an escaping grouse because it has to flee only a short distance to escape a fox. Woodpeckers, on the other hand, are characterized by an undulating flight. They accelerate by beating their wings a few times, then fold them against their body for a couple of seconds before beating them again. Owing to these brief, regular rest periods, the birds produce no lactic acid.

Great Spotted Woodpecker ∗ Sweden ∗ January

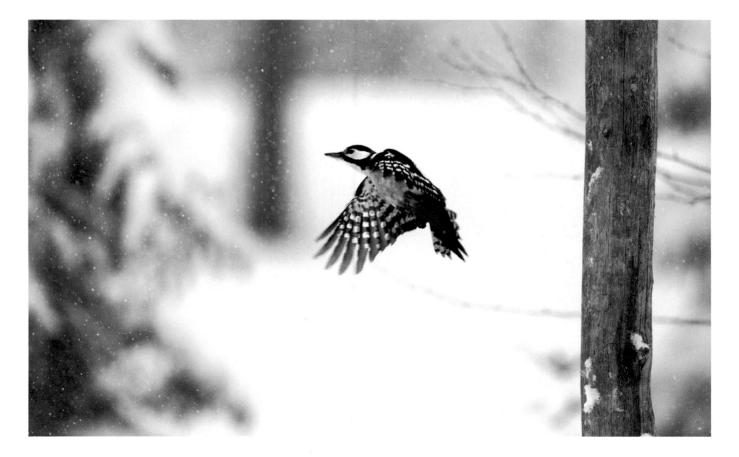

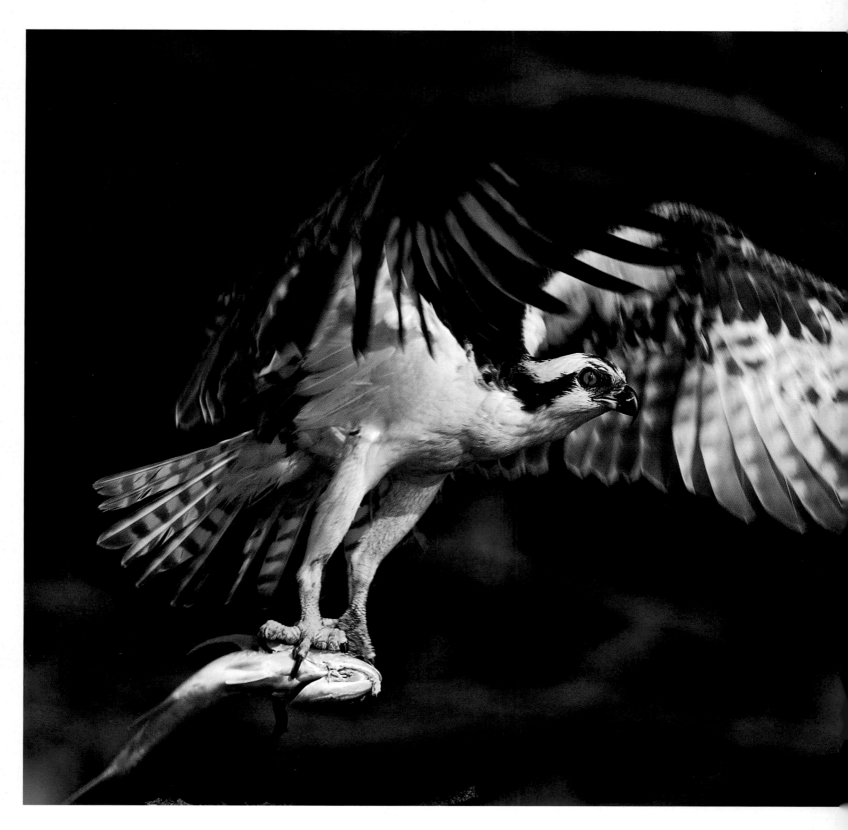

Ocean wanderer. Large birds of prey have long, broad wings, enabling them to soar on the thermal air currents formed as the sun heats the ground. These birds are completely adapted to a life of minimum active flight, and so most are extremely reluctant to fly over water during migration, often assembling en masse at various headlands throughout the world. The Osprey is one notable exception. It feeds entirely on the fish it catches over open water. The Osprey's body, including its muscle system, is adapted to a life on the wing. Contrary to the Buzzard, the Osprey is not afraid of the open sea and is happy to leave land anywhere along the coast.

Osprey ⋆ Florida ⋆ February

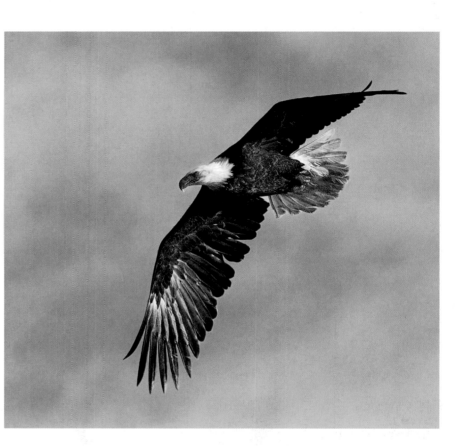

Broad-winged soarers. Large predators such as eagles, storks, cranes, and pelicans fly over land by means of static soaring. They have large, broad wings that carry comparatively little weight (in other words, the bird's weight is low compared to the total surface area of its wings), and this makes them well suited to soaring. They save energy by exploiting the thermal air currents formed above ground heated by the sun or the winds blowing alongside mountains. The ceep slots between their primary feathers improve maneuverability and allow the birds to fly very slowly without losing lift. The broad-winged soarers are therefore rather reluctant to fly over open water.

Bald Eagle ★ Alaska ★ December

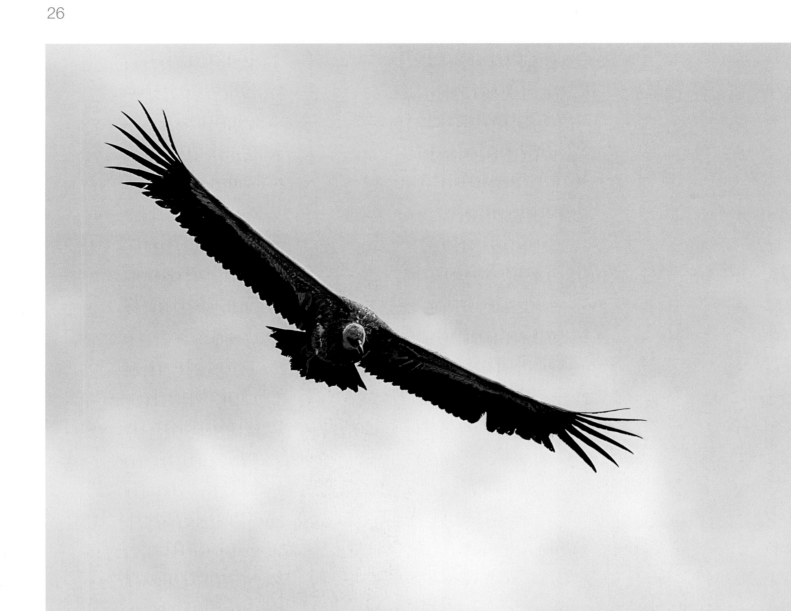

"Fingers". Vultures remain airborne for hours at a time, scanning the landscape for prey. Their large, broad wings allow them to soar without having to use muscle power, which means that their energy expenditure during flight is much the same as when they are idle. As always, stable air currents are a precondition for keeping the bird aloft—gusts of wind may result in the formation of destabilizing vortices around the wingtips. The deep slots between the primary feathers—the "fingers"—of vultures contribute to the formation of updrafts, thereby counteracting the effect of any vortices that may develop.

Griffon Vulture * Spain * March

Complete control. Depending on what a bird is doing in the air—turning, landing, hunting, escaping—it is able to perform the most breathtaking stunts. When landing, for example, geese can fly upside-down in order to lose altitude rapidly. A bird's eyes are always level with the horizon. This allows it to maintain complete control without losing its balance and becoming confused about which way is up.

White-tailed Eagle * Norway * August

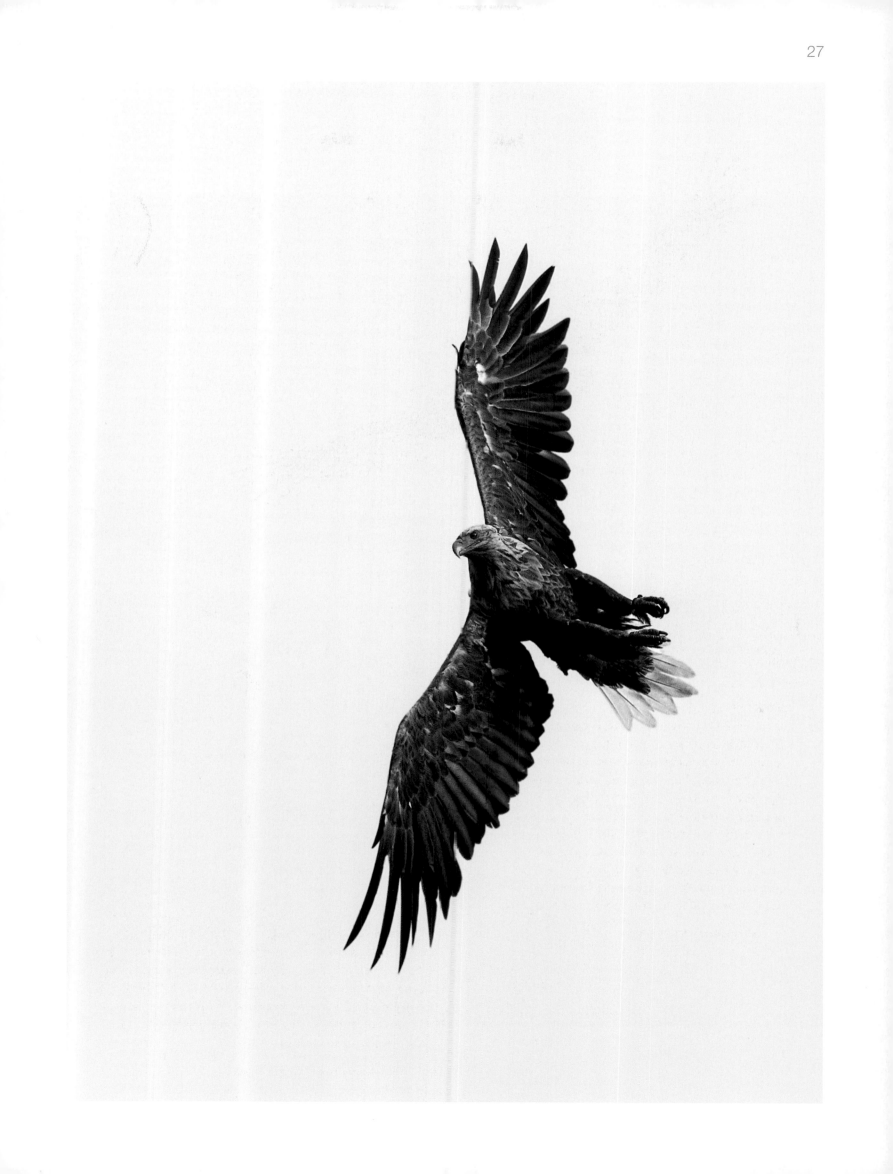

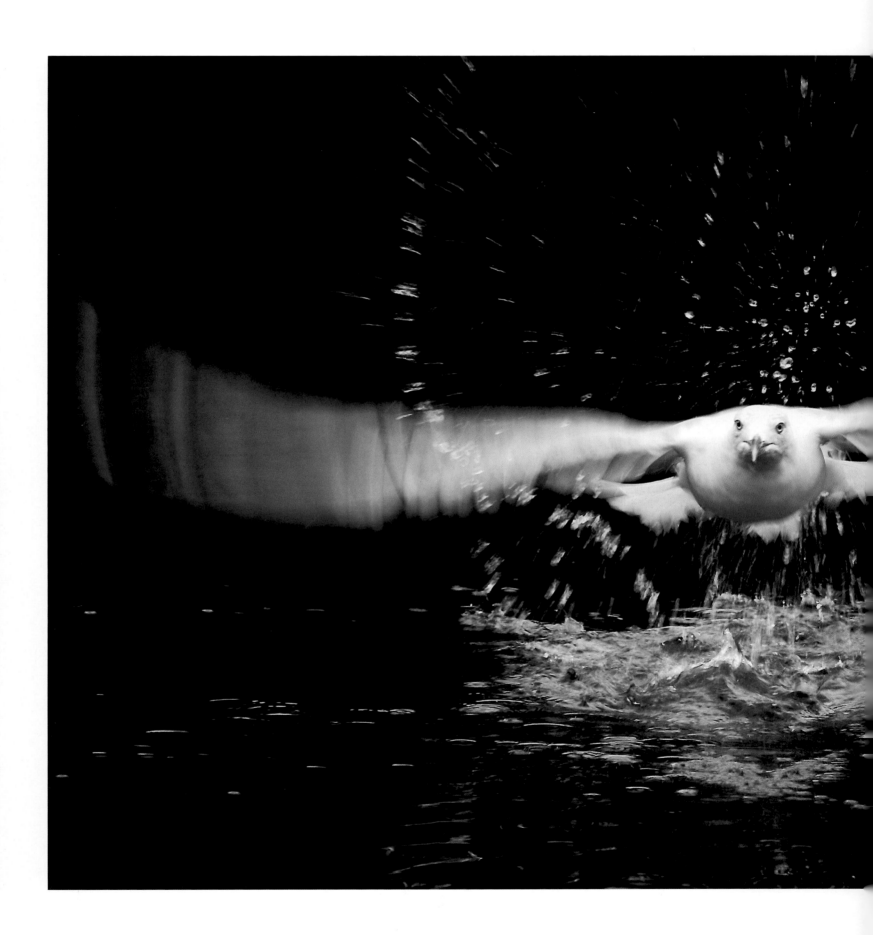

Catapult. Even though many birds need a long runway for takeoff, it is more common that they catapult themselves into the air, taking off like a fly. This, of course, requires a massive burst of energy, but it does have many advantages. Should a predator suddenly appear, a bird able to escape quickly would stay alive. And should a nice piece of bread come floating past, it can always beat others to it.

Herring Gull ∗ Norway ∗ August

The Life of Birds

THERE ARE NEARLY ten thousand bird species in the world. They exist in every conceivable environment, from the densest jungle to the most barren desert, on the largest continent to the tiniest island. It would therefore seem reasonable to think that these birds live extremely diverse lives, involving a thousand different habits, behavior patterns, and approaches to solving problems. You may, for example, think that the Red-billed Tropicbird and the Snow Petrel have little in common. However, their lives are in fact rather similar: They both nest ashore and spend most of their time airborne above the ocean in search of food.

Birds are so purposeful, efficient, and functional it would seem obvious they must plan every action carefully. But this is simply not the case. With few exceptions, bird behavior is stereotypical and is triggered by pure, unpremeditated instinct. To illustrate this, let us look at the behavior of the male Peregrine, which delivers his prey to the edge of the nest. The female then shreds the prey into morsels and feeds these to her young. If the female dies, the male's behavior does not change, and he continues to hunt and deliver his prey to the edge of the nest as he has been "programmed" to do. Eventually, the young will starve to death beside a mountain of dead gulls and pigeons. The male cannot "understand" that he must shred the prey into tiny pieces, and while the female did not understand this either, she carried out the task instinctively.

Bird behavior is mostly rational, which is to say it brings some benefit to the bird itself (or to its young). In the example above, the reason for the Peregrine male's irrational behavior was that he found himself in an abnormal situation for which evolution had given him no tools. We can assume, however, that birds normally react in the way that will benefit them most. The fact that the male does not assist the female in caring for their young is no disadvantage among capercaillie, partly because the young feed themselves from the very beginning, but it would be disastrous for peregrines.

Turning now to the behavior of the Blue Chickadee, why does it warn other birds of an approaching hawk? Wouldn't it be more beneficial for it to keep quiet so the raptor attacks another bird? A possible explanation is that birds in flocks notice one another's behavior. Those that try to profit from others get punished. It could, for example, give them a disadvantage in relation to the opposite sex when it comes to choosing partners. Warning calls are thus a means of gaining access to the flock and contribute to a higher status within the group.

The strictly regulated behavior of birds takes many forms, and it influences such decisions as what food you should put in your garden birdfeeder. If you want to attract robins, for example, sunflower seeds, sheaves of oats, and peanuts are a bad choice because the birds find them difficult to eat—their diet normally consists of insects. By understanding this behavior it makes sense to try sponge cake with small crumbs instead, which are easy for the robin to pick up. There is certainly much to discover when it comes to the life of birds.

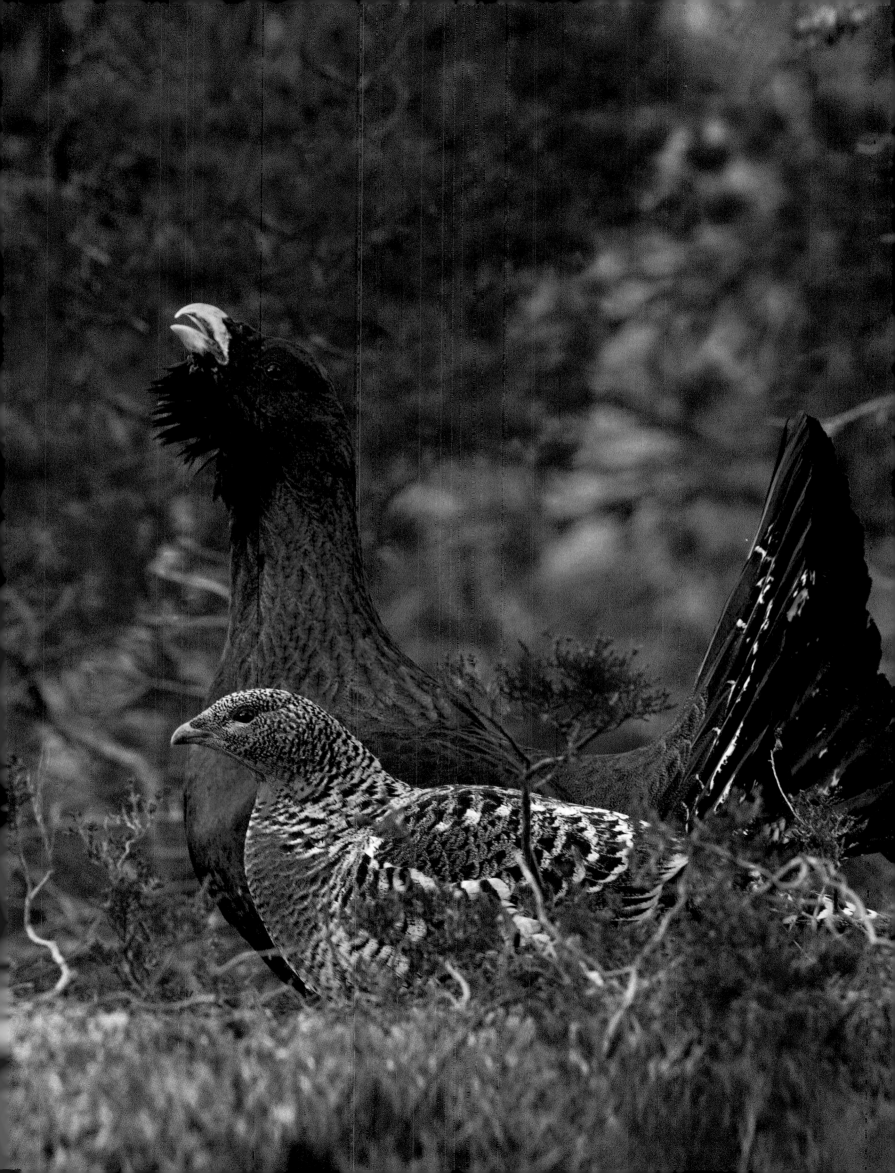

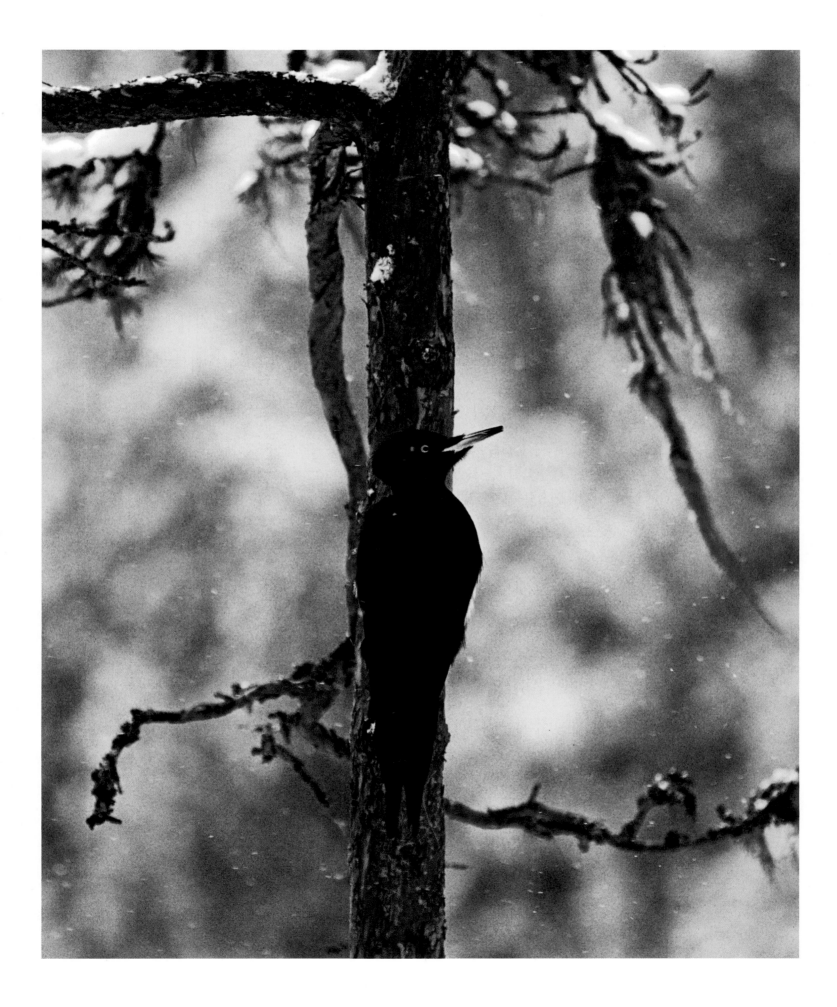

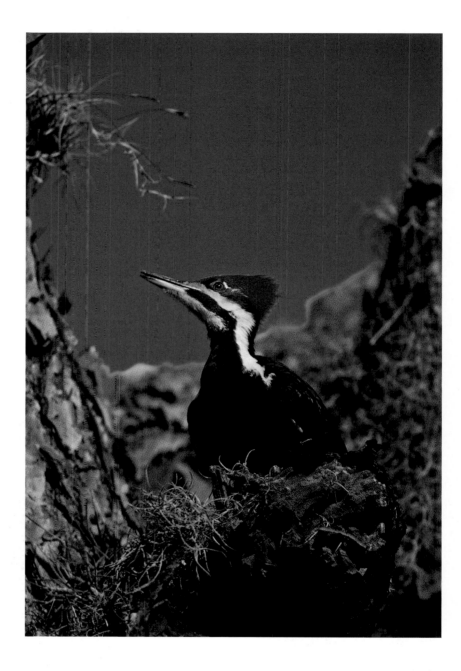

Twin species. The Black Woodpecker is a large woodpecker. It is black, measures nearly 20in (50cm) from bill to tail, and has an unusually strong beak for digging deep into wood, even living wood. It is most common in deep forest with thick-stemmed trees, including dead or decaying ones, and feeds mainly on large ants. It can be found on most parts of the European continent.

North America has many habitats that are similar to those found in Europe, which means that the same wood-pecker niches found over there can also be found here. Consequently, there is a 20-in (50cm) North American 'black' woodpecker with a very large bill, called the Pileated Woodpecker. These two species are so similar that they could be called "twin species." Even without knowledge of their family trees, it is fairly obvious that they share a common ancestry. Twin species like these occur in many places around the world.

Black Woodpecker * Finland * January **Pileated Woodpecker** * Texas * February

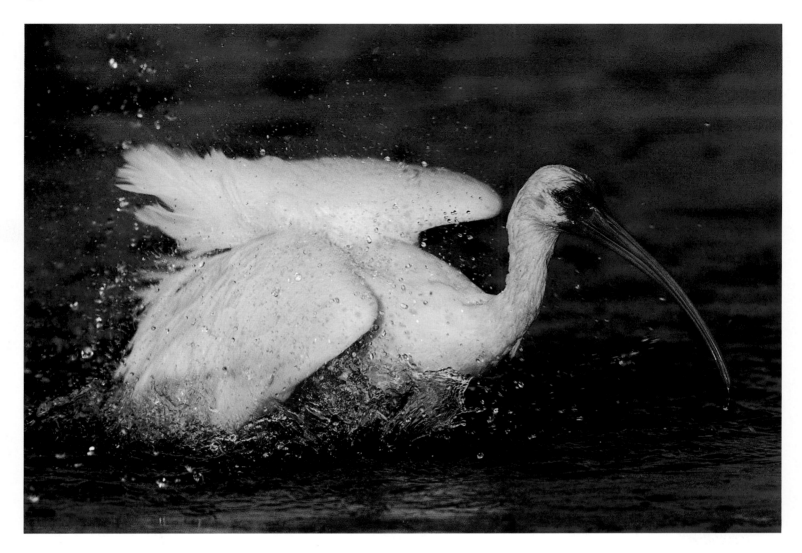

Birdbath. Birds regularly take baths in order to rid themselves of parasites, and they will splash and flap their wings to their heart's content. It is seldom difficult for aquatic birds, such as the ibis, to find a suitable bathing spot, but marine birds also like to find fresh-water lakes in which to bathe. Anyone who has taken a swim in the sea will appreciate why there are freshwater showers at well equipped beaches and why marine species prefer to wash in fresh water.

White Ibis ∗ Florida ∗ March

Overleaf. **Who decides?** Which bird decides where the flock is heading? The answer is that no individual does, or, rather, each does its own thing. Safety in numbers is the reason why birds are reluctant to leave the flock, but it is not unusual for a small flock to form from a larger one and take off on its own.

All Mallards in a flock often take off simultaneously. This doesn't happen on any given signal, but because they are all reacting to the same danger, such as a stalking fox.

Mallards ∗ New Mexico ∗ December

Hygiene. Parasites are an acute problem for birds, and all kinds of lice, mites, and other insects thrive in the warmth of their plumage. Many of these pests spend their entire lives on the host bird. But the vermin must be controlled, and so bathing, preening, and scratching take up a large part of the daily life of birds. That parasites constitute a real threat is demonstrated when a bird sustains a serious injury or is in any other way reduced to a weakened state. The first thing that usually happens in such a situation is that lice and mites colonize the defenseless bird, often causing its death.

No King Eider female will accept a male, regardless of how bright his face is and how seductive his coloring, if he is not well groomed.

King Eider ＊ Norway ＊ February

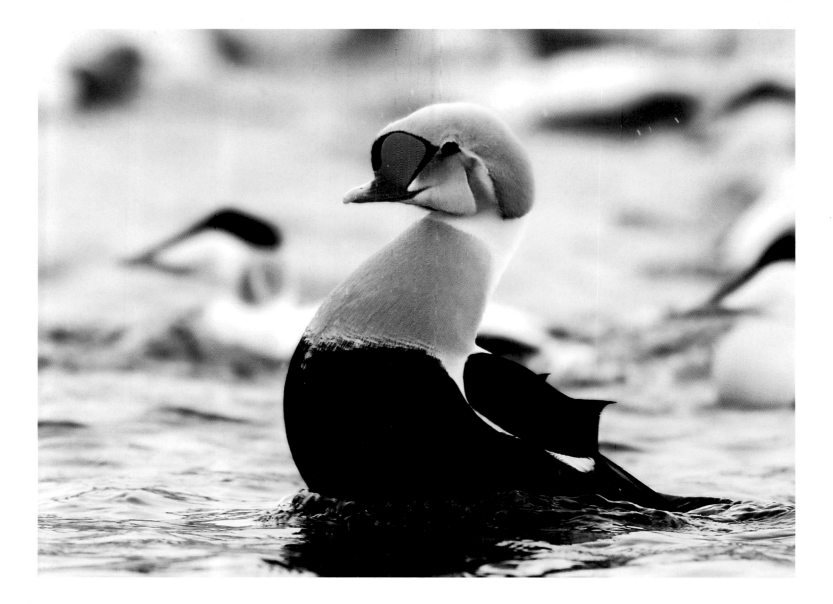

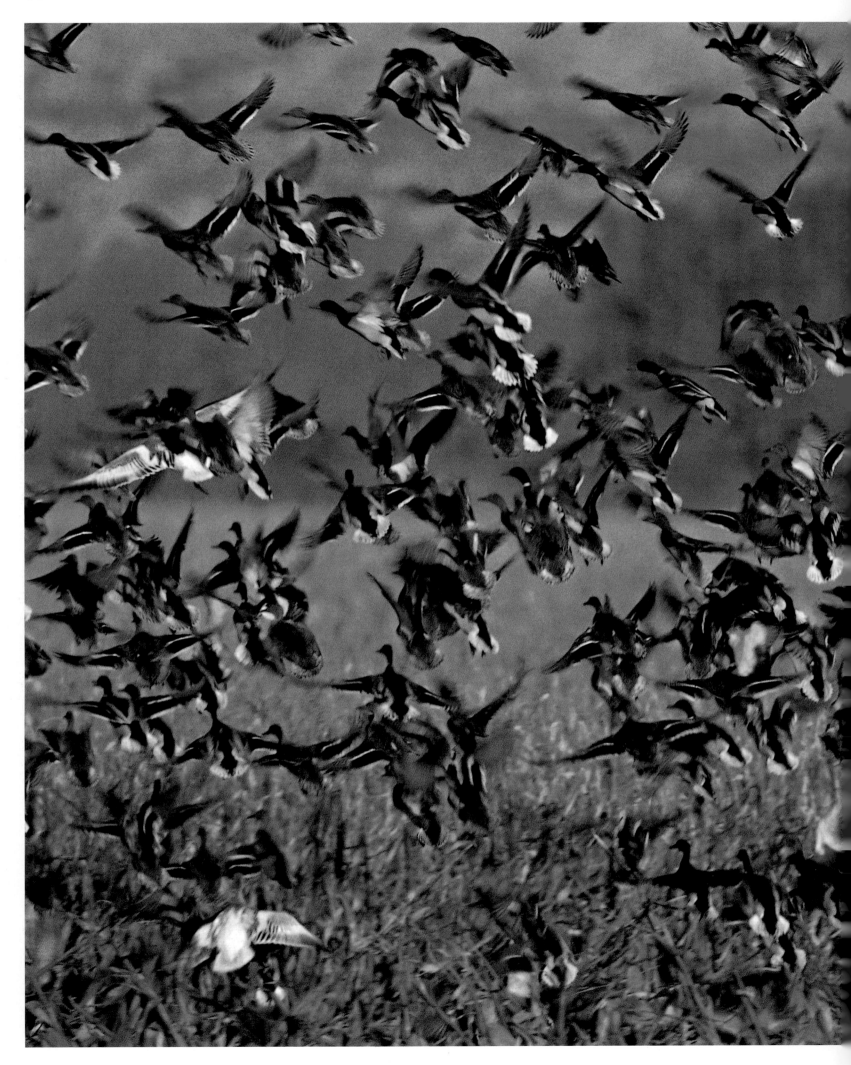

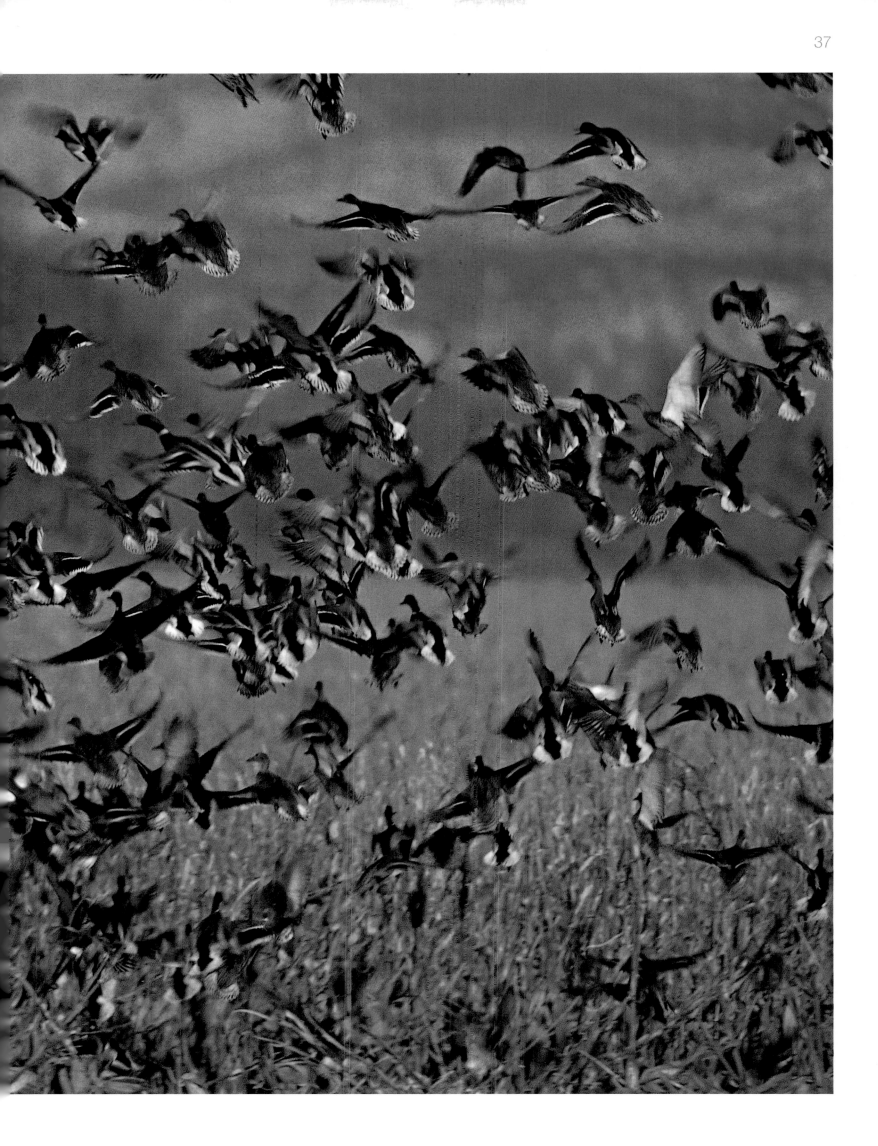

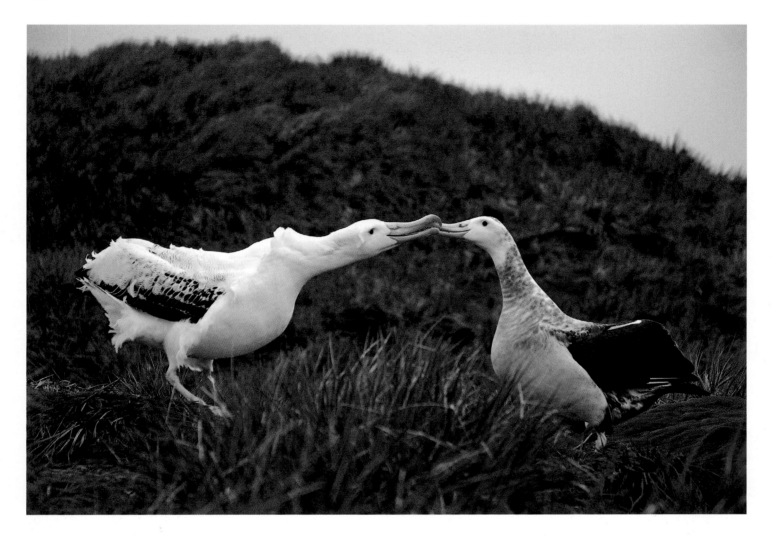

A major misunderstanding. "Some Goldcrests winter in their northerly breeding range, while others move south in order to secure the survival of the species," "Since the Wandering Albatross is so long-lived it needs to produce only one egg every other year in order for the species to survive," and other similar statements turn up every now and then in newspaper wildlife columns. These arguments are based on a serious misconception, for in nature there is no "in order to." Neither Goldcrests nor Wandering Albatrosses have any conscious intention of safe-guarding their species.

Wandering Albatross ∗ South Georgia ∗ January

Salt channels. Ocean birds such as albatrosses, shearwaters, fulmars, and penguins can survive for months without access to fresh water. They still need to drink, so they have to make do with seawater. As is the case with humans, the kidneys in birds can process only a limited amount of salt. Therefore, ocean birds are equipped with special glands, located behind the frontal lobe, to take care of the harmful excess sodium chloride. In fact, all birds have such glands, but their function in land-based species is unclear.

In the tube-nosed seabirds (including shearwaters, petrels, and storm petrels), the excess salt is excreted via one or two channels along the culmen to the nostrils, where it slowly trickles out. In larger species, such as albatrosses and giant petrels, you can sometimes see a drop of saline solution hanging from the tip of the bill, testimony to a well functioning system.

Southern Giant Petrel ∗ Antarctica ∗ January

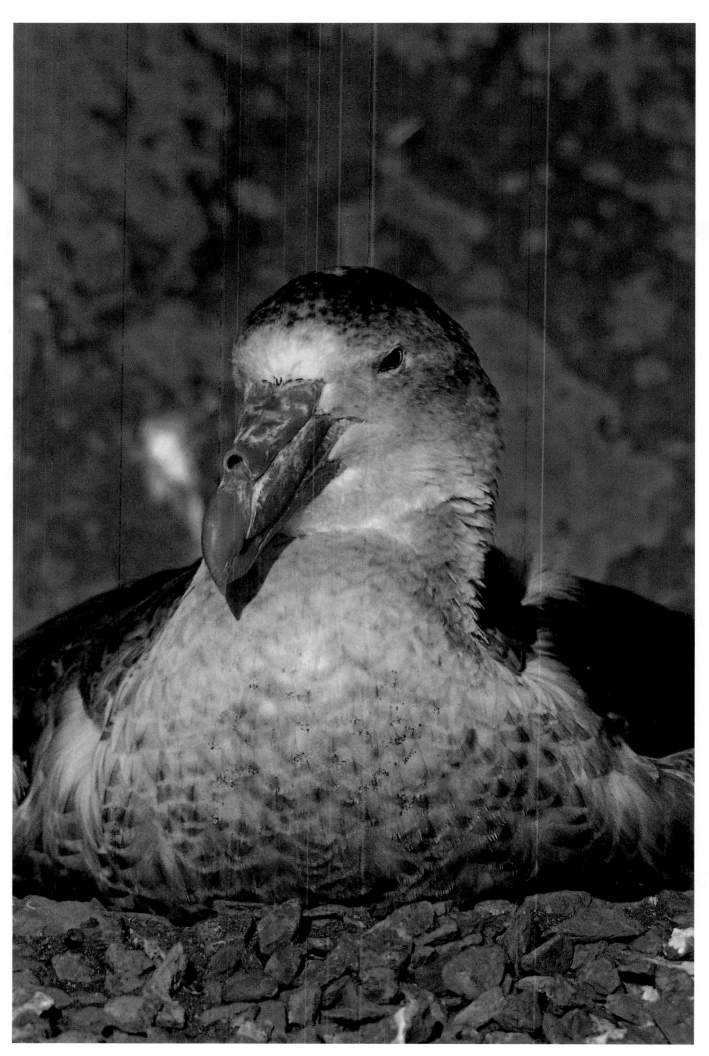

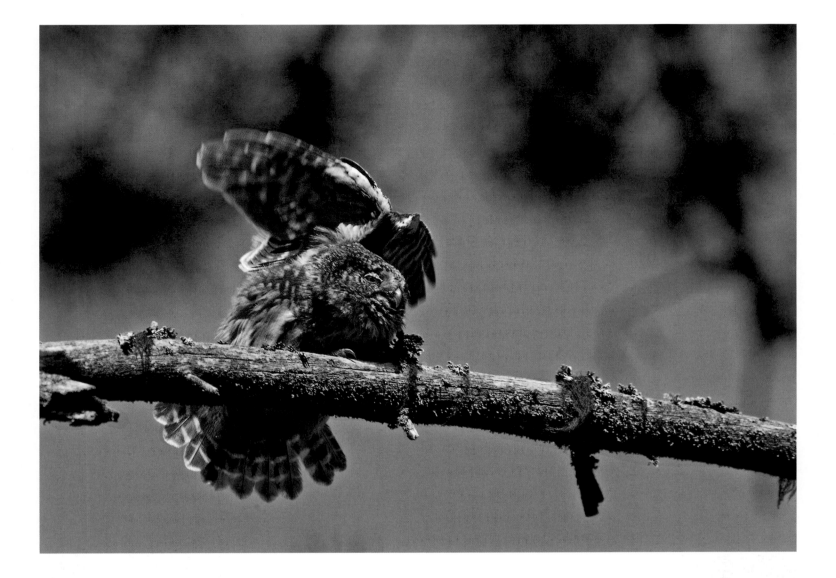

Active at dusk. A small number of birds are active only at night. The best-known nocturnal group is the owls, whose nighttime hooting has inspired man's imagination down the ages. The reason for the nocturnal habits of owls is food supply—many of the small rodents they eat are themselves active at night in order to avoid falling prey to raptors. This food resource is therefore available during the dark hours, and owls are simply taking advantage of the fact.

The Eurasian Pygmy Owl has fine-tuned this specialization by taking it one step further. It has found a niche during those hours when neither raptors nor other owls hunt—at dusk.

Eurasian Pygmy Owl ∗ Finland ∗ June

Molting. Because feathers fray, all birds need to replace them once or twice a year. They do this by molting. Feathers do not wear through the effects of languid soaring up in the air or sleeping on a perch. Instead, wear is usually more pronounced when birds are active, for example, when they are fighting with other birds, killing prey, or moving through foliage or ground vegetation. Strong and persistent sunlight also fades the feathers and makes them brittle.

No matter how frayed a feather is, it will not be replaced until the next molting period, which, at temperate latitudes normally occurs during the summer. However, if a feather is pulled out, a new one will soon grow in its place.

White-tailed Eagle ∗ Finland ∗ November

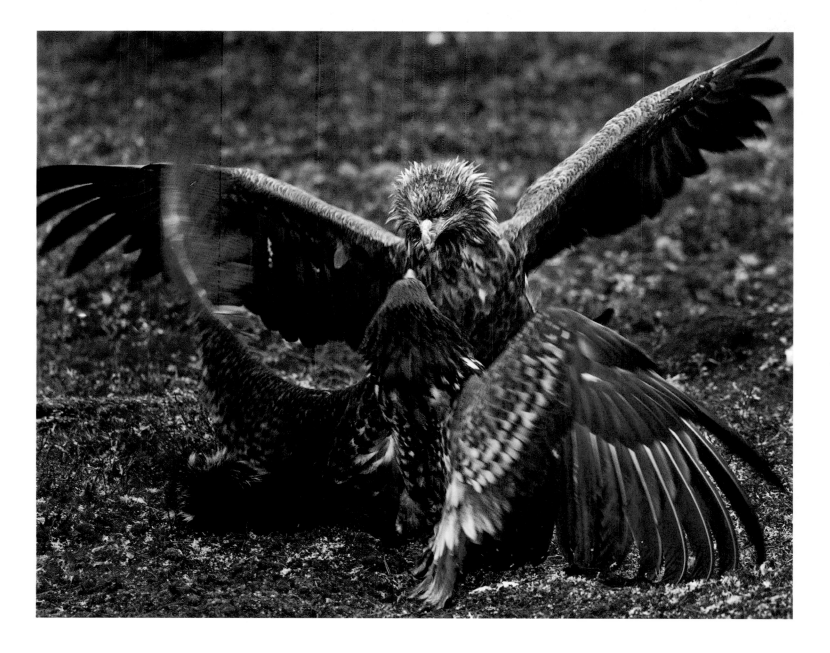

Related. It is fairly obvious that the Gadwall and Wigeon are reasonably closely related, and the same goes for the Iceland Gull and Glaucous Gull. But does this necessarily mean that birds as different as the rather small Glossy Ibis and the large, long-legged spoonbill are not? The answer is no.

Over the millennia, bird species have adapted to the various habitat niches that Mother Nature has to offer. If a food resource is available, a species will take advantage of it—a broad spoon-shaped bill is ideal for filtering water while a slender bill is useful for picking up small food items. Despite their different feeding apparatuses, the ibises and the spoonbills are both descended from a common ancestor, and because of this biologists classify them in the same tongue-twisting family, Threskiornithidae. They are thus closely related, although they hide it well.

Glossy Ibis ⋆ New York ⋆ August

Eurasian Spoonbill ⋆ Spain ⋆ April

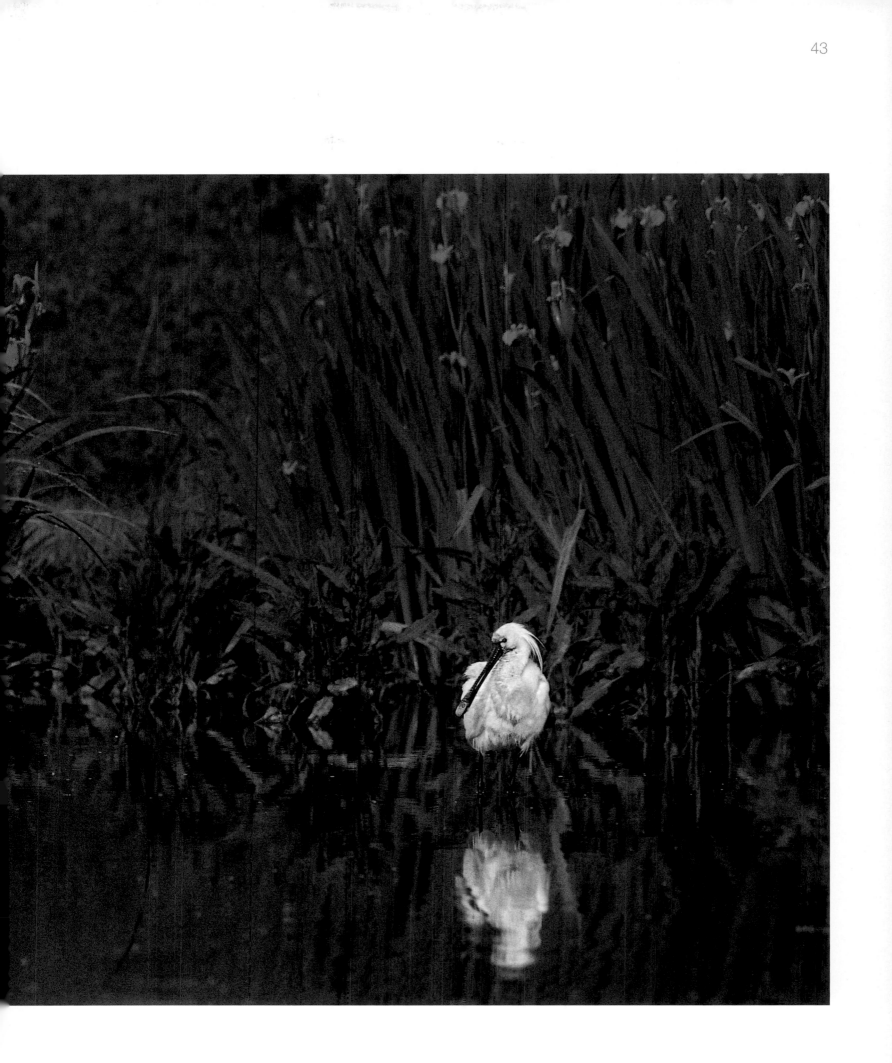

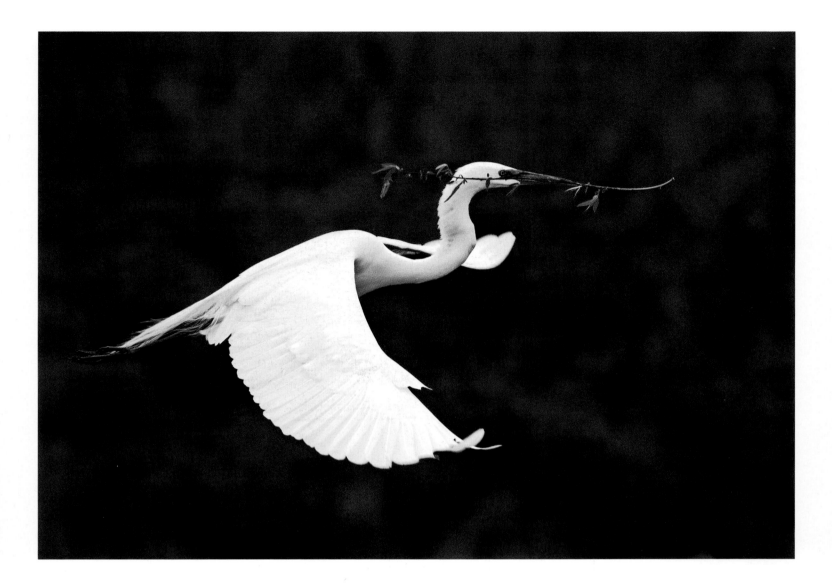

Emotional life. More advanced psychological activity, including emotions, is located in the cerebral cortex of the brain. In this respect, mammals are superior to birds—that a dog joyfully greets its mistress and master when they have been away for a couple of weeks is obvious. Birds, however, possess the mental capacity of a snail or a shrimp, and are unable to have any such feelings.

On the other hand, there is no doubt that in some respect birds are able to experience a sense of satisfaction or, inversely, fear, such as when they are cornered by a hawk. But male birds are not able to express love, and no female demands it. The offering of a branch, however, is always appreciated.

Great White Egret * Florida * March

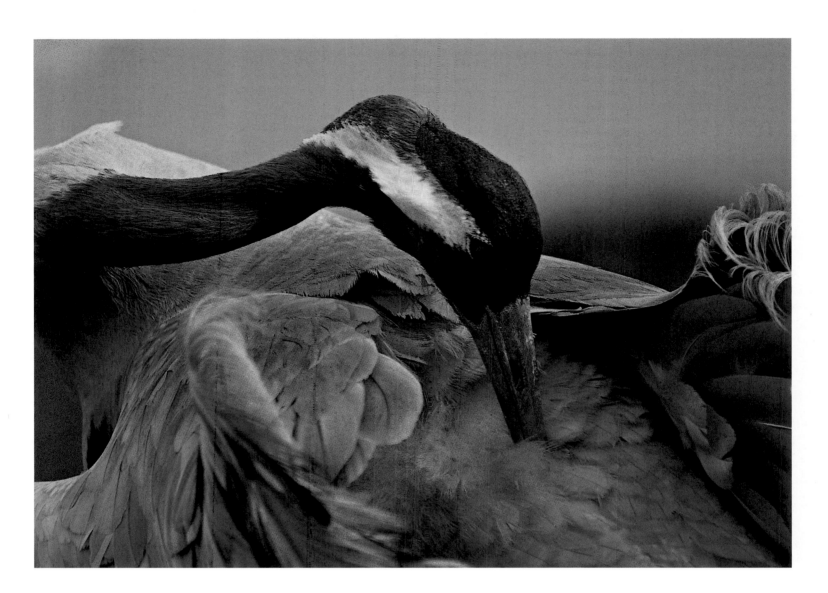

Preening. Birds preen every day, which is to say they give their plumage a good overhaul. It must be kept meticulously clean, not only to remove vermin, but also in order to maintain its aerodynamic, insulating, and water-repelling properties. During preening the bird dislodges parasites and ensures that each feather is in order. Some birds, including the crane, also anoint their feathers with an oily secretion they extract with their bill from a gland on the rump at the base of the tail. This probably increases the feathers' buoyancy, and it may repel bacteria. In geese, it seems that the oil is also used to send odor signals.

Eurasian Crane ＊ Sweden ＊ March

Overleaf. **Diurnal rhythm.** Like all animals, birds have a specific daily rhythm, but differ from mammals by being diurnal. In this respect humans are more like birds than our relatives the elk, the hedgehog, and the bat. Birds have two peak periods: morning and evening. They are most active in the morning, when they sing intensively, and this is also when they eat most of their food. Because birds have a high body temperature and metabolic rate, after a long night it is important they get some food quickly—even before the morning mist has evaporated.

Red-throated Loon ＊ Sweden ＊ June

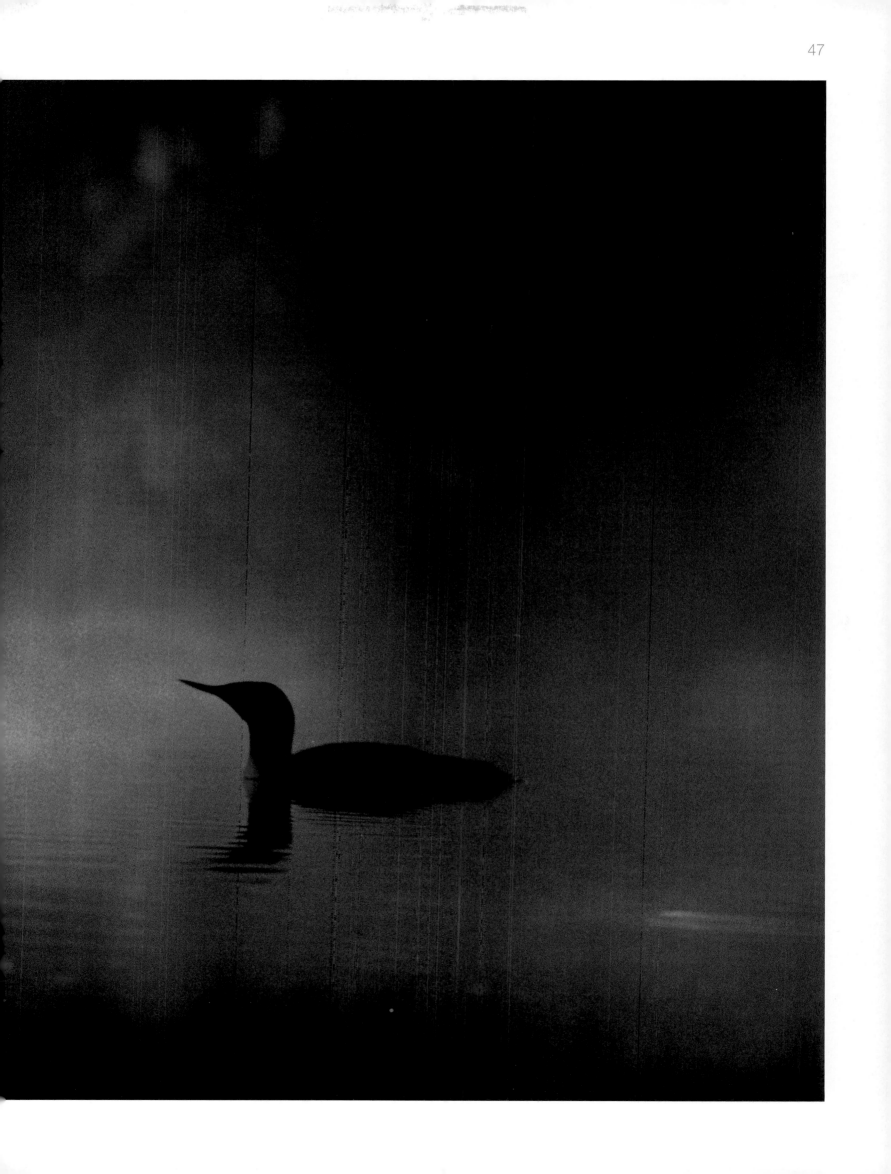

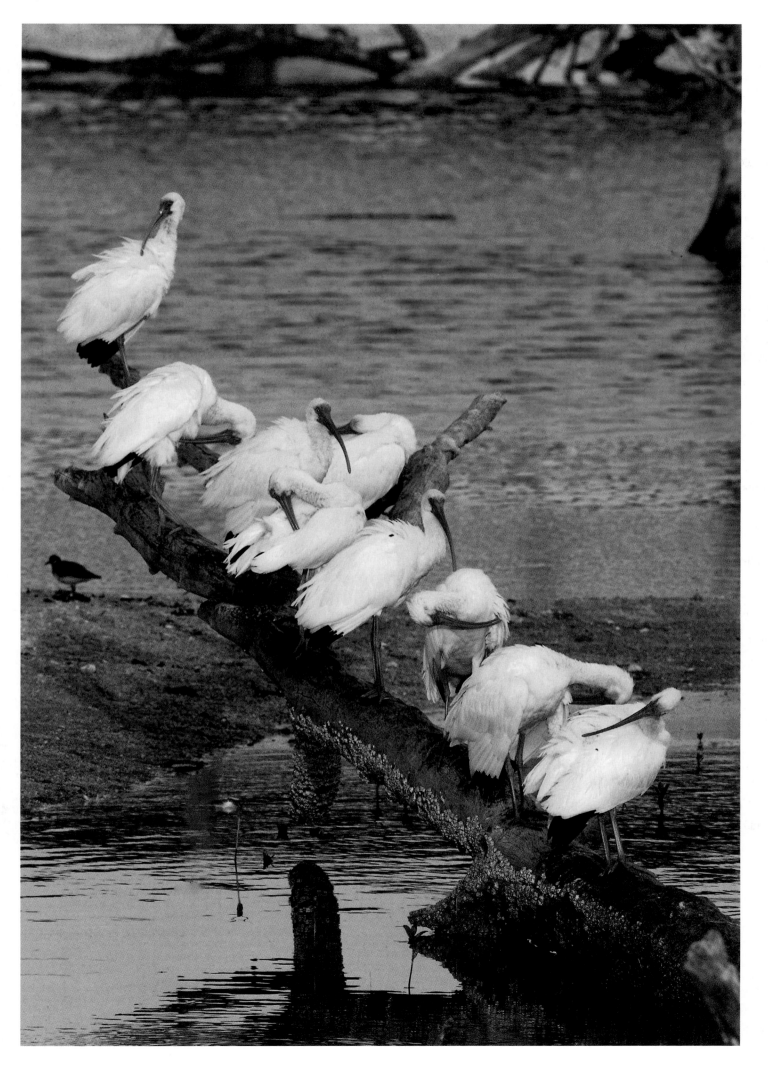

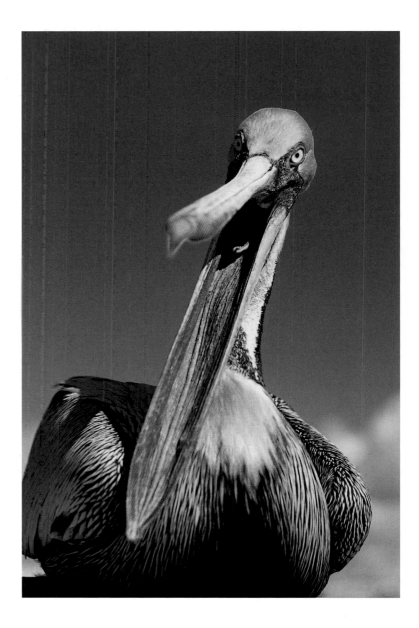

Language. Through song, the Common Chaffinch tells other males of the same species to keep away from its territory. By calling *kip-kip-kip*, the crossbill communicates to others that it is time to fly away—after a few seconds of this, birds can be seen leaving the fir trees whose cones they have emptied of seeds. By insistent thin notes, the chickadee warns that a hawk is approaching, and all of a sudden the whole flock will flee to safety.

Birds have a wide selection of calls, often denoting a function that is fully comprehensible even to us humans. Does this mean that they have a language? The answer is no. They use their calls to convey a *message*, but that isn't the same as having a language. When one dunlin bumps into another, pushing it with its breast, the message is, "Go away! This is my patch!" The message is conveyed successfully without the use of language. If a White Ibis could say to its neighbor, "Watch out, here comes an eagle," as well as, "An eagle came yesterday," "An eagle will probably be coming soon," "Is that an eagle coming?", and "I wish that no rotten eagles were coming this way!", then it would have mastered language. But it cannot, proving that birds have no language.

White Ibis ∗ Florida ∗ February

Big mouth. The bill is not included in the avian voice apparatus, unlike the human mouth or the elephant's trunk. The bill is primarily a tool for catching, transporting, and eating food. The pelican may have a big mouth, but that does not make it any noisier.

Brown Pelican ∗ Florida ∗ January

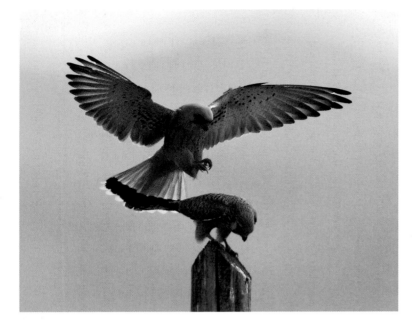

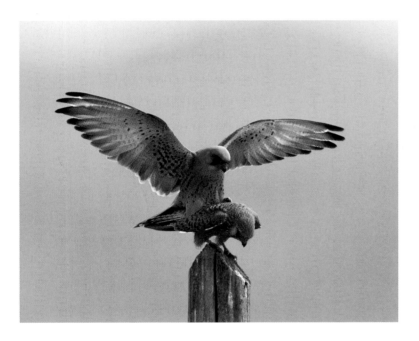

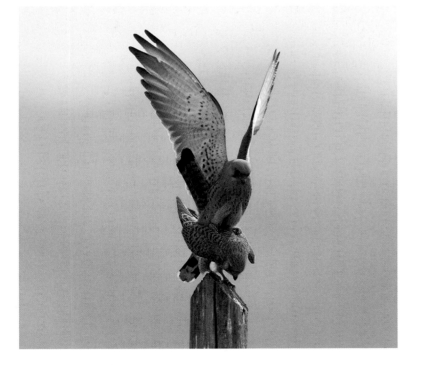

Iceberg. At the time of writing, between 20,000 and 35,000 Lesser Kestrel pairs were breeding in southern Europe, whereas at the beginning of the 1980s the population was estimated at more than 60,000 pairs. This drop is one of the most dramatic in Europe during recent years. The Lesser Kestrel feeds mainly on insects, and, as is often the case, the causes of the fall in population are large-scale agricultural practices and the increased use of pesticides. Even the most uninitiated person must agree that the term "disaster" best describes what is happening, not least when you take into account that the Lesser Kestrel is only the tip of an iceberg that consists of many other disappearing southern European wildlife species. The Lesser Kestrel breeds in colonies and is easy to count, but how many other birds, rodents, lizards, and insects have disappeared unnoticed?

Lesser Kestrel pair ∗ Spain ∗ April

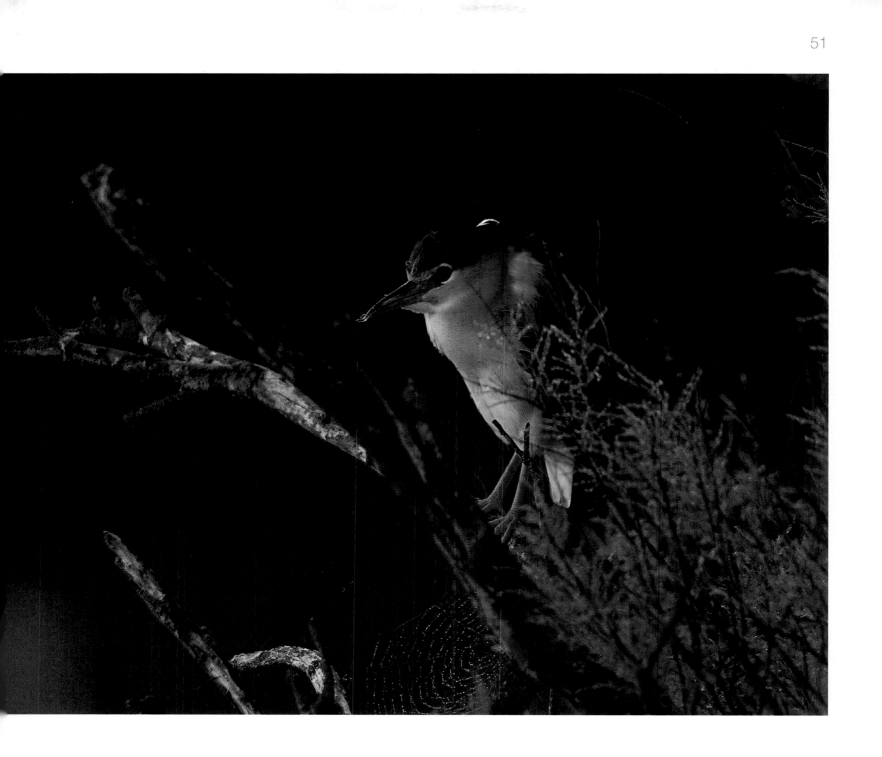

An oddity. If a handful of closely related species live similar lives, you can count on there being at least one oddity among them. With herons it is the Black-crowned Night Heron. The Grey Heron, together with all the various white egrets of southern Europe, is active during the day, while the Black-crowned Night Heron, as its name denotes, is active during the night. The birds telltale large eyes are a clear sign that it is nocturnal, and it hunts prey that in their turn are active during the night to escape from the beaks of the day herons. The Black-crowned Night Heron occupies the same niche in relation to other herons, as do owls in relation to raptors. During the day it usually perches somewhere waiting for evening to arrive.

Black-crowned Night Heron ∗ Spain ∗ April

Pushy. Just like other corvids, magpies are good at looking after themselves. They are alert, smart, and pushy. The many legends involving magpies and crows actually do have some basis in fact. We have good reason to believe that magpies and crows are more intelligent than many other birds. The way a magpie keeps an eagle under surveillance may, for example, be a smart move because the eagle could well have carrion stashed away somewhere. If that is so, there will be some leftovers once the eagle has finished its meal.

**Black-billed Magpie and
White-tailed Eagle** ⋆ Finland ⋆ November

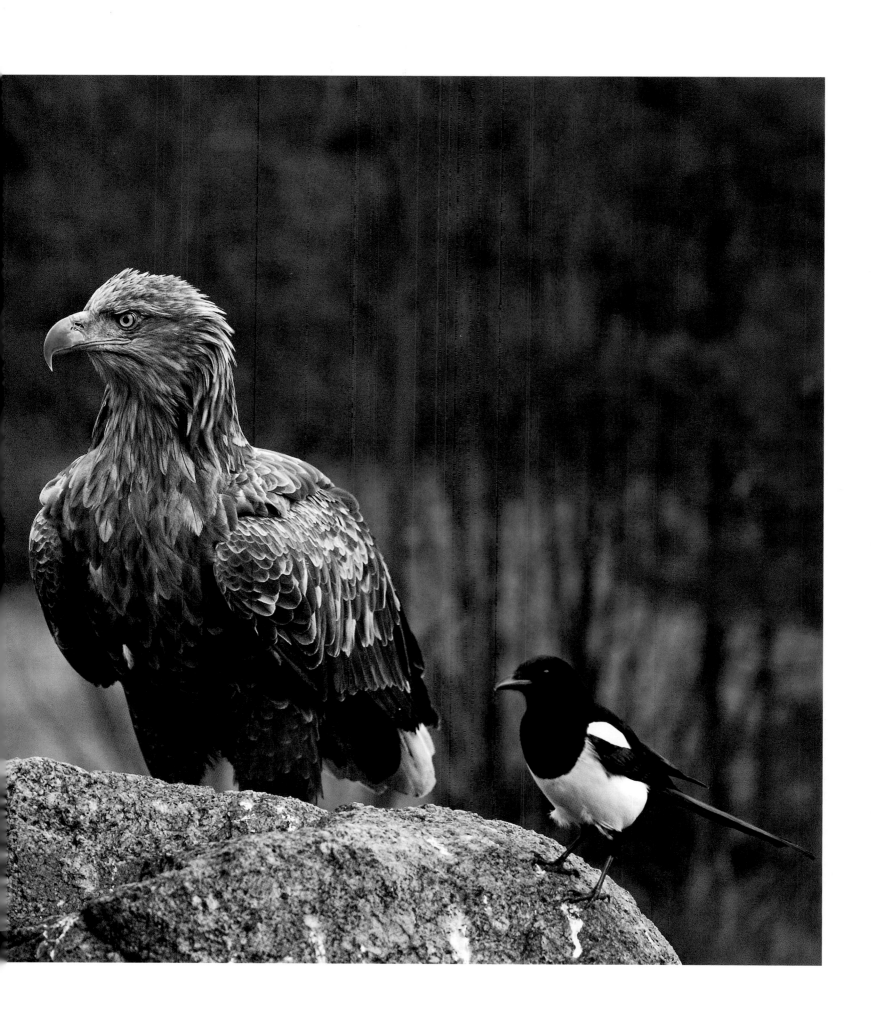

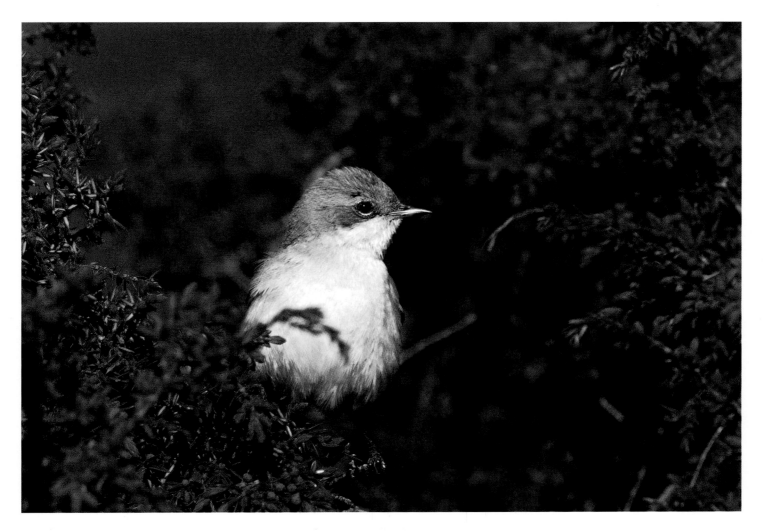

Morning song. Birds sing more intensively in the morning than at any other time of the day, as anyone who has been woken up before dawn by a garden songster outside their bedroom window will confirm. But why do they sing in the morning?

The answer seems to have something to do with the female's sleeping pattern. Many female passerines mate in secret with strange males as a guarantee against low-quality sperm in their own males. This is why their males carefully monitor what they are up to during the day. A male partner may therefore take the opportunity to sing to his heart's content before the female wakes up to her busy day. As she moves around the territory to look for food, he will be so busy keeping an eye on her that he cannot risk allowing his concentration to wander by singing.

Lesser Whitethroat ∗ Sweden ∗ May

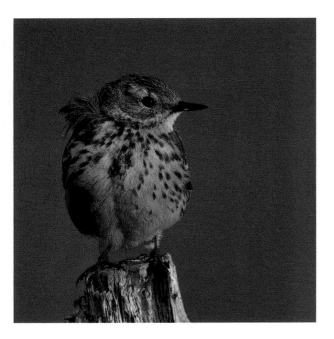

Small but large. Birds mature much more quickly than mammals, and once they are able to look after themselves they have fully grown. It is a mistake to think that because a pipit is so small it must be young. Parents normally abandon their young after two to five months. After that, they stop growing, regardless of whether they are pipits or eagles.

Meadow Pipit ∗ Sweden ∗ May

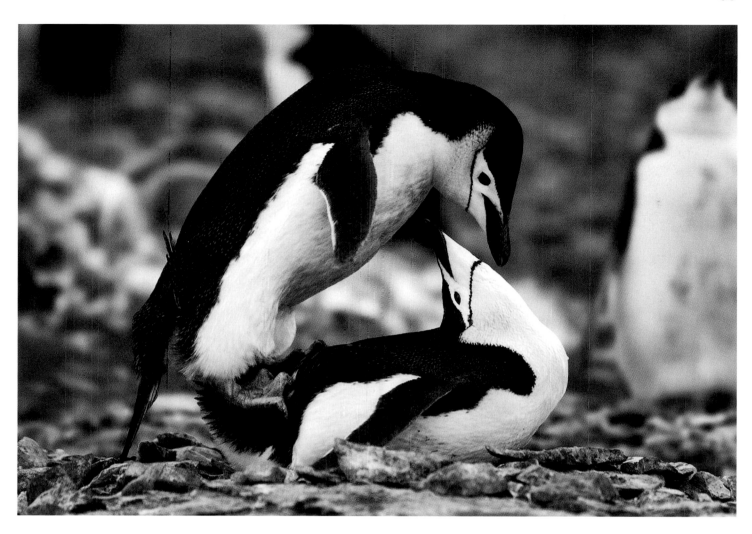

Reptile brain. What do penguins feel when they mate? The answer is nothing. Birds have no emotional life as such. In fact, you could say they have "reptile brains." This is not as disparaging as it sounds, because their brains are actually much more similar to reptile brains than they are to those of mammals.

Chinstrap Penguin * Antarctica * January

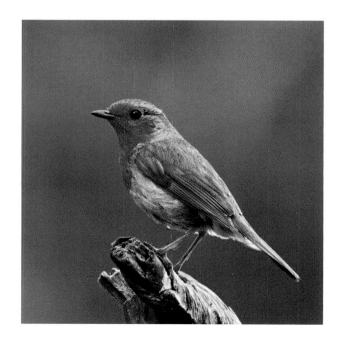

Solitary birds. Many passerines live in flocks, partly as a safety measure. But there are drawbacks to such a lifestyle—for one, they have to share food with others. The robin mostly forages under dense shrubbery where Sparrowhawks cannot reach it. This means robins are solitary except during the breeding season, migrating alone and foraging alone. They chase away other robins by calling, "The food under this bush is mine!"

European Robin * Sweden * June

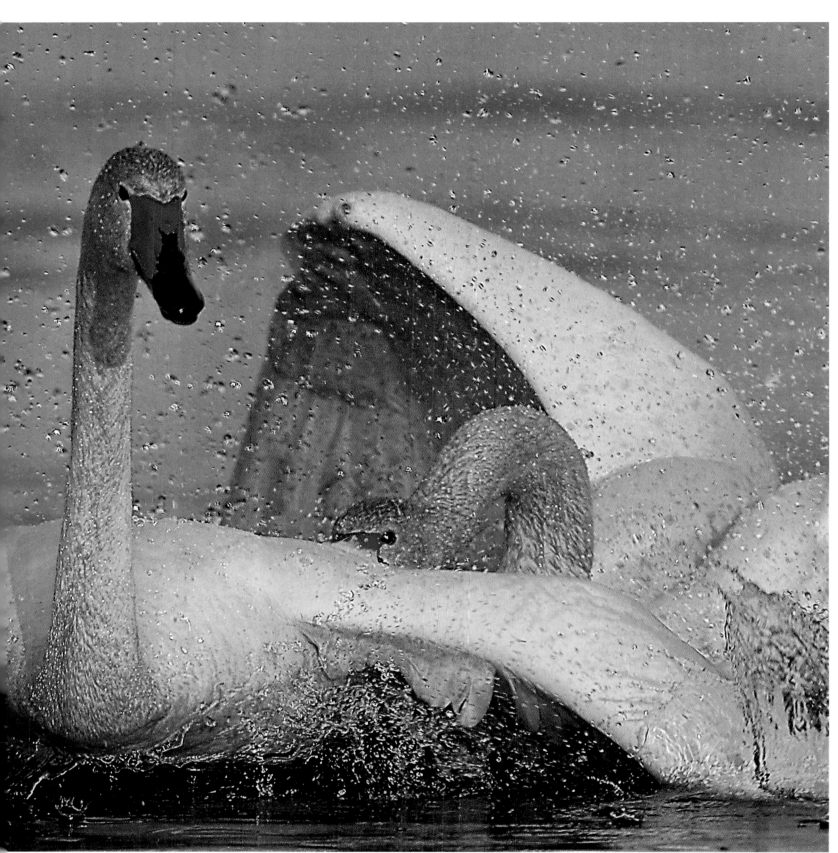

Respect. Birds claim space as their own. Above all, they protect their territories during the breeding season, but during the winter they may also keep more or less permanent territories for foraging, chasing away strangers of their own species. Birds are not as friendly as you may have been led to believe. On the contrary, to them it is all about the survival of the fittest. There are no exceptions to this, and if they want to get rid of another bird they will simply attack it and chase it away. The reason that very little blood is shed during these skirmishes is that the weaker bird is wise enough to withdraw, and the stronger has no reason to kick a loser when it's down. All that the winner needs is to inspire a little respect.

Whooper Swan ⋆ Sweden ⋆ March

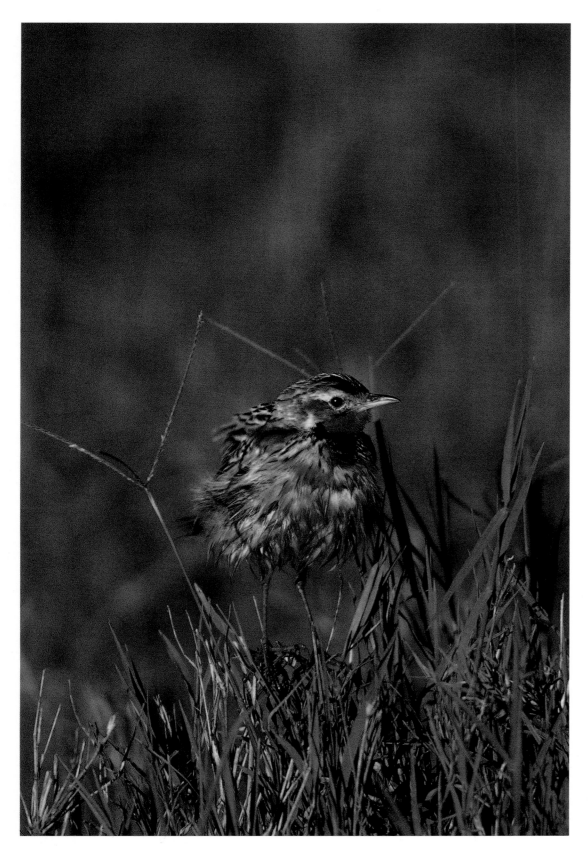

Fluffy. Land birds take a daily bath, too, but they avoid water in other circumstances. Passerines look somewhat miserable after their bath, drenched, tousled, and undignified. Afterward, they carefully preen themselves, soon appearing in their full glory once again. Even the most wretched Rosy-breasted Longclaw is transformed to a handsome pink specimen after thorough grooming.

Rosy-breasted Longclaw ★ Tanzania ★ February

Cruel beauty. In the nineteenth century, ladies in Europe and the North America were so charmed by the plumes of white egrets they wanted to decorate their hats with them. It suddenly became dangerous for a bird to be beautiful. Snowy Egrets, Great White Egrets, and Little Egrets were drastically reduced in numbers. In North America, as well as in Europe, their territories declined along with the dwindling population. The species was protected beginning at the turn of the twentieth century, but it took a long time before they started to recover. In both Europe and North America white egrets have now regained their status, and once again the Snowy Egret and its cousins are allowed to keep their magnificent plumage as well as their life.

Snowy Egret ＊ Florida ＊ April

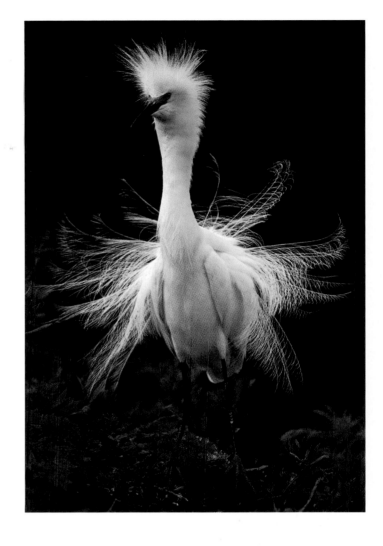

Be vigilant Birds may be hot-tempered when it comes to fighting among their own, but this is not the case when they are defending themselves against predators. The European Golden Plover risks being eaten by, primarily, Peregrines, foxes, and minks, but it needs to worry about any hungry-looking animal. The only way to stay alive is to fly away, and vigilance is the best form of defense.

European Golden Plover ＊ Sweden ＊ June

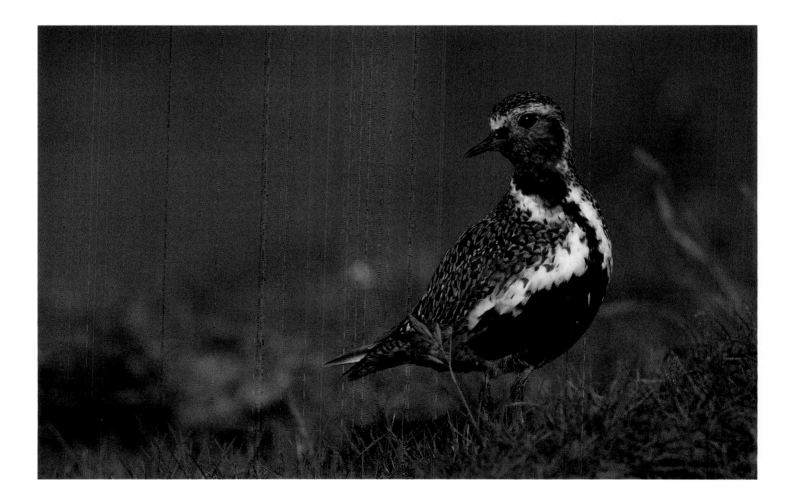

Body and Plumage

NOT ALL BIRDS can fly, and there are other animals that can. Yet birds are particularly defined by this ability. Their bodies are a compromise between various requirements that have to be fulfilled in a very precise way. It is therefore all the more surprising that birds exist in a thousand different shapes and forms. What can a European Goldcrest, weighing just 1/5oz (6g) and smaller than the fist of a five-year-old child, have in common with a White-tailed Eagle with a wingspan of 8ft (2.5m)? The goldcrest would not even qualify as a first course for the eagle's breakfast. Yet they have just about everything in common, from the design of the finest down on their bodies to their respiratory system, bone structure, and aerodynamic design.

If birds are so different yet also have so much in common, it seems sensible not to let their appearance deceive you as to their family connections. For example, auks living in the northern hemisphere are in no way related to the penguins of the southern hemisphere, even though both dress up in coat-tails and have similar spool-shaped bodies. Swallows and swifts have similar blackish or black and white plumage and elongated wings, but again they are not related. There are even stranger similarities, like the North American meadowlarks and the longclaws of Africa, both of which are around 8in (20cm) long, speckled brown in color, and with a yellow breast and elegant black breast band. Although these birds are in no way related, they are confusingly similar.

This phenomenon is called convergence, which is when similarities arise that have nothing to do with kinship, but are instead a response to related living conditions. Penguins and auks are spool-shaped because they catch fish. But why the Yellow-breasted Longclaw of Tanzania should need the same black breast band as meadowlarks in Florida is a mystery.

A bird's plumage fulfills many functions, one of them being storing heat in an efficient way. Humans have challenged nature with their inventions in many areas, but the warmest sleeping bags are still made of down. This is all well and good, but how can birds stand with their naked feet directly on the ice? The answer is that it is mainly because their tissue is adapted to low temperatures in a way that human tissue is not. Furthermore, birds have heat exchangers in their legs, so that blood on its way down to the foot warms the blood on its way back into the body to keep heat loss to a minimum.

Contrary to other diving birds, shags soak their plumage. Is this a bad thing? Not for the shags, because the wet plumage adds weight, making it easier for them to swim underwater. To keep warm, the birds maintain a dry, insulating layer of feathers close to their body.

All in all, birds are adapted in an infinite number of ways to life in the air, on the ground, and underwater.

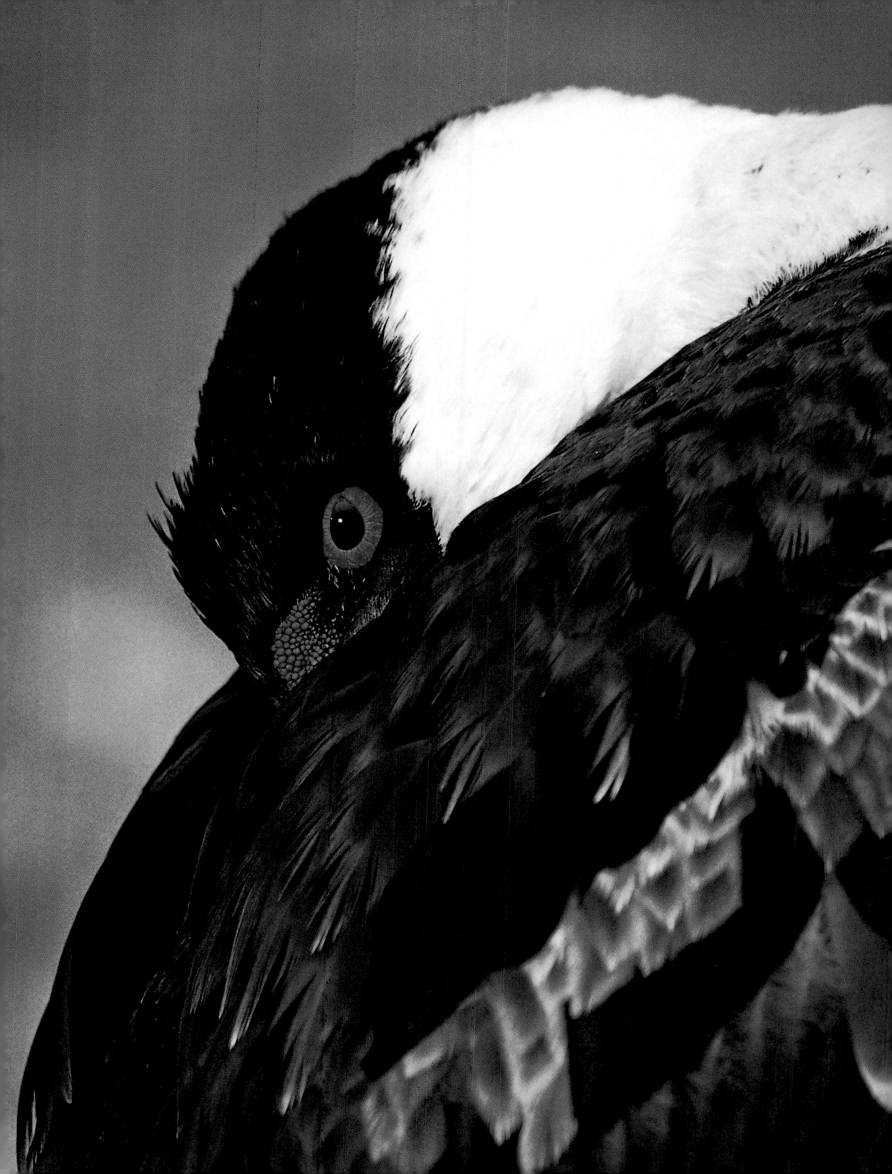

Smooth-billed. Birds normally breathe through their nostrils, which are clearly visible on the upper surface of the bill. A small number of species, however, lack nostrils. If you have ever snorkeled over a coral reef and felt the salty seawater burning the inside of your nose, you will probably have figured out that birds without nostrils are diving species. Among these are steep divers such as gannets and deep divers such as shags and cormorants. A closer look will reveal that Anhingas also belong to this exclusive group of birds that breathe through their bill.

Anhinga ∗ Florida ∗ February

Sunbirds and hummingbirds. The world is full of bird species that are in no way related to one another, but look as though they should be if we were to judge them on appearances alone. The sunbirds of the Old World and the hummingbirds of the New World provide an example. Both are small birds, characterized by spectacular iridescent plumage, and they both have long bills and a diet that consists mainly of nectar. Sunbirds are passerines, and their closest relatives have descriptive names like spiderhunters and flowerpeckers. Hummingbirds, however, belong to the order Apodiformes, and their closest relations are the swifts.

Hunter's Sunbird ∗ Tanzania ∗ February

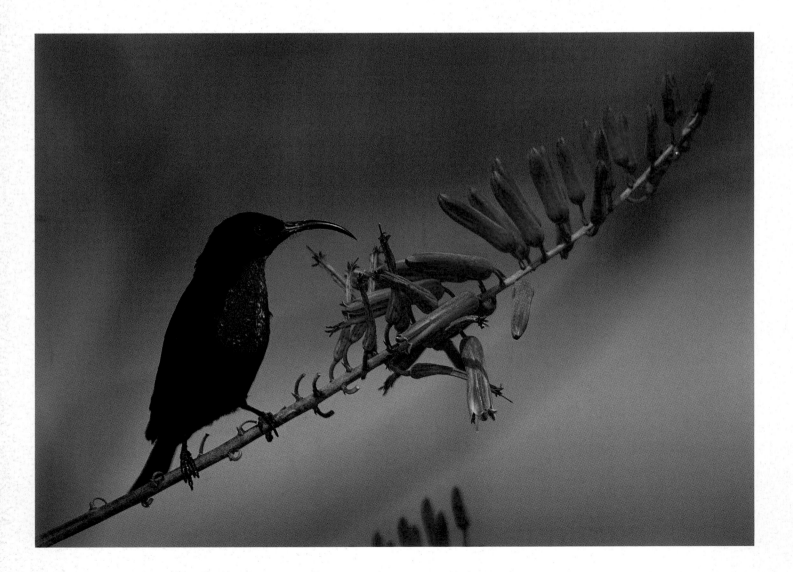

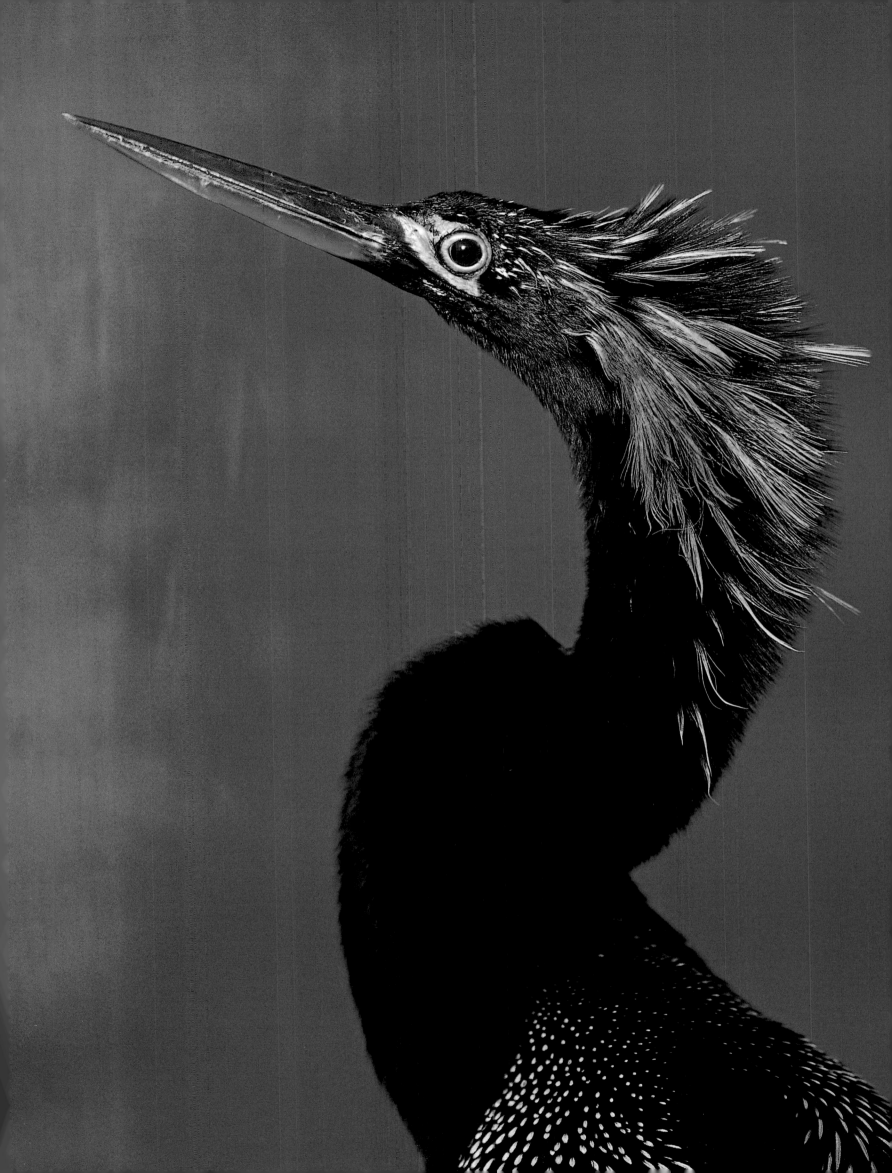

Turning the other cheek. The eyes of many birds, including waders and passerines, are placed on the side of their head, which would be like us having eyes on our temples. They thus register two entirely different images, and the small area just above the tip of their bill that can be seen with both eyes is extremely narrow.

The kingbird is one such bird. Because of its eye placement it lacks stereoscopic vision, but on the other hand it has a 300-degree field of view—it can take in the whole horizon except the area directly behind its head. This is useful for species that do not want to end up in a hawk's claws. Similarly, when you see thrushes hopping around on the lawn with their cheek to the ground, they are not listening for worms but looking for them.

Couch's Kingbird ∗ Texas ∗ April

Ornament. Some birds are fantastically beautiful while others almost seem to overdo their drabness, but each species has its own reasons for its appearance. There is no point in the Grey-crowned Crane trying to find a partner without its tasteful crown, for example, but a House Sparrow carrying such a feature would probably generate a lot of confusion and be just as unpopular on the mating market. Why different species have such different ways of adorning themselves is often hard, or even impossible, to explain. Suffice it to say that each species must follow its home rules, whether we humans are impressed or not.

Grey-crowned Crane ∗ Tanzania ∗ February

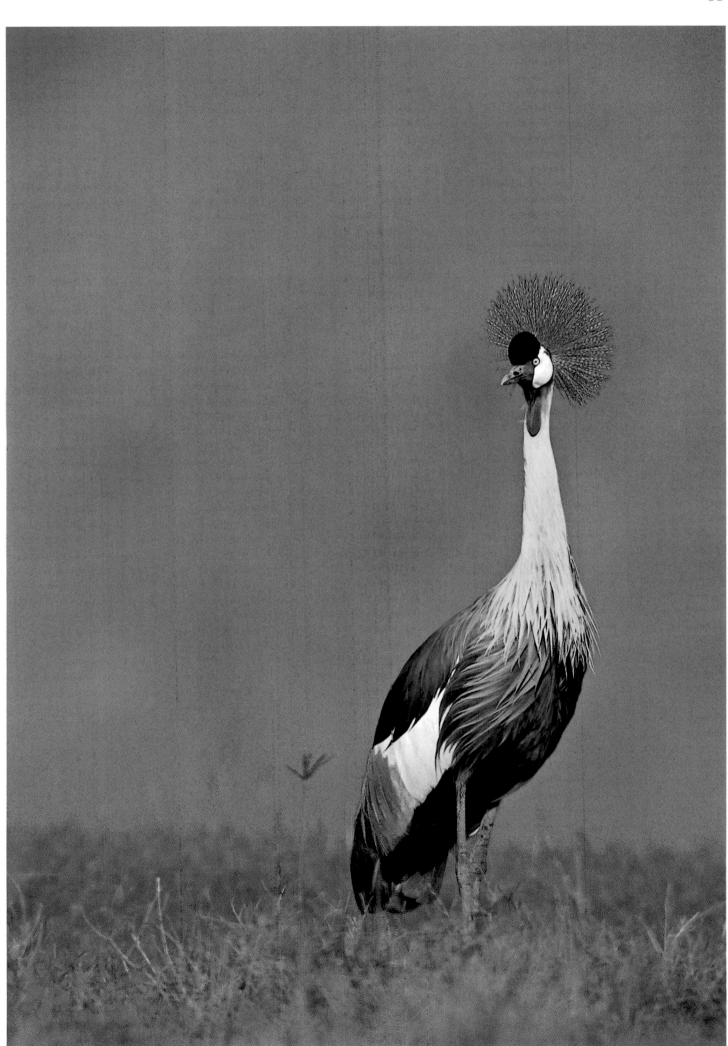

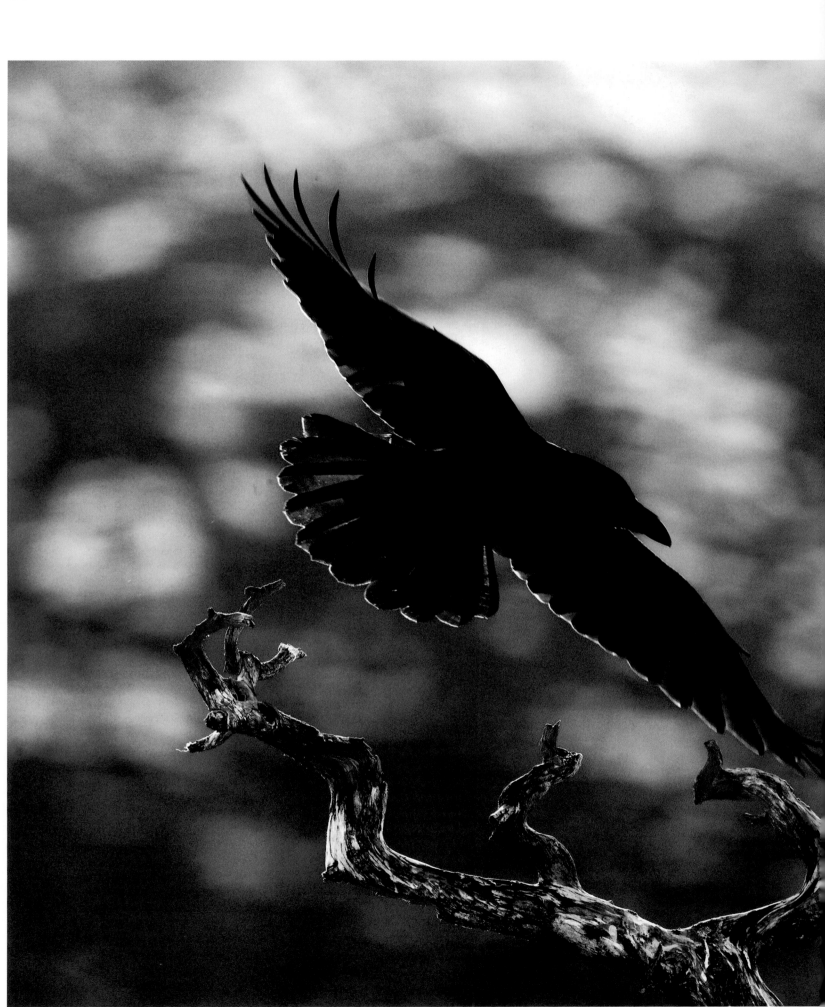

The giant passerine. The Common Raven is a passerine and therefore related to the Horned Lark as well as to the Wheatear and Willow Warbler, even though it is as large as a Buzzard and has bill like that of a Golden Eagle. It is the raven's feet that reveal its kinship with small birds: They are not suitable for carrying prey, for which the thick toes and powerful, curved, sharp claws of a raptor are needed. Instead, the raven carries its prey in its beak.

Common Raven ★ Norway ★ February

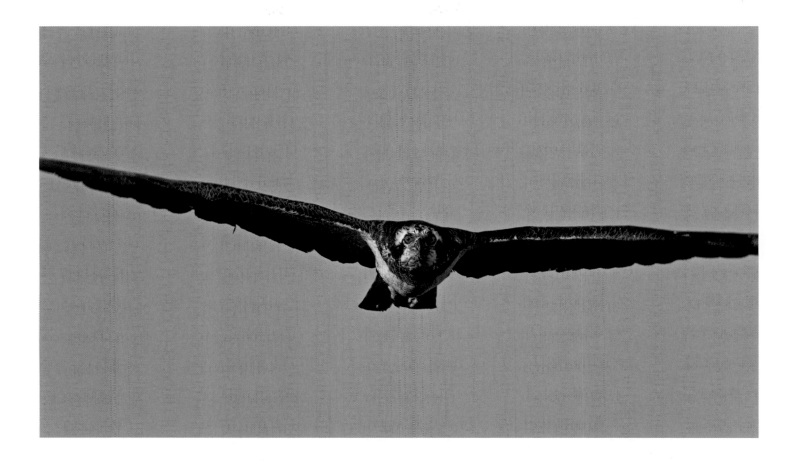

Stereoscopic vision. In many raptors and in all owls the eyes are placed beside each other at the front of the face, just like in humans. When eyes are positioned so close to each other and pointing in the same direction, they register virtually identical images and so create good stereoscopic vision. This is essential for judging distance, which is especially important to birds that hunt on the wing and perform stealth attacks.

Here, an Osprey dives to kill a pike, which is sitting just under the water surface. It grabs the pike with lightning speed and pinpoint precision, but to do so it must be able to judge the distance to the fish exactly during the entire attack.

Osprey ∗ Sweden ∗ July

Melanin, carotenoids, and hemoglobin. A bird's color is often caused by pigmentation, particularly noticeable in the feathers, bill, legs, and the orbital ring around the eye. The most common pigment is melanin, which is often black and is abundant in blackbirds, for example. Melanin can also be brown, reddish brown, and even yellow, and it causes the camouflaging brownish color of many birds, including all members of the skua family.

Different red or orange hues are caused by carotenoids, a group of pigments that also give color to egg yolk and to carrots. Other pigments, including hemoglobin, color the plumage and soft tissues, giving turkeys, for example, their red neck.

Brown Skua ∗ Falkland Islands ∗ December

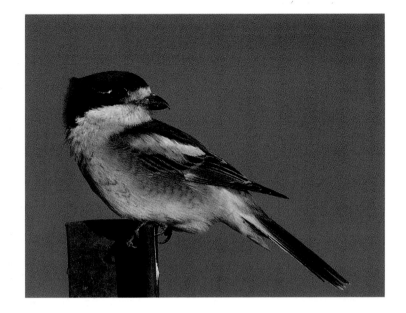

Bull-necked. Shrikes have thick, raptorlike bills, indicating that they handle their food with great energy. They eat large, mainly hard-shelled insects that need "cracking" open. Many small birds have strong bills, including crossbills and hawfinches. What these species also have in common—regardless of whether they feed on vegetable or animal matter—is a large head and strong neck. The neck is reinforced with large muscles that give the bill its fearsome strength.

Woodchat Shrike ＊ Spain ＊ April

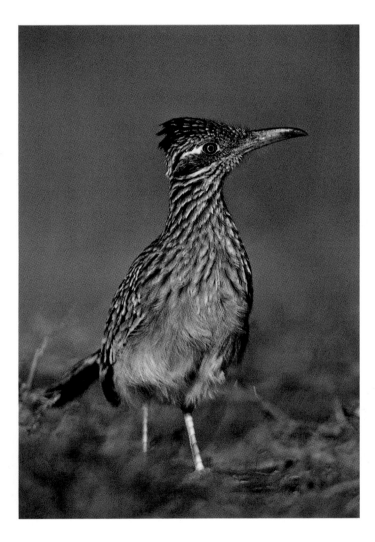

The upper mandible. The bird's bill consists of two parts: the upper mandible, which is joined to the upper jaw; and the lower mandible, which is joined to the lower jaw. Both operate with the help of an ingenious construction.

The Greater Roadrunner is a funny bird that rushes around in the desert flicking up sand with its long, slightly curved bill, looking for insects, lizards, and other small animals. A closer look reveals that its upper mandible is thicker than the lower one, a feature that it shares with all other birds. Why? Nobody knows!

Greater Roadrunner ＊ Arizona ＊ November

Support. In order to perch securely, woodpeckers have thick legs and unusually stiff tail feathers, which they place against the tree trunk for support. Another group of birds with thick legs and feet is the chickadee, which hops nimbly around on the ends of branches looking for spiders and seeds. You often see them hanging upside-down on birdfeeders, pecking away at the same suet ball the House Sparrows are desperately trying to reach. Only Willow Chickadees and other members of this group are able to perch horizontally, seemingly defying the laws of gravity.

Black Woodpecker and
Willow Chickadee ＊ Finland ＊ March

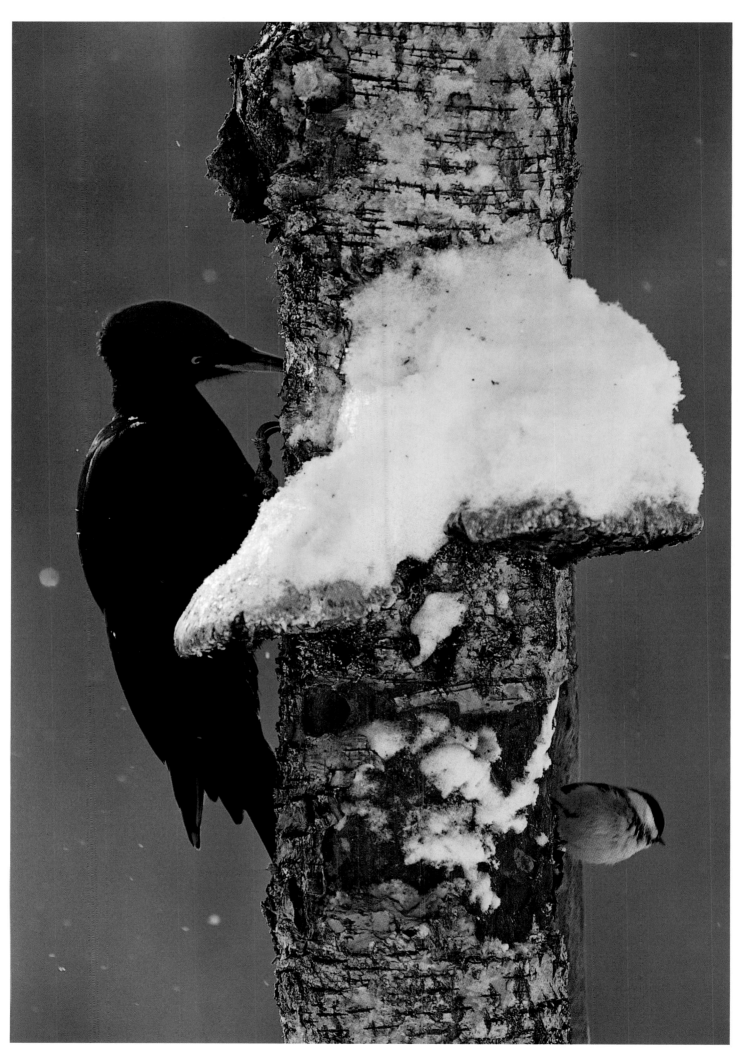

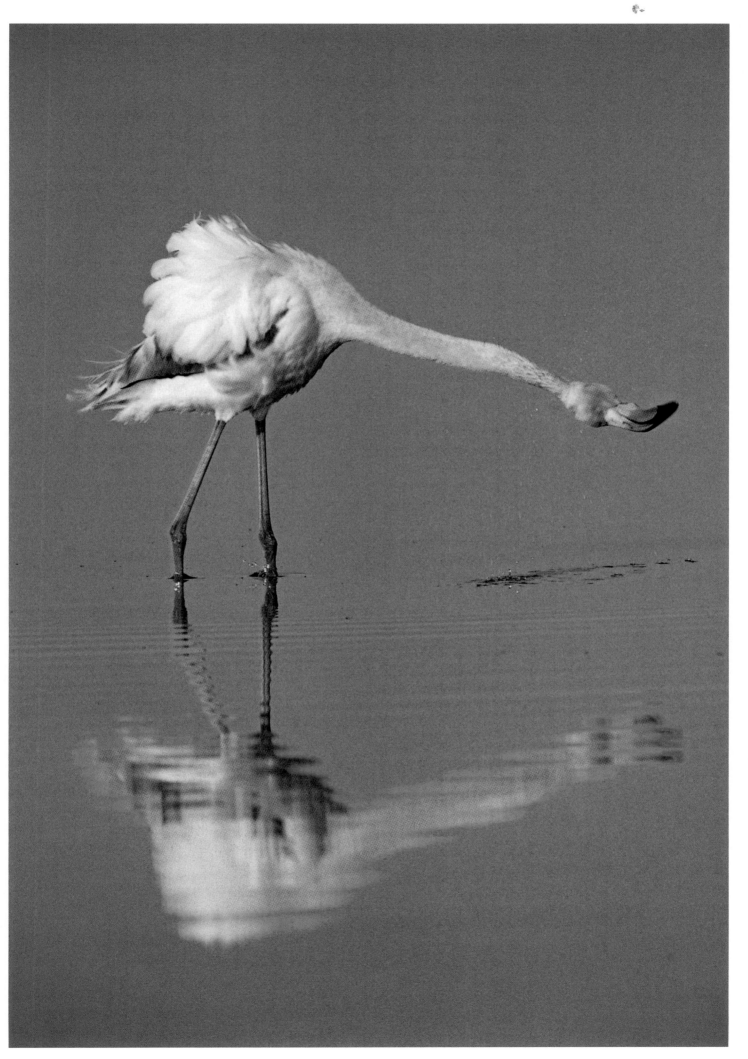

Upside down. Unlike all other birds, the lower mandible of a flamingo is thicker than the upper one. When it is feeding, the flamingo sticks its head into the water and peers backward between its legs. It filters the water in a similar way to a baleen whale, sieving out small organisms. When flamingos are actively feeding, with their heads upside down, the thicker lower mandible is actually uppermost, which this bird kindly demonstrates.

Greater Flamingo ⋆ Spain ⋆ April

Floating like a cork. Because birds fly, they are designed to be as lightweight as possible. However, they are not solely flying machines; many are aquatic, too, and need to be able to find food at great depths underwater. Some aquatic birds find it frustrating to float like a cork and, in the case of cormorants, have solved the problem by soaking their plumage to gain weight so that they can dive far down into the water. Pelicans are more reserved. They tread water like a paddleboat, so they can reach their bill only a short distance down into the water.

American White Pelican ⋆ California ⋆ December

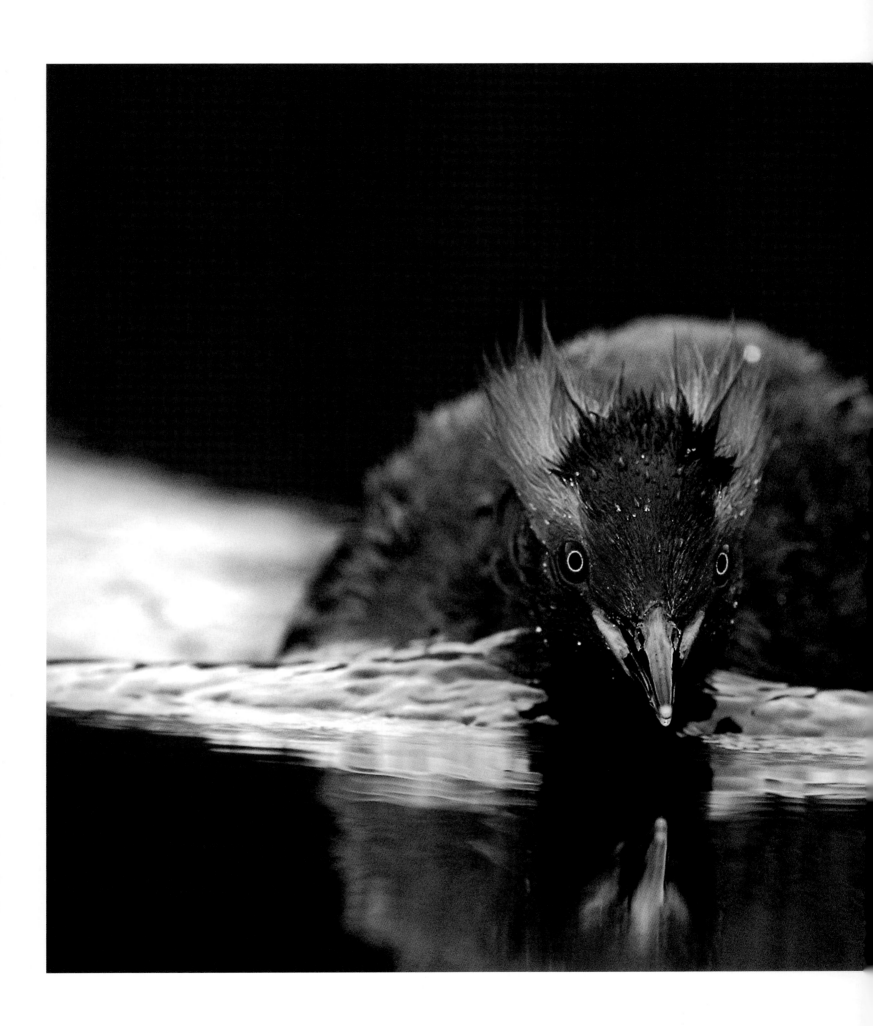

Water off a duck's back. To try to soak a Slavonian Grebe is as ineffective as pouring water onto a duck's back—these birds simply don't get wet. A bird's plumage is not water repellent because it is coated in a waterproofing grease or oil, but because of the way the bird arranges the feathers when it preens itself. The feathers are not only sorted in relation to one another, but every single part of each feather is also combed, making the whole plumage tightly "knotted" like the finest Persian carpet. Owing to surface tension, water does not enter the structural part of the feather, but forms droplets on the outside—so the bird remains dry and warm.

Oil slicks are bad news for grebes and other water birds in two different ways. First, the oil clings to the bird, so it cannot preen, and second, it decreases surface tension, allowing water to penetrate the plumage.

Slavonian Grebe ∗ Finland ∗ June

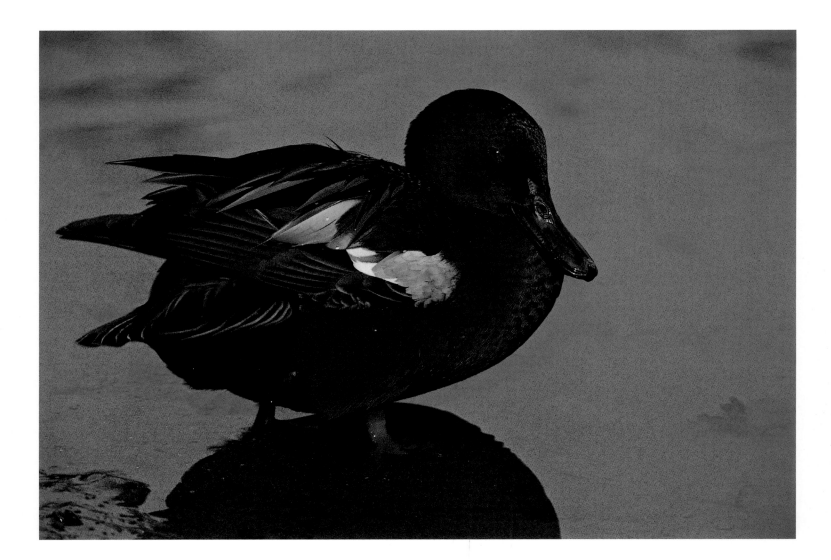

Summer plumage in winter. Birds normally wear their nuptial plumage in the spring and summer, just before and during the breeding season. It is the male's colorful plumage that attracts females. Ducks are a notable exception to this rule. They acquire their nuptial plumage between August and October in order to appear at their most impressive during the early months of winter, which is when pair-formation takes place. In the spring, they migrate to their breeding grounds together with their partners. As competition for females is most fierce during the winter, it is important for the males to look their best at this time.

Like most other ducks, the male Cinnamon Teal becomes grayish brown after the breeding season, when it resembles the female. In other birds, this would be called winter plumage, but in ducks it is called eclipse plumage. By September, the male will start to shed his speckled plumage and change it for a magnificent, mahogany ensemble with long, elegant, yellow ocher scapulars, which will be carried throughout the winter until it is shed in June or July the following year.

Cinnamon Teal (male) ∗ California ∗ January

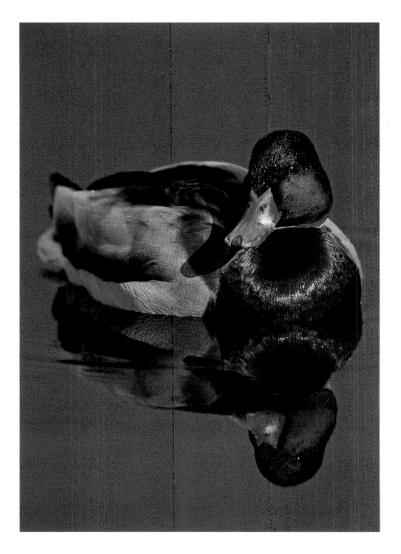

Structural colors. Some of the more splendid plumages do not owe their sumptuous colors to pigmentation, but to the microstructure of the feathers themselves. One type of structural color is that which changes according to the position of the observer. A famous example is the Mallard, whose head changes in appearance from green to dark mauve. This effect is created by interference, whereby the barbules (the finest structural part of the feather) are flattened and twisted, giving the illusion of changing colors depending on the position of the observer. So when children fight over whether the mallard's head is green or mauve, you can wisely and truthfully claim that it is both.

Mallard (male) * Sweden * May

Iridescence. Structural colors can also be created by the differential reflection of wavelengths of light by feathers. Minute air pockets in the barbules refract incoming light, so that only light of a certain wavelength (color) is actually reflected and the feather appears to be blue. Unlike interference, this structural color is lusterless, not iridescent. Blue, mauve, and green hues are usually created by interference or refraction, whereas interference alone can cause iridescence. The Superb Starling's palette is a combination of blue and iridescent green mixed with reddish-brown pigmentation.

Superb Starling * Tanzania * February

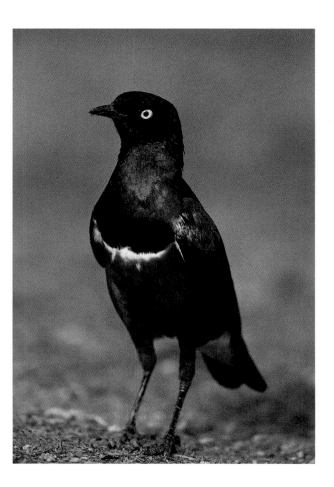

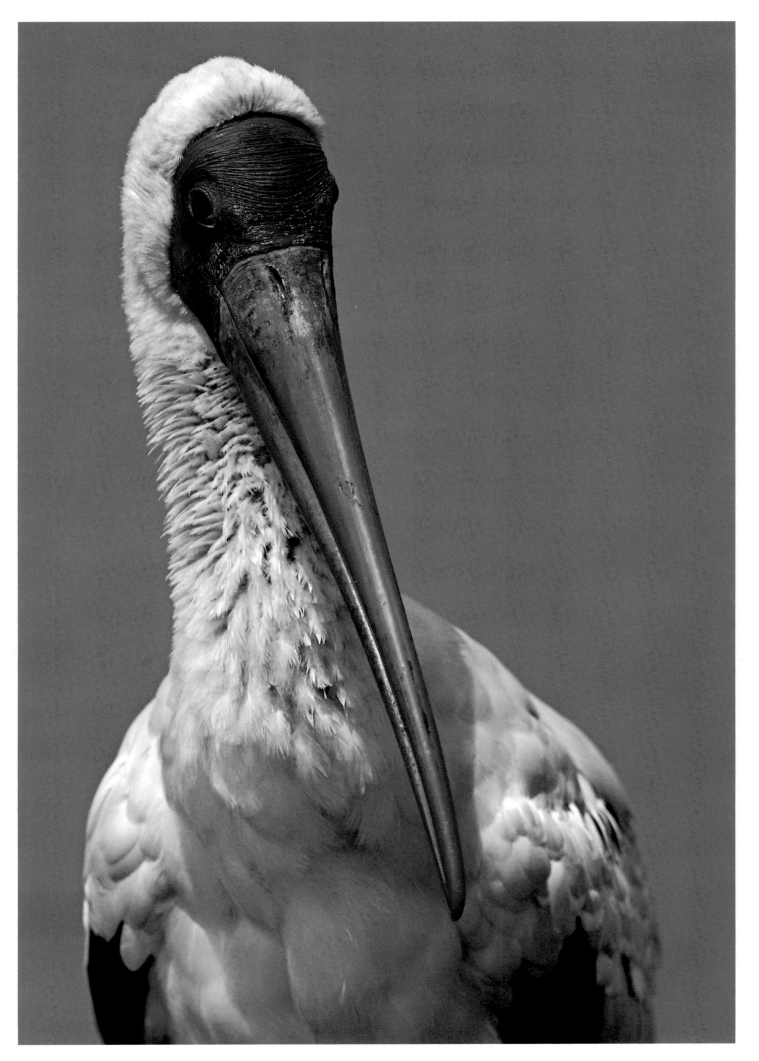

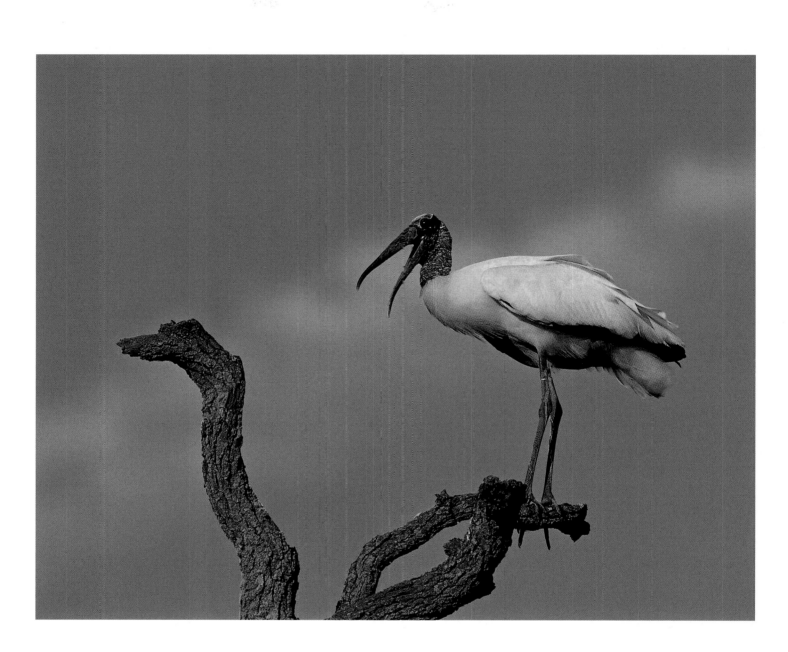

Snap! Herons use their long bills like a spear when catching fish, but Mycteria storks, which have a slightly curved bill, use theirs in a different way. They often forage for fish, frogs, crayfish, and other organisms in places with poor visibility, such as muddy water and wetlands covered in vegetation. Rather than relying on their eyes, they use the sensitive tip of their bill to locate their prey. Once they have found food, they waste no time wondering whether it is a special treat—if they do, it will soon escape. It takes just a fraction of a second between the stork locating its prey and its beak snapping shut.

Yellow-billed Stork ★ Tanzania ★ February **Wood Stork** ★ Florida ★ March

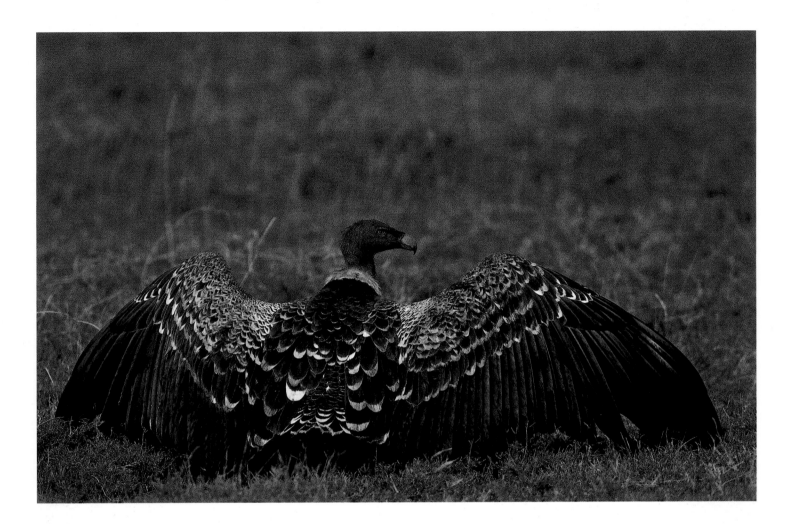

Reinforcement. Some feather patterns occur frequently among different types of birds. For example, a narrow, contrasting fringe along the edge of the feathers, creating a scaly pattern, is very common and is normally used for camouflage. One of the finest examples of this feather pattern can be seen in the Rüppell's Vulture, which uses it not only for camouflage but also to attract the opposite sex.

Narrow fringes normally appear as a lighter contrast to a darker feather, although the reason for this is unknown. The dark pigment melanin reinforces feathers, so the lighter parts will tend to fray more quickly. It would therefore seem to make more sense for the fringes to be darker to prevent wear and tear. However, since birds with lighter-tipped feathers exist everywhere, this must not be a disadvantage. Most important is that the basal, larger part of the feather remains intact.

Puzzling or not, the Rüppell's Vulture is imposing in its delicate plumage. The cocksure spread of the wings show that it might even be aware of it.

Rüppell's Vulture ⋆ Tanzania ⋆ February

Under the chin. The chinpart of a heron is so narrow its face resembles a wedge of cheese. The eyes are placed on either side of the wedge, enabling the bird to see the ground below its chin. Consequently, it does not have to bend down to look into the water—it can merely choose to direct its gaze, either straight ahead, looking out for enemies, or down, looking for prey. Similarly, airborne gannets and boobies are able to look straight into the sea without having to bend their head. This Tricolored Heron manages to resemble the surrounding vegetation as it keeps an eye on the photographer.

Tricolored Heron ⋆ Florida ⋆ January

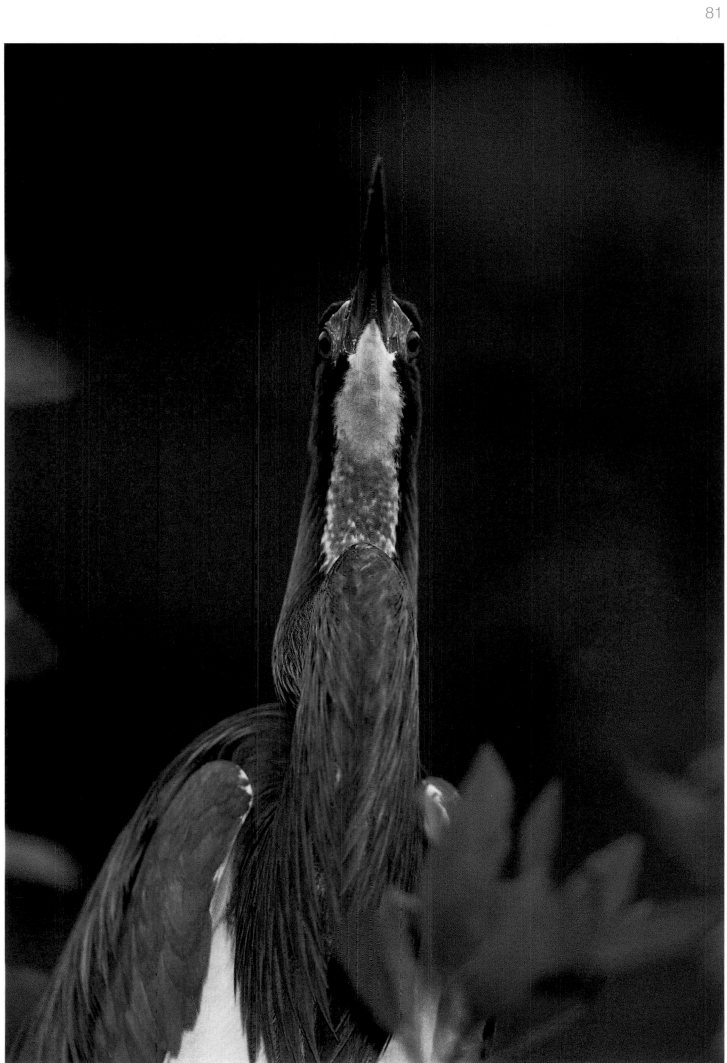

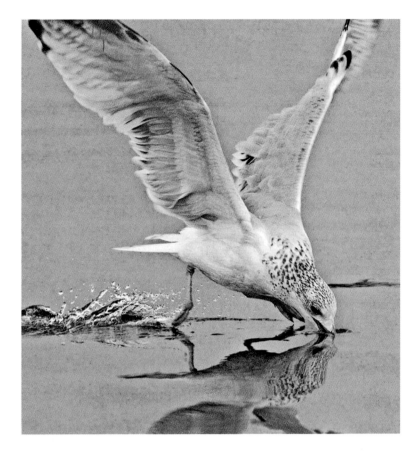

The cerebellum. The best-developed part of the bird's brain is the cerebellum, which governs muscle coordination and movement. To watch graceful gulls as they search for food along the water surface is to witness elegance in combination with complete control.

The forebrain in birds is smaller than it is in mammals. The most important part of this area to birds is the diencephalon, where instinctive, inherited behavior is located. This is why young birds are able to migrate hundreds of miles on their own, visiting continents they know nothing about.

In mammals, it is another part of the brain, the cerebral cortex, that is most developed. This is the center for learning and information storage, areas in which we mammals are far more accomplished than birds. Unlike birds, we stay under the protection of our parents for a much longer period, during which time we learn from them before setting off on our own.

Ring-billed Gull ⋆ New York ⋆ September

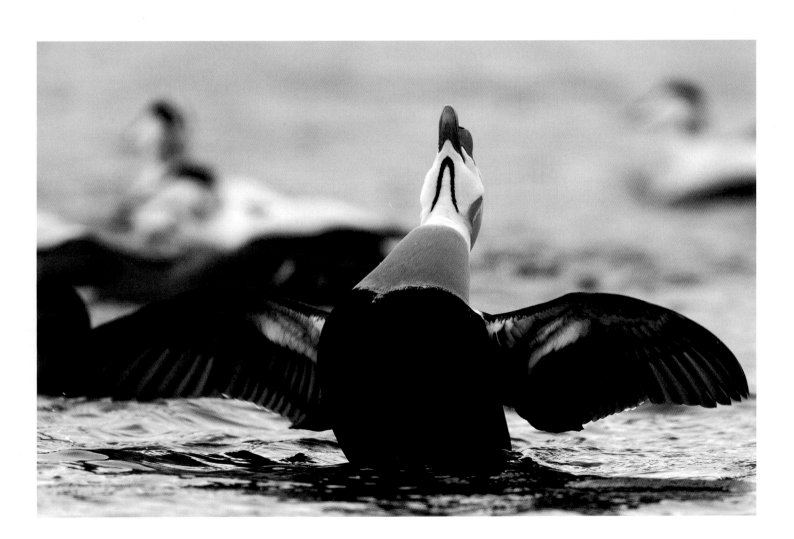

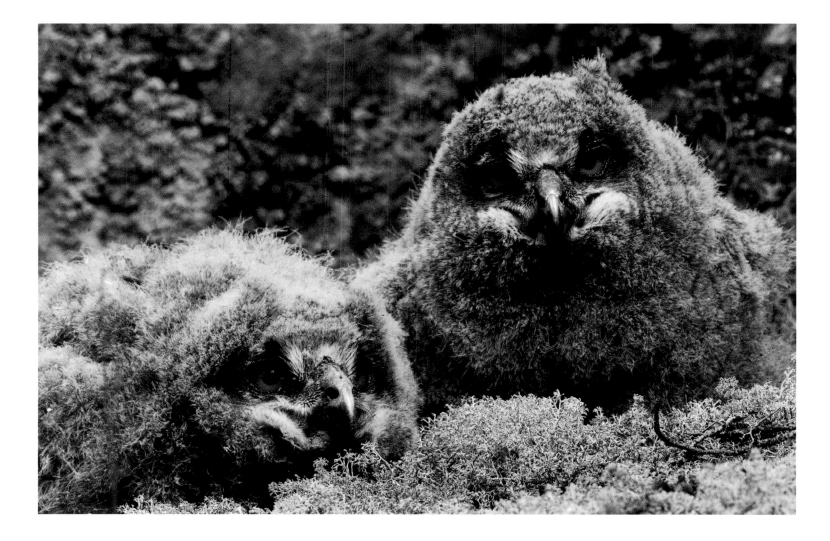

Owl ledge. Two species that were definitely on the way out over much of Europe a couple of decades ago, but have now recovered, are the Peregrine and the Eagle Owl, both of which have been the subject of ambitious conservation projects. Peregrines often choose to place their nest on the same ledges used by the species 30 years ago. Old owl ledges are, however, more likely to be deserted, with the birds choosing to nest on nearby silos or industrial buildings instead. It is possible that the human environment has influenced reintroduced eagle owls, or perhaps it is only we humans who like to see these giant birds nesting on lichen-covered rock ledges. After all, the young owlets are unlikely to complain.

Eagle Owl ∗ Finland ∗ June

Unnecessarily good looking. We often associate spectacular, colorful birds with lush, hot, humid environ-ments, especially the rain forest. Looking through a tropical bird book, you encounter all the colors of the rainbow: sunbirds, hummingbirds, rollers, parrots, and other beauties. There is even a rule, called Gloger's Rule, which states that the colder and drier the climate, the lighter the color of a bird's plumage. The rule explains how birds adapt to the lower temperatures and snowy environments they encounter in, for example, the Arctic.

We northerners tend to covet birds from southern climes, thinking they are more spectacular than our own dull grayish-brown species. To be fair, however, there are colorful fowl in the Arctic too. The King Eider is just one example, a species that is almost unnecessarily good looking.

King Eider ∗ Norway ∗ February

84

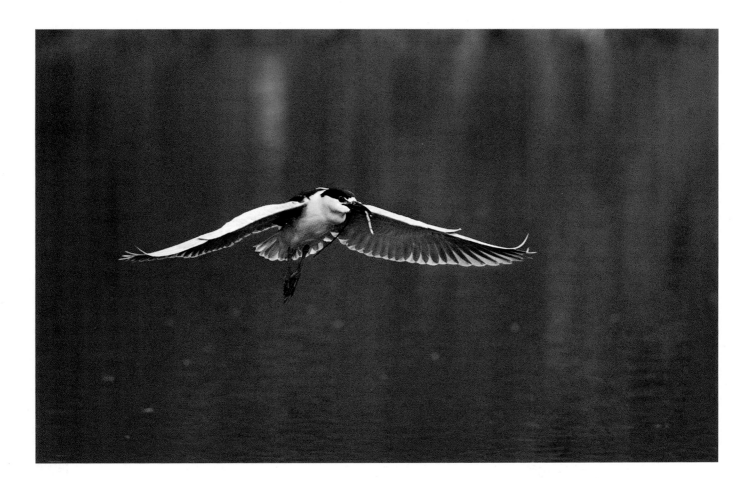

Transportation. Much of what we humans do with our hands, birds do with their bills or feet. Their hands are their wings, and in most cases, they are used for flying. The majority of birds transport prey or nesting material in their beaks because their feet and toes are usually too weak for holding objects and are instead mainly used for walking, standing, or scratching. Birds that do use their claws to carry prey are almost entirely restricted to those species whose legs and feet are used for hunting—primarily raptors and owls. Their feet and toes are so strong they can capture and hold onto an animal that is trying to escape.

Black-crowned Night Heron ∗ Spain ∗ April

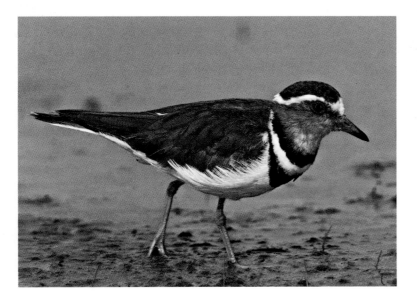

Orbital ring. Nearly the whole body of a bird is covered in feathers, and, apart from their beak, legs, feet, and eyes, most birds have only one bare surface—the orbital ring. This circle of naked skin resembles a human eyelid, and in many species it is brightly colored and easy to see. The Little Ringed Plover, for example, is distinguished from the Ringed Plover by its yellow orbital ring, while the African Three-banded Plover has an even more defined, bright red ring. The orbital ring is also an important signal to the opposite sex and so is at its brightest during the breeding season.

Three-banded Plover ∗ Tanzania ∗ February

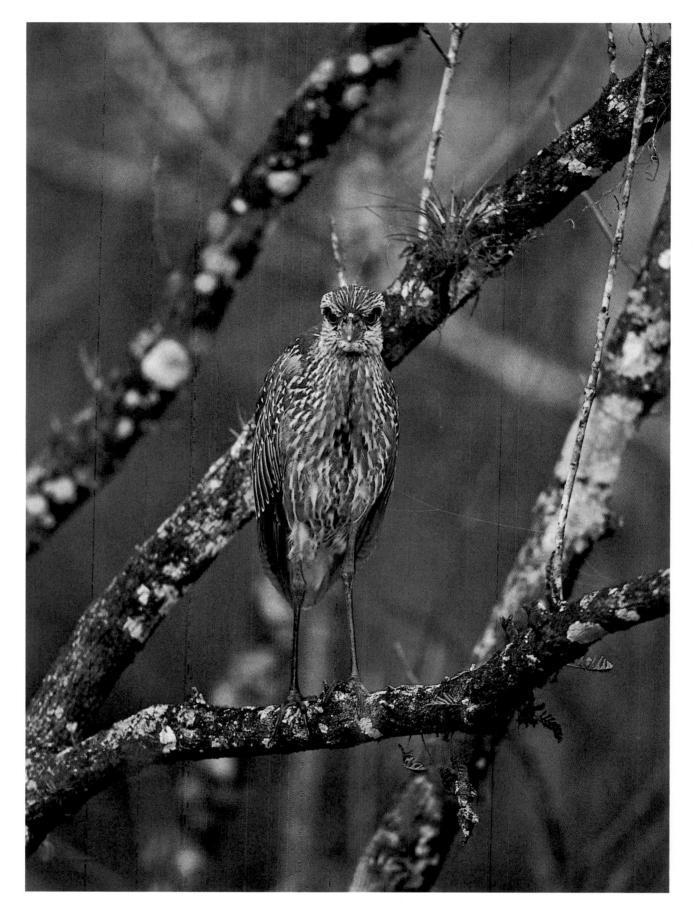

Speckled. Many young birds from a wide variety of groups are brown or gray and speckled, even when the adults are an even, bright color. The reason is that juvenile plumage provides good camouflage, making the birds more difficult to spot. When the young Yellow-crowned Night Heron stands motionless among the trees, for example, it is easily mistaken for a branch.

Yellow-crowned Night Heron * Florida * December

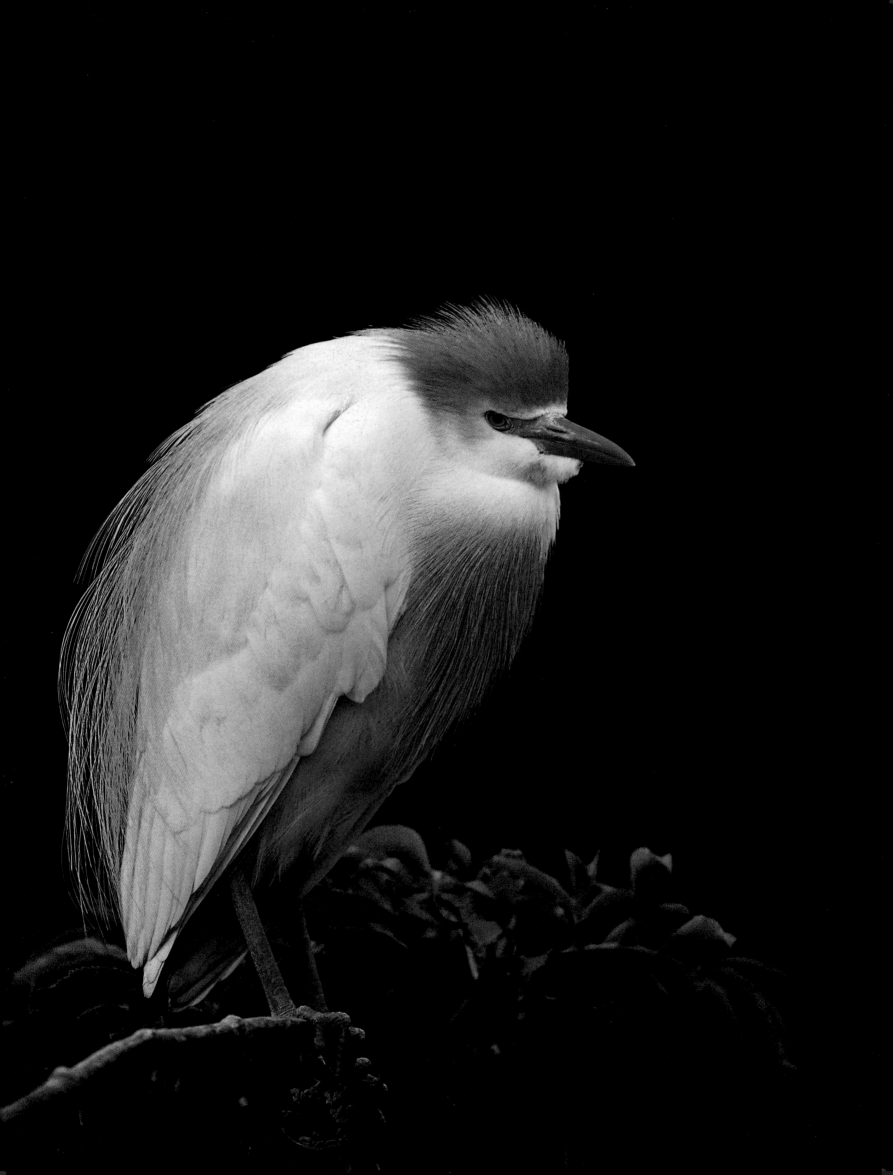

Nuptial plumage. One of the many differences between mammals and birds is that the latter produce two sets of plumage, one for breeding and one for the rest of the year. The magnificent nuptial plumage is often a sign of excellent health and signals to others that it is time to breed. This plumage is characterized by richer, more intense colors than the winter plumage. Producing it is energy consuming, which partly explains why it is not worn in winter and why it is so important as a signal to potential partners. The production of breeding plumage does not necessarily mean the birds have to change all their feathers. The cattle egret, for example, swaps just some of its white winter feathers for beautiful rust-colored ones. In addition, its bill and the naked part in front of the eye change color at the beginning of the breeding season.

Cattle Egret ∗ Florida ∗ April

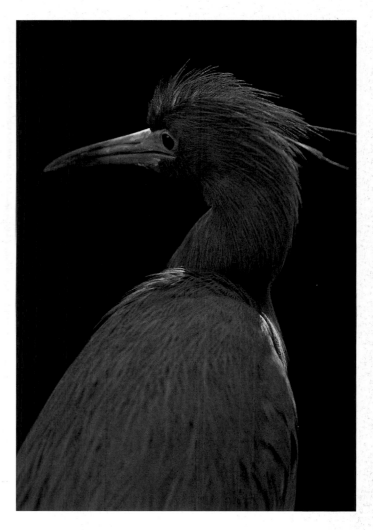

White blue herons. With the common name of Little Blue Heron and a Latin name, *Egretta caerulea*, meaning "dark blue egret," it comes as little surprise that this bird has a blue plumage. What may be surprising, however, is that young Little Blue Herons are completely white. The Little Blue Heron can be found from central North America to central South America, and in this area there are more than enough white herons. The Snowy Egret and the Great White Egret are always completely white, while the Cattle Egret is white except when breeding. Then there are the rare white morphs of the Great Blue Heron and the Reddish Egret—and, of course, the white juvenile Little Blue Heron.

Little Blue Heron ∗ Florida ∗ January

Desert red. Many birds need a coloring that provides camouflage. Therefore, it is very common for birds that breed in the desert to have a fawn or desert coloration. The Pyrrhuloxia is an excellent example: It is really a desert version of the bright crimson Northern Cardinal. Desert-colored or not, the Pyrrhuloxia has some red in it too. A few well placed red brushstrokes are all it needs to attract females.

Pyrrhuloxia ∗ Texas ∗ April

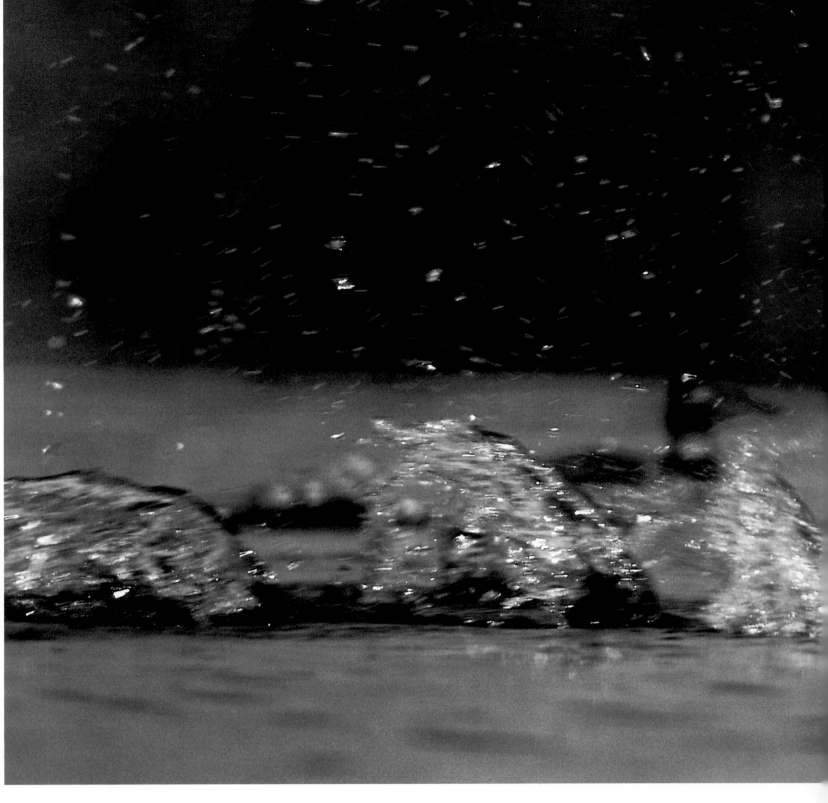

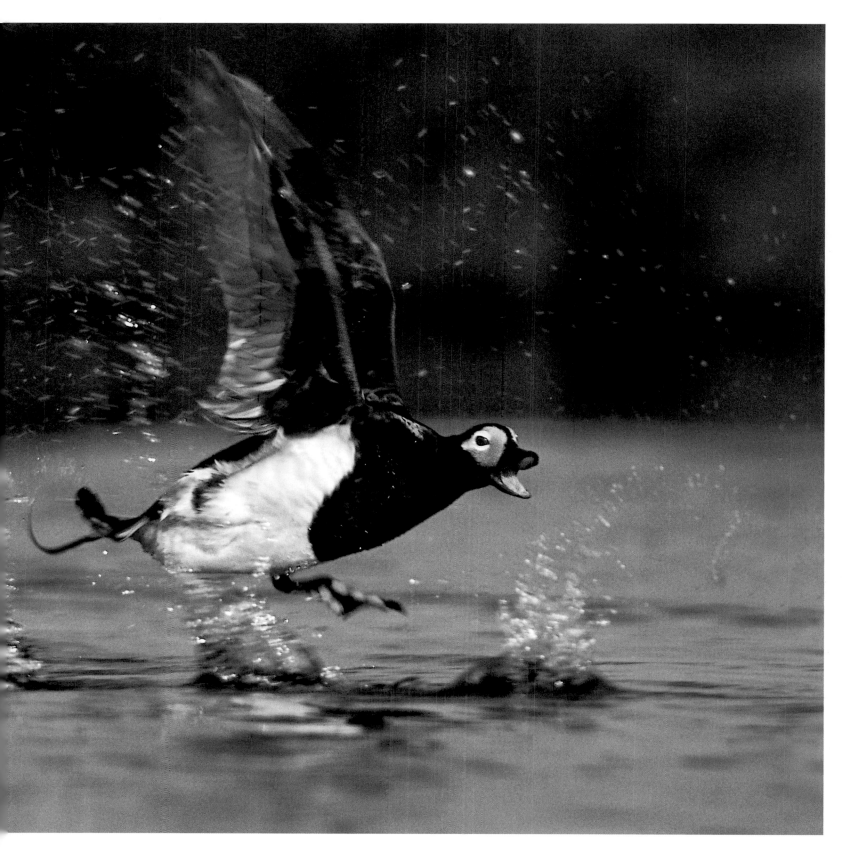

Summer plumage in summer. Just like other ducks, the male Long-tailed Duck acquires his lovely, mostly white nuptial plumage around September or October. In April and May, he goes through an extra molt and displays a black head and whitish "spectacles," which he uses during the breeding season. So, unlike other ducks, the Long-tailed Duck uses a different plumage for breeding than for attracting his female. In July and August, he molts again, putting on a speckled appearance until the mostly white nuptial plumage appears a few months later. Why the species differs from other ducks in this way is a mystery.

Long-tailed Duck * Manitoba, Canada * June

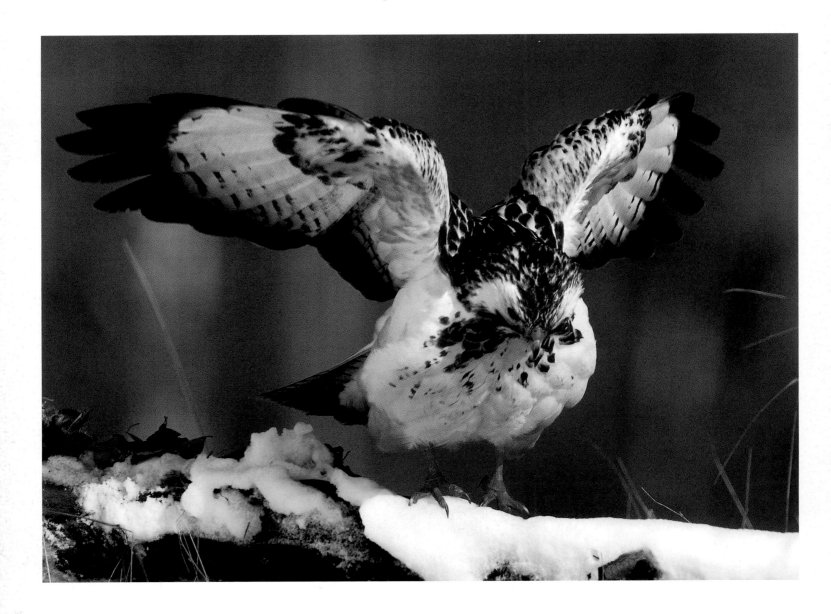

Variations on a theme. Some species come in different colors, or morphs, like the light and dark morphs of the arctic skua. Buzzards have no set morphs, but exist in an infinite number of variations—a common type has dark upperparts with a rather light breast. In central Europe, even lighter Buzzards occur, with a white breast and light-colored head. Others are almost completely dark brown, while in between the two there is almost every conceivable hue.

The color variation of Buzzards is unusually wide, but it is individual. As in dark and light Arctic Skuas, there is no advantage of one color over another for finding a partner—even though we humans are often impressed by the splendid white of the palest specimens.

Buzzard * Sweden * March **Buzzard** * Sweden * February

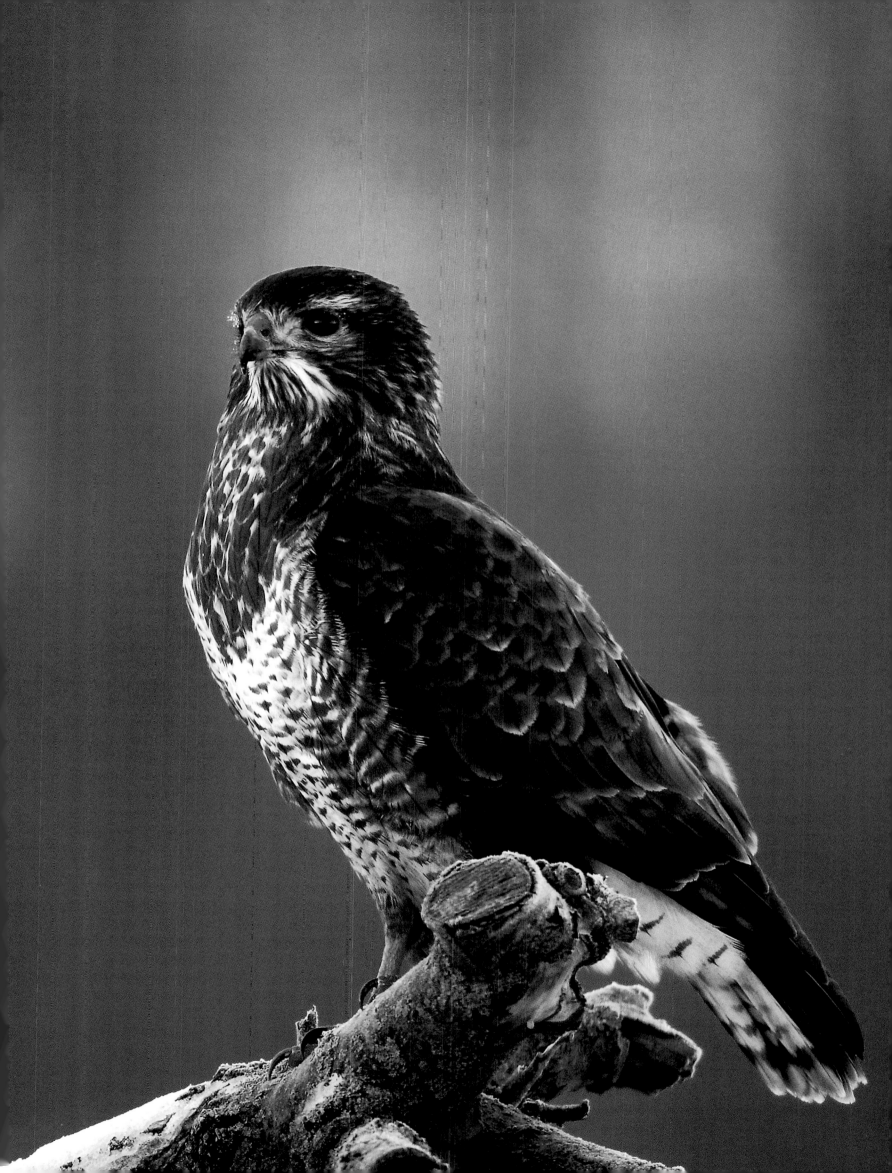

Nostrils. The ability to fly puts great stress on a bird's respiratory system, because its muscles require enormous amounts of oxygen. Many migrants travel at altitudes of 20,000 ft (6,000 m) or more, where oxygen levels are low, so it is vital that the respiratory organs are kept free of any obstruction.

Birds breathe through nostrils placed near the base of the upper mandible. Like other gallinaceous birds, the chachalaca stays mostly on the ground—it certainly never reaches 20,000 ft—but it can still get out of breath when running or flying.

Plain Chachalaca ∗ Mexico ∗ April

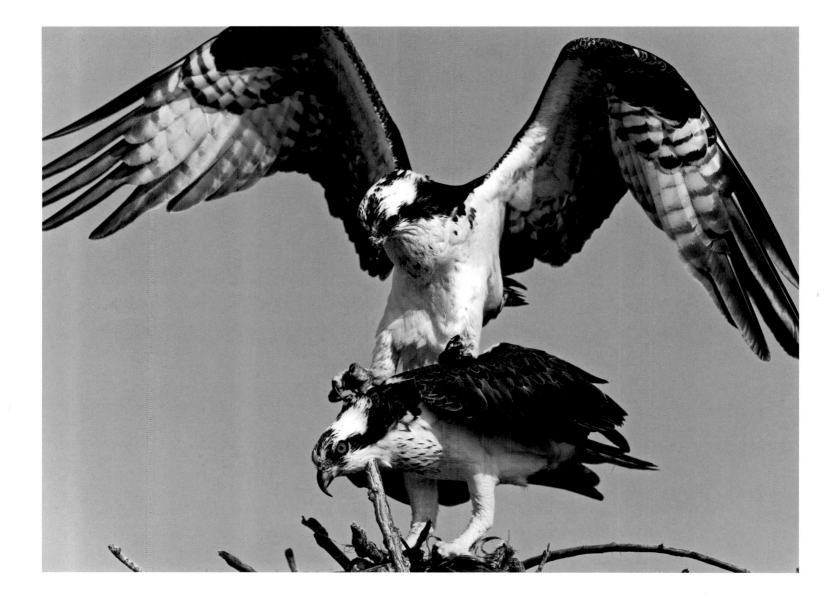

Fast-growing. Feathers are not placed randomly. Each feather grows from a sac under the skin, starting off inside a protective sheath. When the feather is fully developed, the sheath becomes brittle, cracks, and is shed.

An Anhinga's large tail feathers grow from long, clearly visible sheaths. In the birds pictured, all the feathers are the same length and undamaged, signs that these are juveniles. Only young birds grow all the feathers of a set simultaneously. In this way they can rapidly obtain the full complement. The disadvantage of this strategy is that the feathers are of low quality, which means they wear out more quickly than those produced by adult birds. For their part, adult birds employ a different strategy, changing their feathers in stages. This takes longer, but the feathers are stronger and more resilient.

Anhingas * Florida * February

Proof. In many species there are small but universal differences in plumage between males and females. In Ospreys, for example, the male has a somewhat fainter dark band across his breast than the female. This can, however, vary between individuals and so is of little help if you are confronted with a solitary bird. In the pair shown here, the female has a few more dark streaks than the male. But the difference is so inconspicuous that we would be quite lost in differentiating the sexes without the proof provided by this mating scene.

Ospreys * Texas * March

Lifelong. Many raptor pairs coexist in lifelong relationships, even in the north where males and females may not spend winters together. Most large and many small birds of prey thus choose partners only once in a lifetime. Males and females of these species are normally identical, even though it is not unusual for the females to be larger. A good example of identical plumage in both sexes occurs in the caracaras, large New World raptors that are closely related to falcons.

Striated Caracara ⋆ Falkland Islands ⋆ December

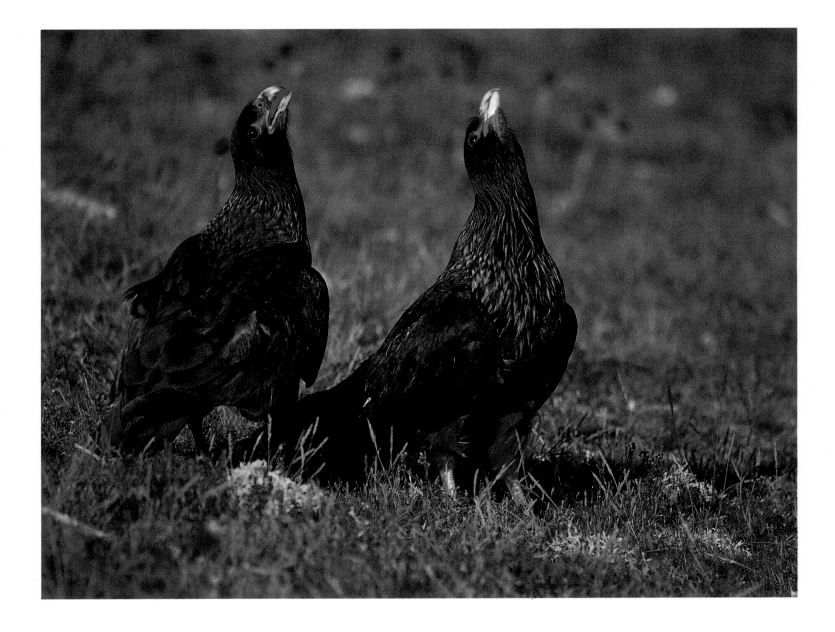

Camouflage. The more often males within a species compete for females, the greater the differences in appearance between the sexes. This is especially true of ducks, which find their mates in the winter and stay together until the eggs are laid, after which they split up. The following winter they form new alliances, in what is a complete contrast to the lifelong marriage of raptors. Therefore, most female ducks have a subdued plumage pattern, while the males are more colorful.

The female eider sits on her eggs and looks after her young, and so is brown and speckled to remain camouflaged. The male, however, has no role in caring for the young, so he can go courting in a black and white plumage with an apricot-colored breast and pistachio-green neck without jeopardizing the safety of his offspring.

Female Common Eider surrounded by males and females ⋆ Norway ⋆ February

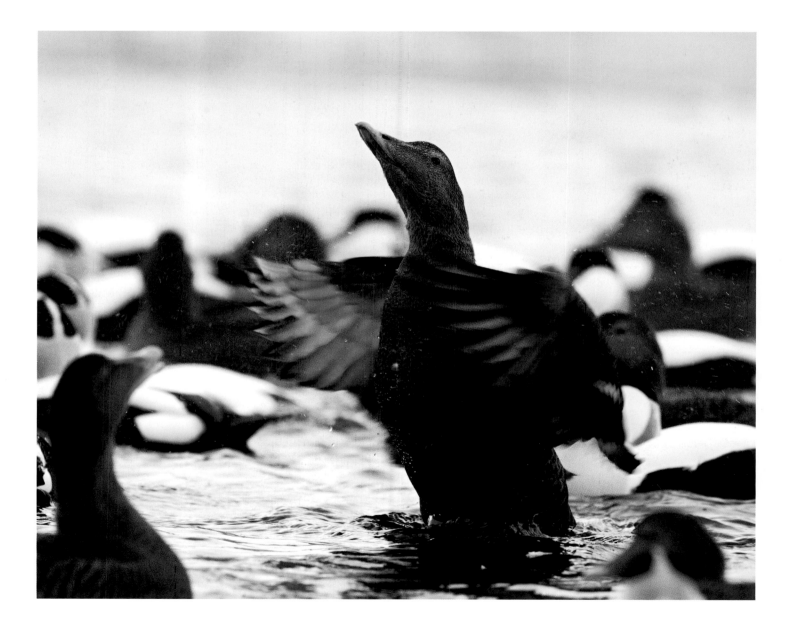

Feeding

BIRDS HAVE COLONIZED every continent and every type of environment—they are both numerous and virtually ubiquitous. This means there are large variations in diet between the different species, as can be seen when you observe the birds attracted to a birdfeeder hanging outside your kitchen window. Not only will pretty chickadees approach the food, but also "greedy" magpies.

Birds can be divided into three categories according to their diet.

1. The consistent, for example, the Osprey, which eats only fish all year round.
2. The seasonal, for example, thrushes, which, to put it simply, eat vegetable food in winter and animal food in summer.
3. The opportunist, for example, gulls, which eat whatever is available, both vegetable and animal food.

Many species that eat the same food all year round have to migrate to warmer climates in the winter, as is the case with insect-eating small birds. The choice of food determines the migratory strategy. Meanwhile, many of the species that do stay—such as chickadees—have to change their diet to take advantage of the food that is available at different times of the year.

Only a few birds will eat anything, including gulls, crows, and the African carrion-eating Marabou Stork. In fact, most birds have somewhat conservative eating habits, which may be a problem in today's world. The negative environmental impacts of man's activities have led to diminishing natural food resources, something affecting many species that, unlike crows, are unable to switch diets in order to survive.

Not all birds can benefit directly from bird-feeders in the winter, because they may not eat the food that is being offered, but many species can benefit from them in an indirect way. For example, by keeping small birds well fed, you are also making sure that Sparrowhawks have access to prey throughout the winter. This may seem cynical, but nature has its way whether we like it or not. Furthermore, the Sparrowhawk is an especially fascinating bird as well as a crucial player in the food chain.

All ecosystems contain a representative of the "sparrow-hawk niche," in other words, predators that hunt small birds in the forest. They may be actual Sparrowhawks or perhaps Sharp-shinned Hawks or Shikras. Their existence is, in fact, the reason why many passerines live in flocks—the risk of falling prey to the hawks encourages them to stay together.

While the struggle for food—eating or avoiding being eaten—dominates birds' lives, it also influences the way they are built. The most obvious example is the bill, which comes in hundreds of different shapes. Nearly all birds use their bills as a highly specialized tool for capturing or picking up food, so by examining this feature you can gain an idea of the species you are observing and what it likes to eat.

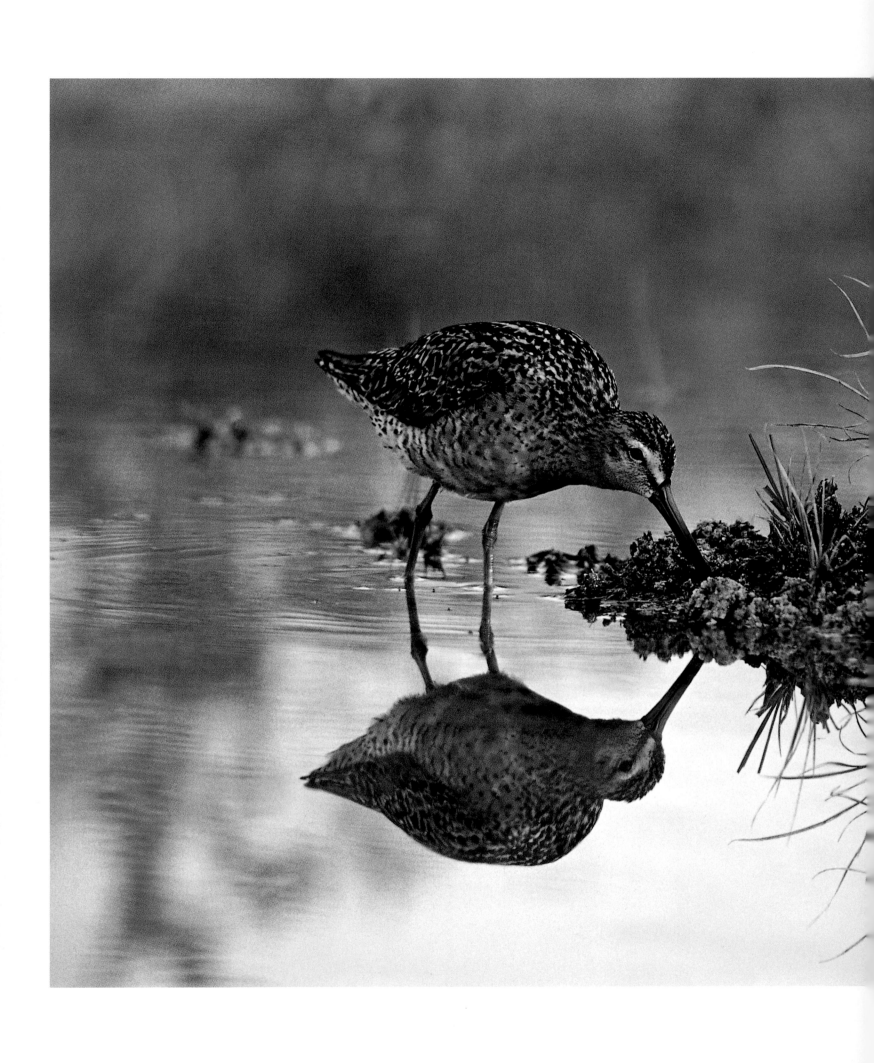

Scissor-billed. Many waders are equipped with long bills, some almost embarrassingly long. Imagine what it would be like to walk around with such a thing pointing straight out between your eyes. In all walks of life!

Waders run their bill straight into the mud, and with its sensitive tip they can detect movements from small organisms living there. But what happens next? You can't open a pair of scissors that are stuck in the ground up to the handle, so how can waders open their bill to eat their prey? The answer is that the distal part of the bill is soft and flexible, and can be opened like a pair of lips in the same way horses nibble at a lump of sugar. So, Short-billed Dowitchers and other similar waders can bury their bill several inches deep into the mud and still manage to feed.

Short-billed Dowitcher ∗ Manitoba, Canada ∗ June

Sack-billed. There are seven species of pelican in the world, all of which are among the largest birds in existence. But why are they so big? The most likely strategy behind having a large size is that it allows heavy loads to be carried. Pelicans often fly long distances between their fishing grounds and their nests, so it's very useful for them to be able to carry most of the day's catch all at once.

The pelican's bill is also somewhat special. It is large, with a skin pouch attached to the lower mandible. The bird uses its bill to catch food in much the same way as whales do, opening wide and scooping up a couple of bucketfuls of water. Any fish it catches stay in the pouch.

Pelicans use their pouches to bring fish to their young and also to carry nesting material. An obvious advantage that comes with this internal transportation system is that carrying prey in its claws or hanging from its beak does not slow down the bird. The pouches of some populations, such as the Brown Pelican in California, are also brightly colored during the breeding season, which is an important signal to potential partners.

Brown Pelicans * California * January

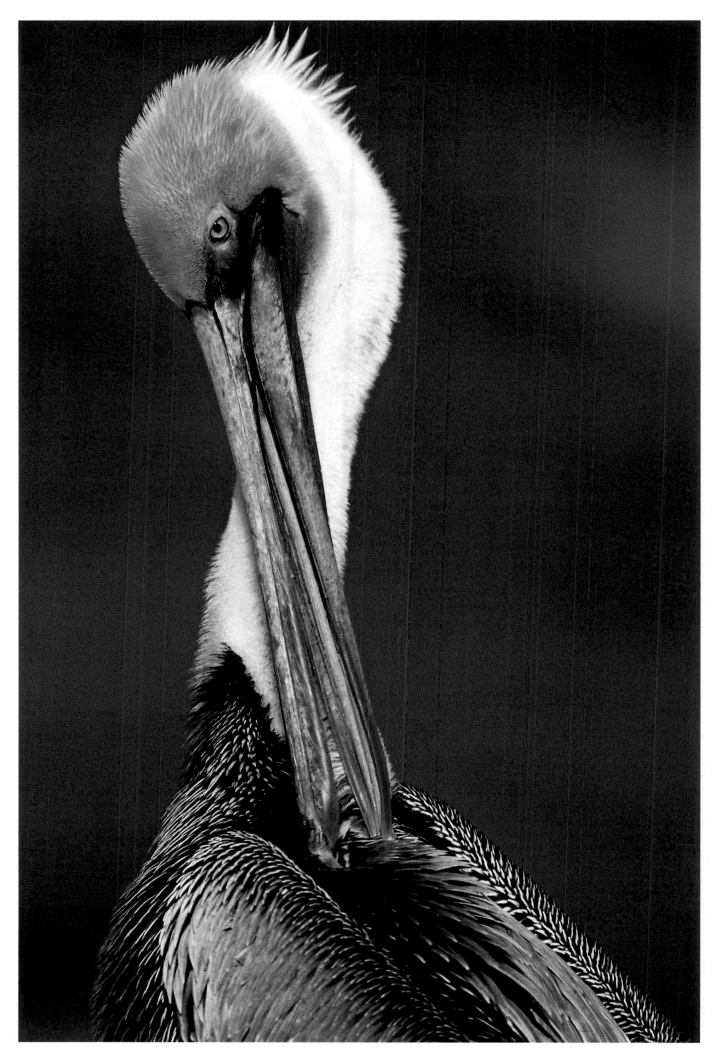

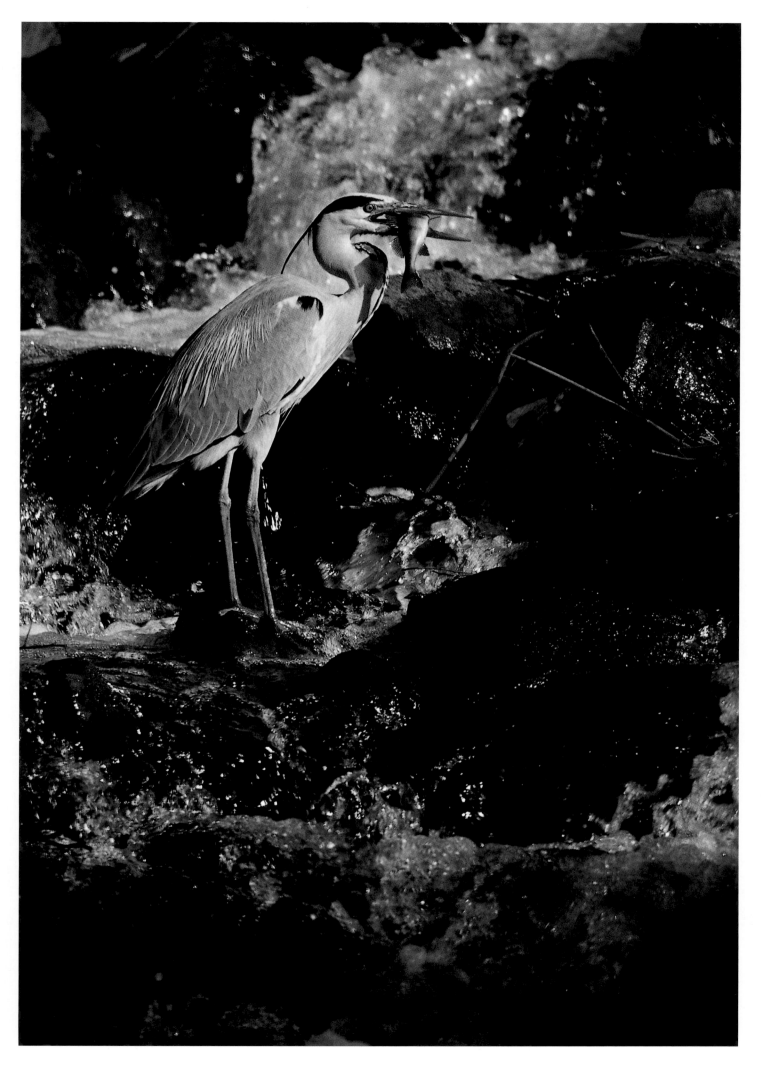

High-velocity weapon. A very common shape of bill is one that is long, straight, and sharp at the tip. It is easy to see that this is an effective fishing implement because it is a feature of a large number of birds that are in no way related but that all catch fish. Examples of these are loons, grebes, gannets, herons, auks, kingfishers, and some ducks—all very different types of birds. The long, pointed bill is primarily a high-velocity weapon, because the bird needs to take its prey by surprise and then spear it with lightning speed as it attempts to make its escape.

Grey Heron ∗ Sweden ∗ June

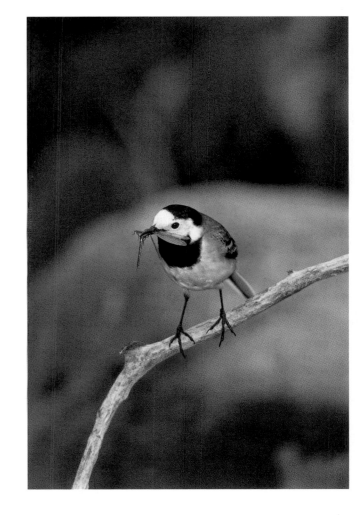

Bird of prey. Many bird species are predators, catching other living animals for food. A wagtail may seem harmless, but to mayflies and other insects it is a deadly threat. Bear in mind, however, that the term "bird of prey" is not used to refer to all birds that catch prey, but only to hawks, buzzards, eagles, falcons, and other species closely related to them. So, like the wagtail, an owl is not, strictly speaking, a bird of prey.

Pied Wagtail ∗ Sweden ∗ May

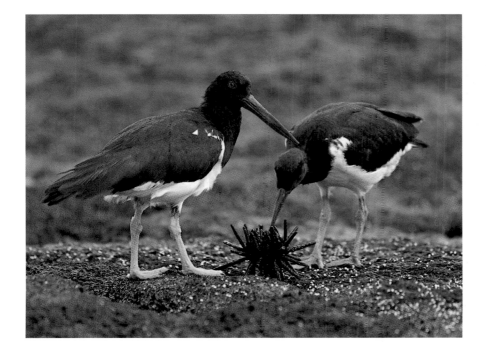

Chisel. In contrast to the majority of juvenile waders, young oystercatchers do not feed themselves from the start but are fed instead. Although the diet of most waders consists of small animals that any bird could eat, the oyster-catcher feeds mainly on mussels. While the bill of young oystercatchers may look impressive, the birds are unable to open mussel shells or to break into spiky sea urchins. To do that, they need more than their custom-designed chisel. Their jaw muscles have to develop first and they need to learn a special technique. This is why the adult oystercatchers—both male and the female—feed their young.

American Oystercatcher ∗ Galápagos ∗ February

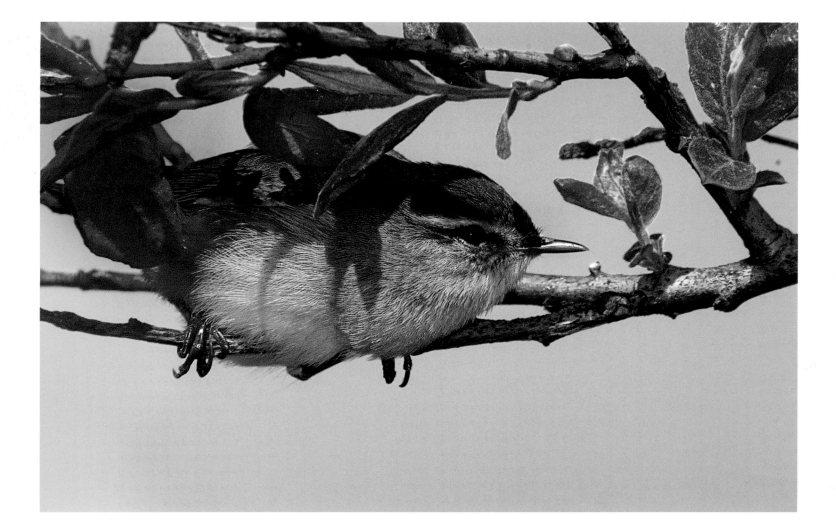

Tweezers. Small birds can be divided into those that eat insects and those that eat seeds. The insect-eaters live primarily on small insects and spiders, tiny creatures that are often easy to catch but hard to find. Once a midge has been found, for example, it will hardly put up much resistance. The bill of an insect-catcher is therefore primarily a precision tool for extracting tiny insects from grooves in the bark of trees, from underneath leaves, and so on, and is narrow, pointed, and elongated for this purpose. Dimensions vary depending on what type of insects the bird prefers. The Willow Warbler's bill, for example, is among the narrowest.

　　Apart from warblers, wheatears, redstarts, and pipits also feed on insects. The hunting style of all these birds places special demands on their eyes. For example, a Willow Warbler that has just focused on a lacewing an inch or so from the tip of its bill may need to readjust its eyes instantly to watch an approaching Sparrowhawk 300ft (100m) away, and then home back in again on its insect prey.

　　Willow Warbler * Sweden * May

Feeding. Most birds use their beaks both to catch food and to carry it to their young. If you see a bird flying off with food in its beak, you can be sure that it has young nearby because most adults will feed themselves wherever they come across food. "Bird carrying food" in an ornithologist's records means the individual in question will be classified as a nesting bird.

Rock Pipit * Norway * June

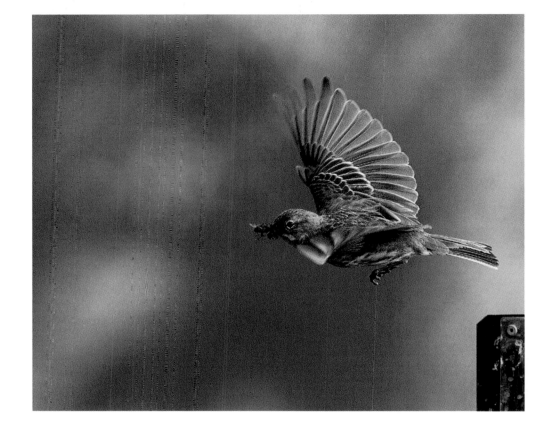

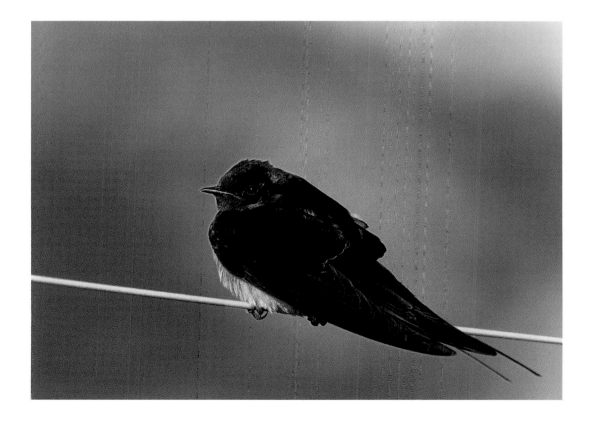

Netting. While the tweezer-billed birds pick insects off surfaces in a calm, dignified manner, another group of insect-eaters catches its prey in the air. These birds include the swifts, nightjars, swallows, and flycatchers. They all have a small, short bill they can open wide and which functions like a net as they fly around searching for food. When the barn swallow is perching, there is no way an observer could know that it has such an impressively large mouth.

Barn Swallow * Sweden * May

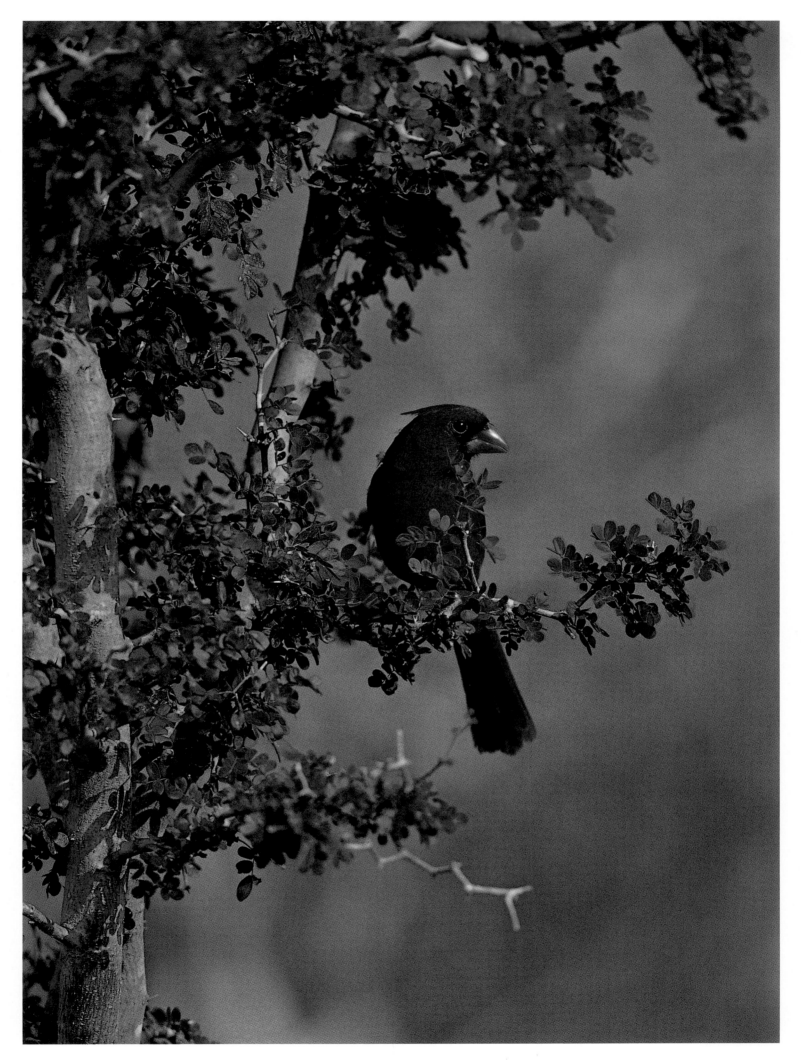

Seed-breakers. Seed-eaters are, together with insect-eaters, the largest group of small birds and include our most common finches. Seed-eaters prefer vegetable foods for most of the year, including seeds, buds, berries, and other plant material. They all have thick bills, often triangular in shape, that are thick near the base and have a more or less pointed tip. The cardinal's thick bill proves that it is a worthy representative of this group.

Northern Cardinal * Texas * April

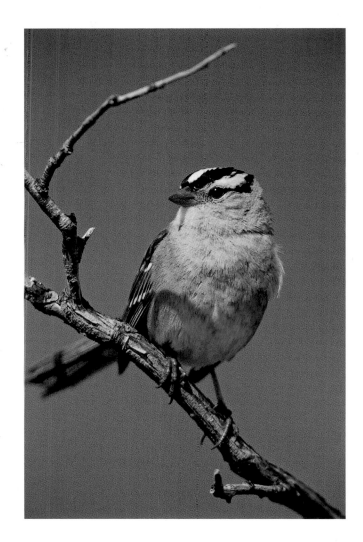

Seed-pickers. The dimensions of a seed-eater's bill vary depending on the type of food it prefers. Many seed-eaters with medium-sized bills handle tiny grains with husks that break easily, so the bird can get to the nutritious seed inside. These species are best described as "seed-pickers." Buntings comprise several species with thick, pointed bills, including the Yellowhammer (common over much of Europe) and the White-crowned Sparrow (common over much of North America). The bills of these species are not only powerful to break open husks, but are also pointed so they can extract the seeds from the husks with great precision.

White-crowned Sparrow * Manitoba, Canada * July

Insect-eating seed-breakers. Sparrows are seed-eaters, and examples of this group that are common in residential areas include the House Sparrow and Tree Sparrow. Regardless of whether they are seed-eaters or not, however, most small birds feed their young insects and other animal food because such a diet provides the growing birds high levels of protein and liquids. This applies to the tree sparrow, even though the adults prefer to eat seeds.

Eurasian Tree Sparrow * Sweden * July

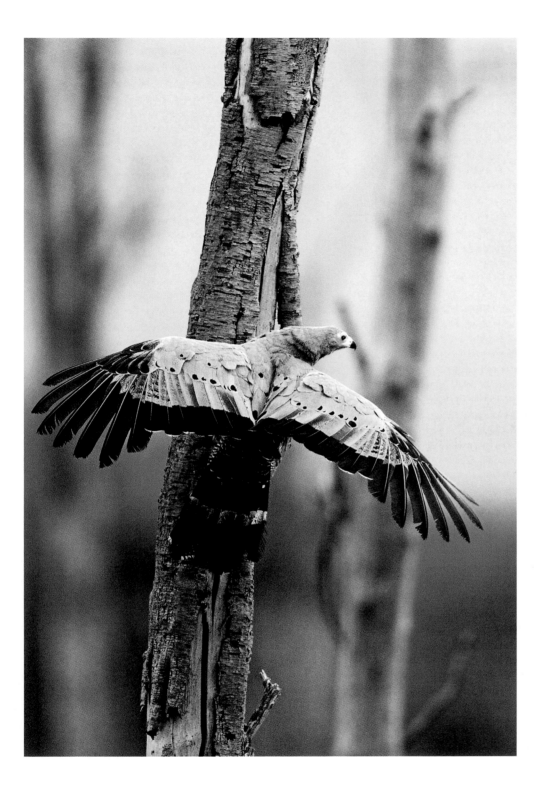

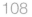

Tree-climber. Most raptors kill their prey at high speed in more or less open terrain, but the African Harrier-hawk has its own particular way of doing things. It climbs trees, and with its feet it searches for insects, lizards, small rodents, eggs, and birds among the branches. Its legs are long and bend easily in all directions, allowing it to gain access to those hard-to-reach places, and it uses its long tail feathers for support and balances itself by spreading its wings.

African Harrier-hawk ⋆ Tanzania ⋆ January

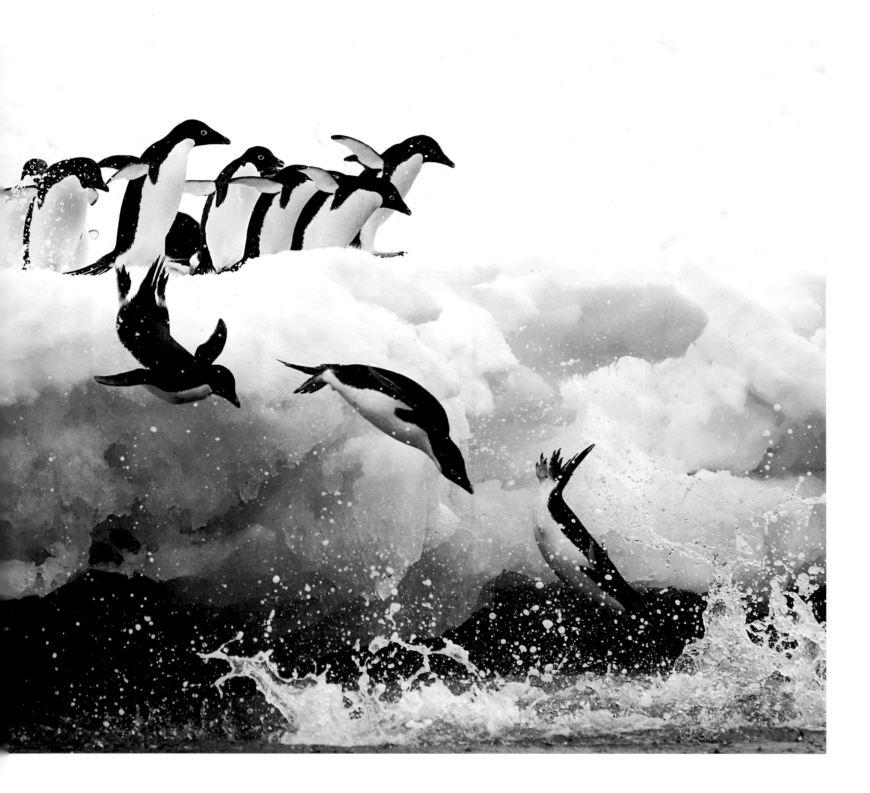

Jabbing away. Some penguins eat fish, but most do not. The small Adélie Penguin will occasionally catch fish in the Antarctic Ocean, but primarily it lives on krill (tiny shrimps) and, to some extent, cephalopods. This is why it does not have a long, pointed bill like many other penguins, but a short, blunt one, more suitable for jabbing than for sudden attacks.

Adélie Fenguins ★ Antarctica ★ January

Cattle Egret. Most egrets have long legs and long bills, adaptations for hunting fish and other animals in fairly deep water. The small Cattle Egret, however, prefers to keep its feet dry. It feeds on the plethora of insects, spiders, worms, and frogs, found near grazing herds of wild or tame cattle. It eats both the insects that the cattle attract and those that are disturbed by their hooves. This is why the relatively short-beaked and aptly named Cattle Egret can be seen near cattle on dry agricultural land or near wild animals in a similar environment.

Cattle Egret on African Buffalo * Tanzania * February

Insects. You might think that all birds that live in water eat fish, but this is far from the truth. Among the northerly ducks, it is mainly the long-billed sawbills that eat fish, while other species have a different diet. The goldeneye, for example, has a short, wide bill that would be of little use in catching fast-swimming fish. Instead, it eats insects, larvae, and tiny shrimps.

Common Goldeneye * Sweden * May

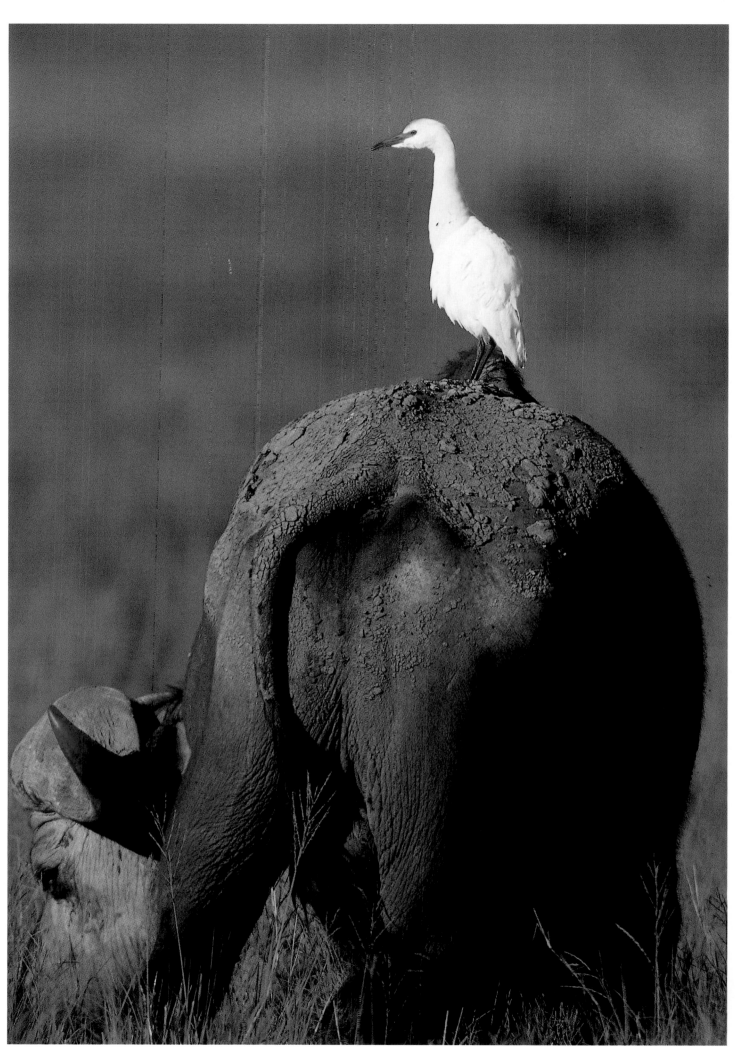

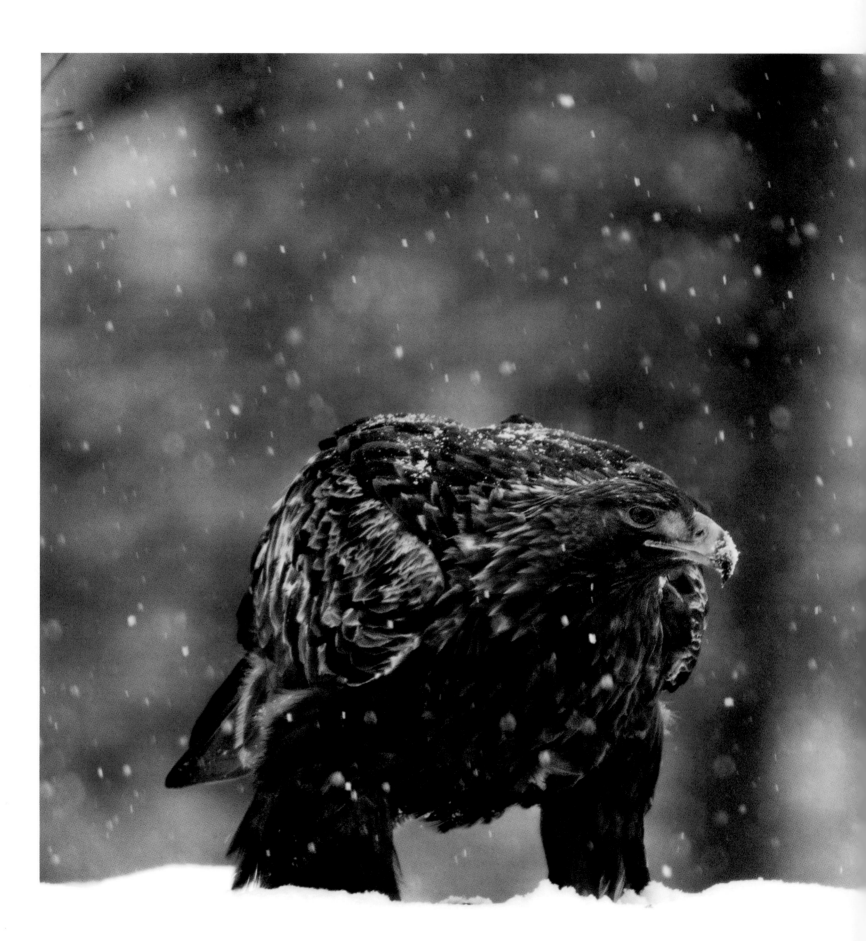

A butcher's bill. Both small and large raptors catch prey with their feet. As a result, their bill does not need to be designed for hunting, but for tearing up the catch. All raptors' bills are rather similar: They are short, high, and powerful, and have a sharp point. There is little room for good table manners when the bird pulls its prey apart—it is all about using brute force with the help of a sharp tool.

Golden Eagle ⋆ Finland ⋆ February

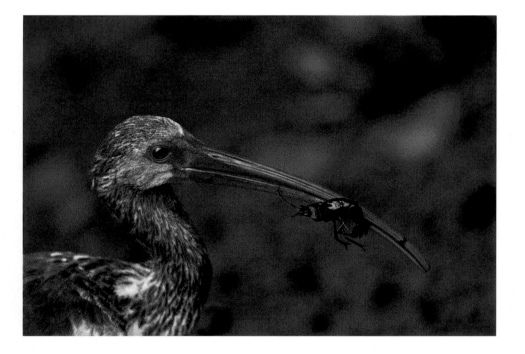

Pinching and poking. Not all long-billed birds use their tool as a high-velocity weapon. This is especially true of birds with curved bills, such as the White Ibis. The long bill of this bird is an excellent instrument for picking up or investigating prey, such as small organisms living in the water or in undergrowth on land. Its staple food is crayfish. The bill is also very useful for keeping the crustaceans at a distance until they have been rendered harmless.

White Ibis ⋆ Florida ⋆ February **White Ibis** ⋆ Florida ⋆ January

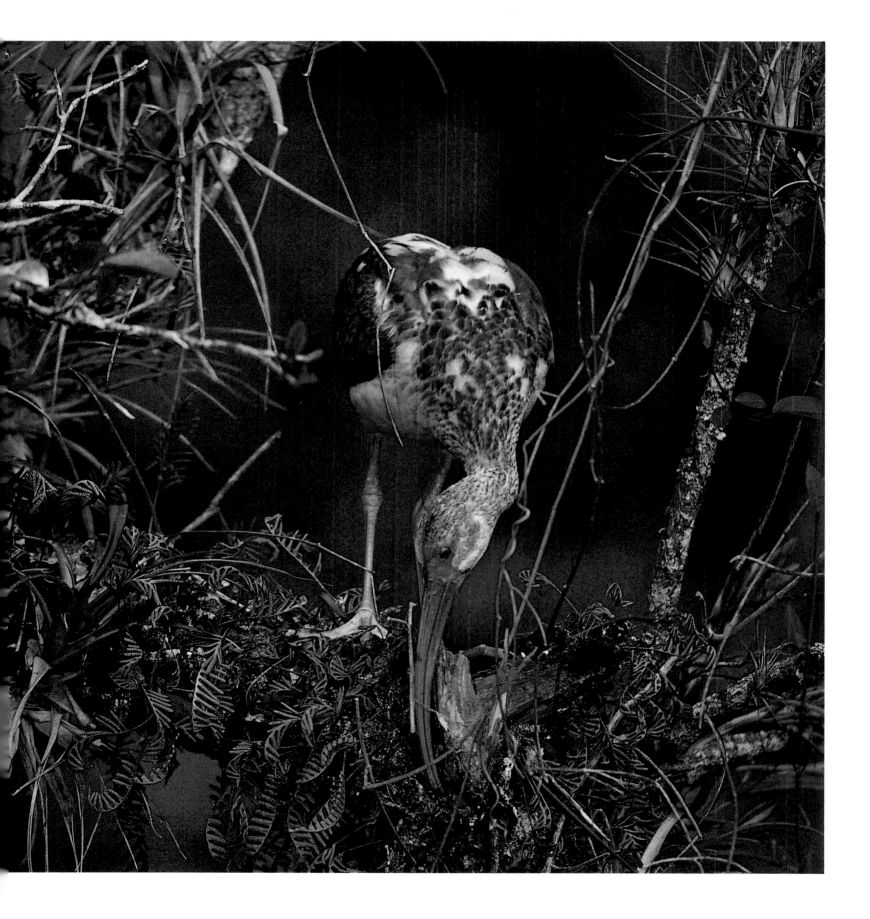

Dinner is served. Parents feed their chicks in most species, with the exception of shorebird and duck chicks who feed themselves. Large birds such as raptors and owls continue their feeding after the nest is abandoned. Gyrfalcons fledge at the age of 7–9 weeks, after which they move about freely throughout the territory but continue to be fed for another month. So, when a chopped up grouse falls from the sky— delivered by a caring parent—all junior needs to do is to sink his bill into the delicious meal.

Gyrfalcon * Sweden * July

Bee-eater. Like swallows and other "net-billed" species, bee-eaters catch flying insects on the wing. They do not, however, have small bills and large mouths, but long, extremely accurate tweezer-bills. When a bee-eater catches a bee, it doesn't swallow it immediately but holds it delicately in its bill instead and flies to its perch in an elegant arc-like movement. There, it removes the sting from the bee by pulling the insect along a branch until the sting catches in the bark. Even though bee-eaters are immune to bee venom, they prefer not to swallow the barbed sting.

Little Bee-eater * Tanzania * January

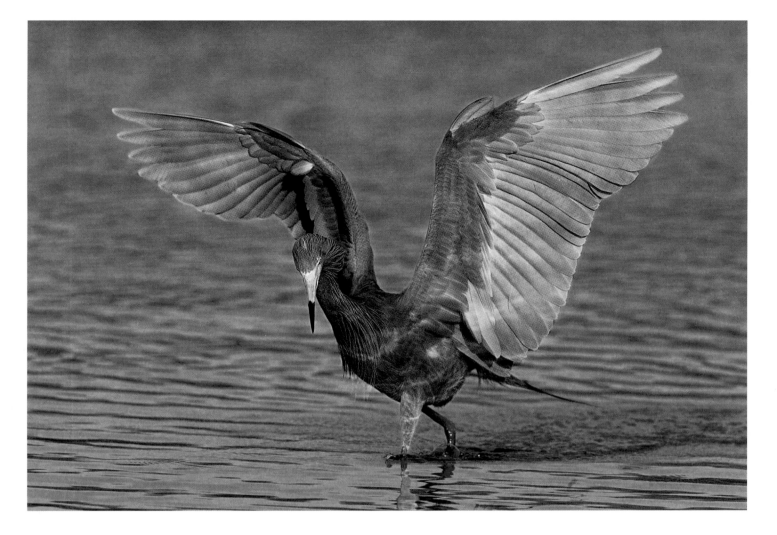

Shadowmaker. Some egrets catch fish by spreading their wings, probably to shade the water surface to prevent distracting reflections—if you have ever tried to count your toes underwater when the sun is shining, you will know the feeling.

The outstretched wings may also frighten fish into making sudden movements, revealing themselves to the egret as it stalks slowly through the water. Reddish Egrets do not just tiptoe but also run, lifting their legs in long strides the way we do when we think the water is too cold.

Large, long-legged, and long-winged, they look as if they are about to topple over— but then suddenly they will turn around and elegantly snatch a fish out of the water.

Reddish Egret ⋆ Florida ⋆ February

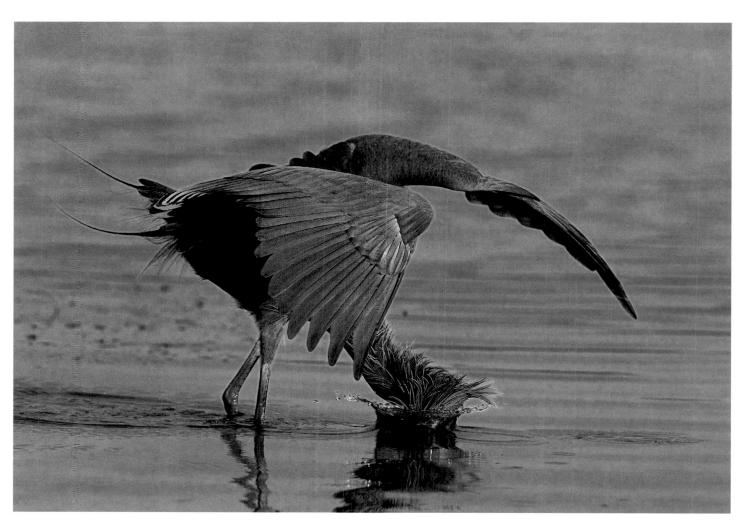

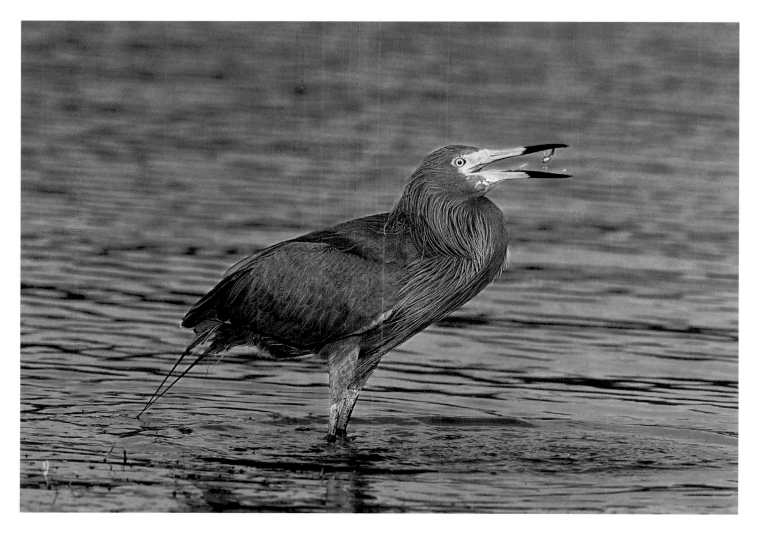

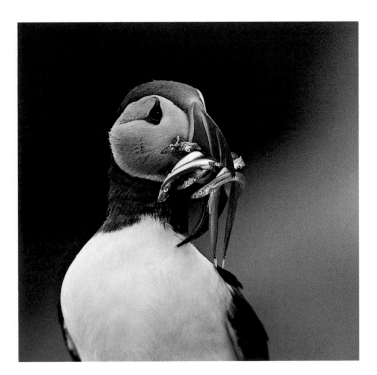

Fish-holder. The puffin's spectacular bill is the most magnificent among the North Atlantic birds. As colorful as a flag, it is also extremely flat and cuts easily through the water when the bird dives. Since the bill covers most of the puffin's face, it is easy to forget that it is also long, which means that it can hold many fish simultaneously. You might wonder, however, why the first fish doesn't escape as the bird opens its bill to catch more. The answer is that those already caught are held against the bird's palate with the help of its long, powerful tongue.

Atlantic Puffin * Norway * July

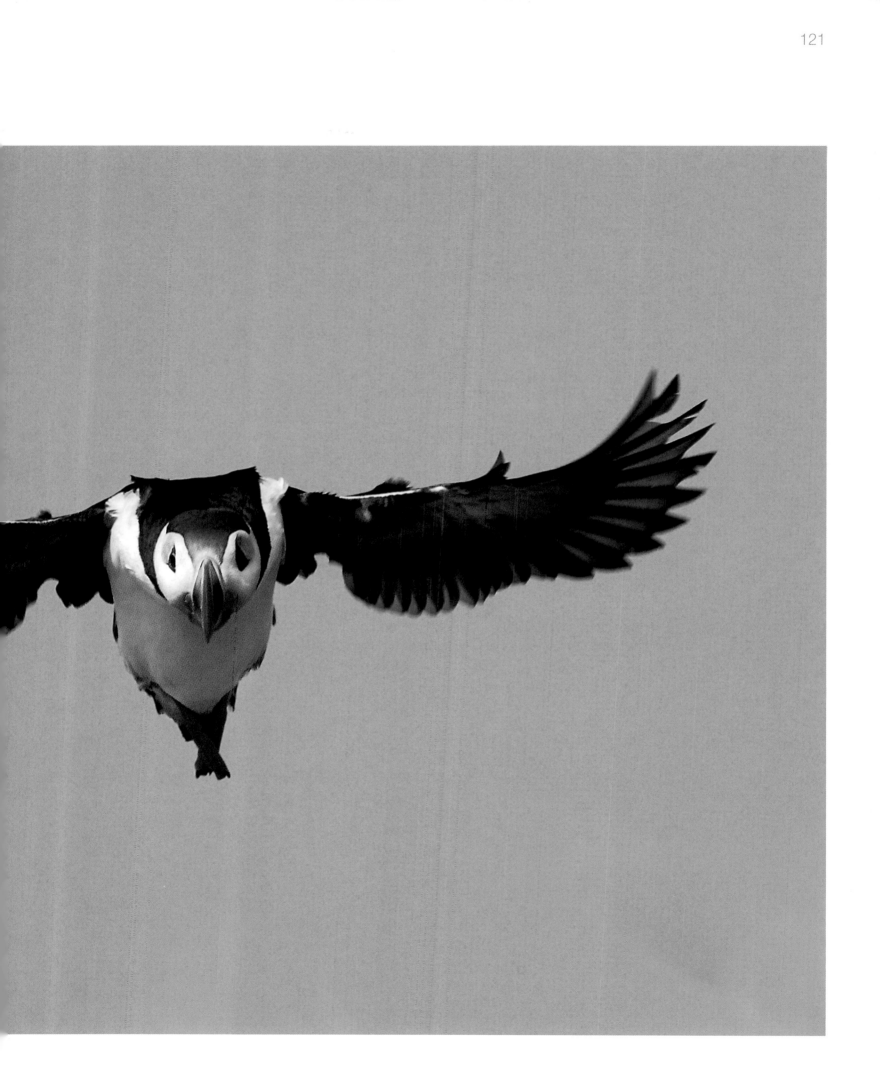

Habitats

BIRDS FORM A large group within the animal king-dom, and some 450 species breed in Europe alone. The reason why so many species feel at home in that part of the world is because they have adapted to fill the vast range of habitats. There is a close connec-tion between animals and their habitats, such that the different species become specialists within their own environments. To put it simply, if a resource is present, a species will make use of it and so will become adap-ted to that resource, filling a habitat niche within the wider environment.

But there is a conflict between the habits of birds and the changing world. Over thousands of years birds have become dependent on stable forest habitats so rich in plants and insects that we humans do not even know all the species they contain. When these ecosystems are destroyed and substituted with wind-swept clear-felled land or plantations of fast-growing alien trees, many birds simply cannot keep pace with the changes.

Another problem is the use of modern, highly rationalized, large-scale agricultural practices. When every inch of space needs to be cultivated, marginal environments such as ditches, weed patches, hedge-rows, and isolated coppices disappear. This leads to more restricted access to suitable nesting places and shelter, as well as a reduction in the number of insects. The increased use of pesticides has further reduced insect numbers, destroying what for some birds is their only source of food.

Because some birds are migratory, they are especi-ally vulnerable to new threats, and nature conservation without international cooperation is rarely successful in protecting them. The links go beyond national boundaries for such species as the Greater Flamingo, which will breed one year in Doñana, in Spain, the next maybe in the Camargue, in France, and the year after that in Chott el Djerid, in Tunisia. These days environmental awareness is widespread, and with the ample resources we now have on hand to deal with the problems, the future is looking bright. It is impossible to imagine that today we would repeat the pesticide scandals of the 1960s. Surely we have learned from our mistakes.

Or have we? During the past few decades the number of House Sparrows has fallen across large parts of Europe. These birds have now disappeared from areas where they were once common, largely for unknown reasons. Linnets, swallows, and martins, and skylarks and other birds of the agricultural land-scape are also all fast disappearing. Coinciding with these losses has been the steadily increasing use of pesticides in the natural environment.

At the same time, the hunting community is asking to be allowed to use lead shot again. But what is more important—effective hunting or protecting game animals and our common environment from the continued use of toxic heavy metals? With one breath we sigh over air pollution, mysterious bird deaths, and unexplainable allergies in children, then with the next we scream in protest over every minor increase in the price of gasoline. In all this, it seems that our private consumption desires win out every time over an improved quality of life offered by a healthy natural environment.

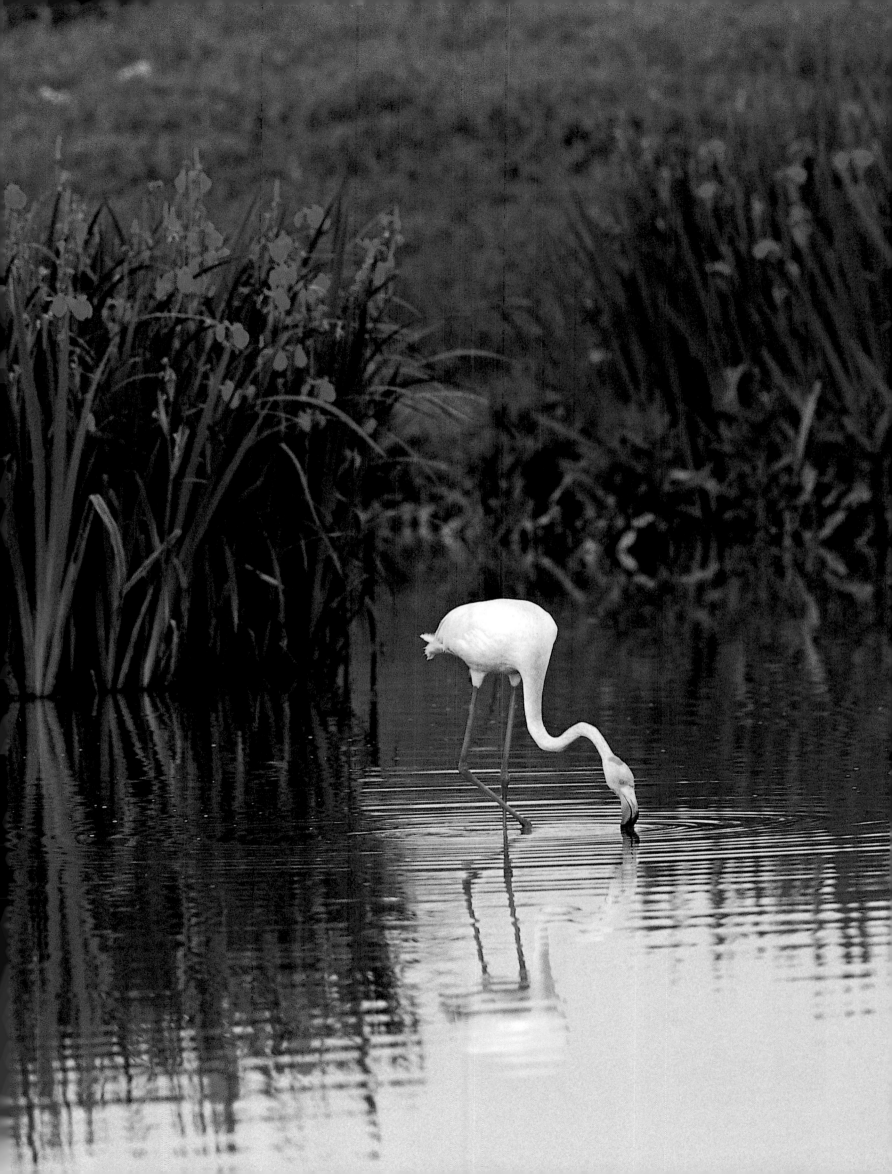

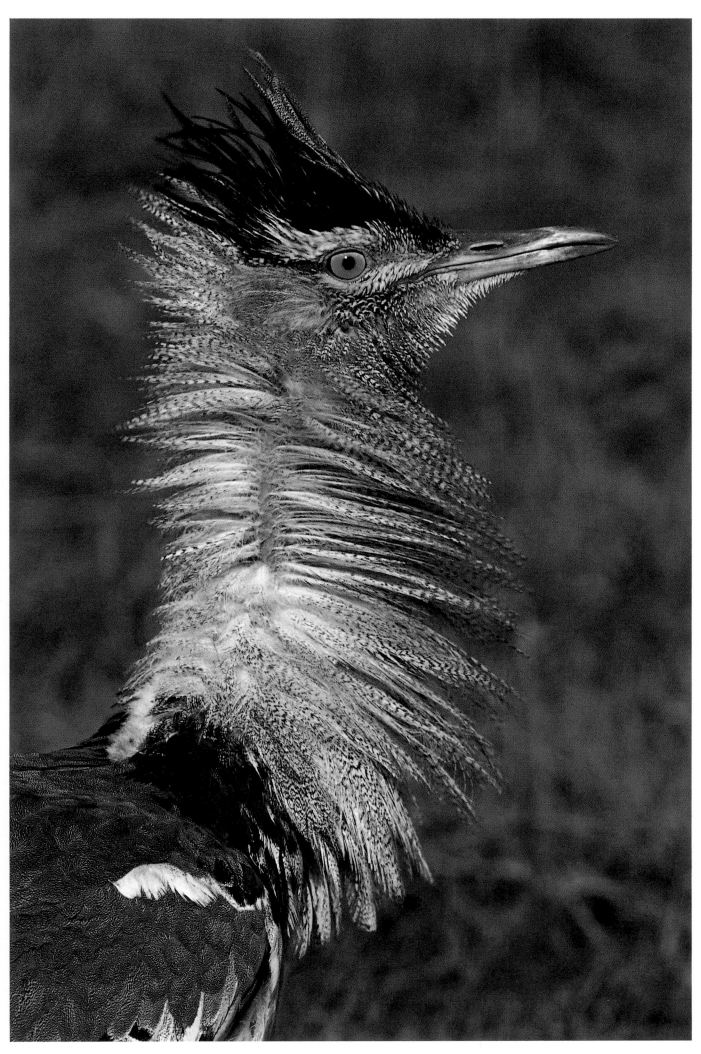

Collective threat. While threats against birds often concern specific species, some affect whole groups. One of these is the bustard, a large, elegant bird that can be found in southern Europe, Africa, and Asia. These are birds of the steppe and large plains, choosing to nest on the ground and avoiding residential areas and human contact. However, as natural grasslands are being plowed over for cultivation, the bustards are becoming endangered—many species are disappearing and need help to survive. The situation is further complicated by the fact that many of these birds are hunted for meat or sport. However, the giant, magnificent Kori Bustard is still common in the Masai Mara, the Serengeti, and other top-class nature reserves in East Africa.

Kori Bustard * Tanzania * February

Lacking the will. Not all bird species are disappearing, but many are, especially those that live on agricultural land. Skylark numbers are decreasing in half of all European countries but are not increasing in a single one. Why is this? One theory is that at least some of it has to do with the accumulation of chemical substances that are now detected everywhere: in our tissues, in breast milk, in skylark feathers, and in wild angelica flowers. Even though we ought to be better than earlier generations at dealing with pollution, it still poses serious problems. Awareness and the resources to tackle the issue are simply not enough if the will to do so is lacking.

Skylark * Sweden * June

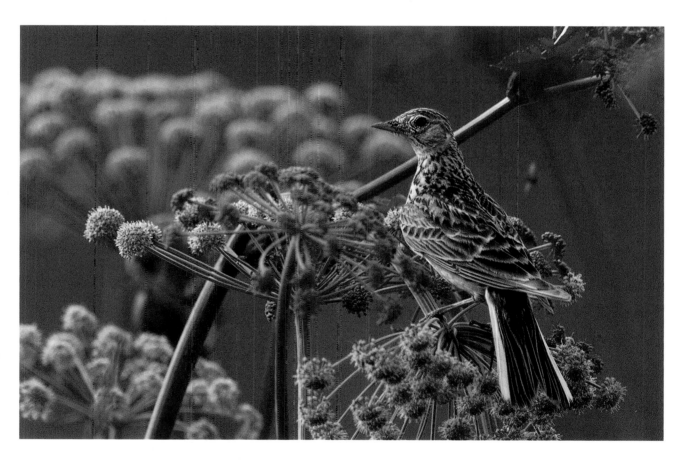

Overleaf. **Slovenia.** DDT, PCBs, logging, hunting, persecution, and general misery—is it worth fighting such seemingly insurmountable threats for a cleaner environment? During the early twentieth century, numbers of White-tailed Eagles fell in most parts of Europe. In the 1950s and 1960s, the bird was chosen as a symbol for the rise in environmental awareness. Populations of the species are once again growing in Europe. In Slovenia and a couple of other countries they are stable, and there are no signs of a decrease anywhere.

Don't despair!

White-tailed Eagle and Hooded Crows * Sweden * February

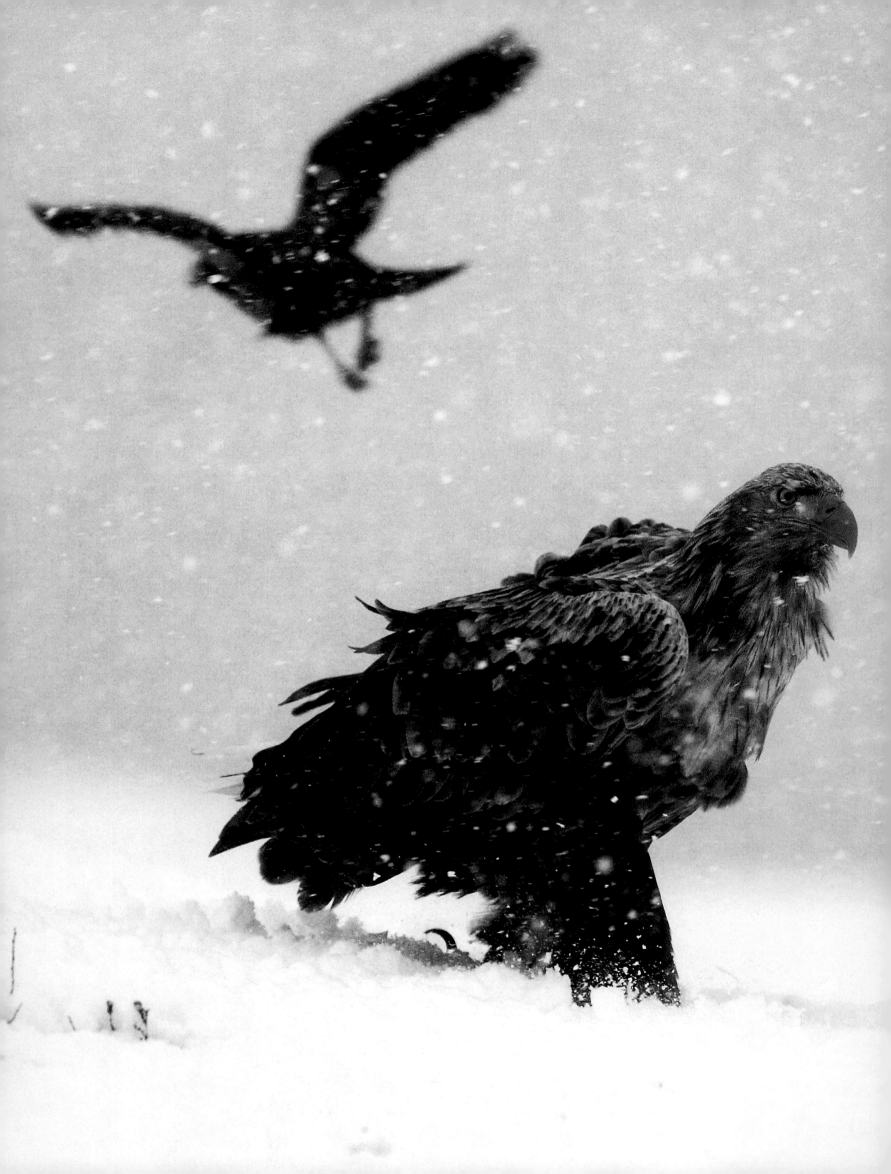

Immigrant. The blackbird was once a shy bird of the northern European forest you might, if you were lucky, encounter on a woodland walk. Around the turn of the twentieth century, however, in common with large numbers of the human population, it began to move into the cities. Today, the blackbird's song can be heard coming from the top of television aerials in every suburb. Although we are not fully sure why this migration took place, the blackbird may have been able to adapt to the new habitat niches that came into being with the creation of urban parks and gardens.

Strangely enough, another thrush, the Fieldfare, followed the blackbird's suit and began to move into the cities somewhat later, perhaps in the 1930s. Since both species are common in the countryside too, this has resulted in an overall increase in the population of thrushes.

Eurasian Blackbird * Sweden * July

Pine Chickadee. Virtually endemic to Europe, the Crested Chickadee is a common bird numbering six to 12 million pairs and breeds mainly in various types of pine forest. Fringe populations are less traditional in their choice of habitat, accepting forests of beech in the Pyrenees and cork oak in southern Spain. The British population, however, has clung stubbornly to the species' original setting, and does not occur outside old, open stands of Scots pine. Because the range of the Scots pine is highly restricted, the British Crested Chickadee population numbers no more than 2,400 pairs and is vulnerable but stable. In contrast, the Norwegian population is entirely representative of the species, preferring general pine forest, and is quite common (50,000–200,000 pairs).

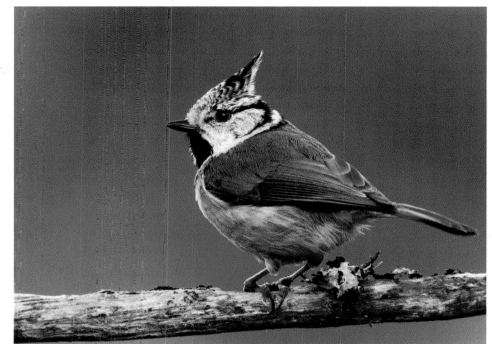

Crested Chickadee ∗ Norway ∗ April

Change of scenery. The Bullfinch breeds in lush spruce forests. Even though it is a common species, it is often surprisingly hard to encounter during the summer, even if you are out in the forest on a regular basis. During late fall, however, it goes for a complete change of scenery and becomes a major exhibitionist in parks and gardens.

Bullfinch ∗ Norway ∗ February

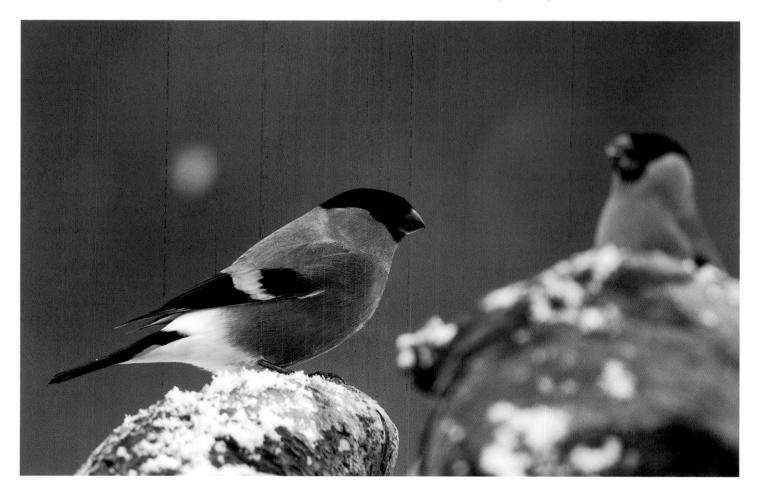

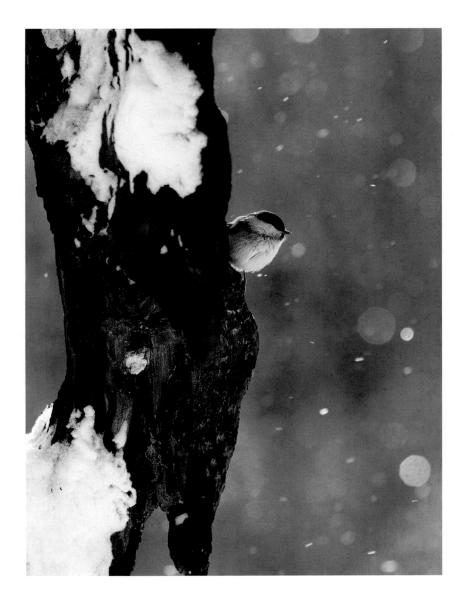

Saving energy. Chickadees have a body temperature of 107°F (42°C), and because many members of the family do not migrate, northerly breeders risk freezing to death during the winter. In contrast to human babies and bears, birds have no brown (heat-generating) fat. So, somewhat like adult humans, their only method of generating heat is to burn fat, which they do by using their muscles. When their body temperature starts to drop below 70°F (21°C), chickadees must generate heat themselves, and to do this they need to expend energy. We can jump up and down, but what can birds do? The answer is that chickadees shake in their sleep during the winter, shivering to keep their bodies warm.

Ninety-eight percent of the energy of a small bird is used for heat regulation and for basic metabolism, leaving 2 percent for foraging. Shouldn't the bird keep still and save that 2 percent for heating? The scenario is horrifying: On a cold winter's day two million chickadees out there would have to choose between freezing or starving to death.

It is not as bad as that. It isn't actually possible for a bird to save energy by being inactive instead of foraging, because its alternative would be to sit still and shiver to keep warm, thereby expending the same amount of energy. In contrast, using muscle power when foraging generates "bonus" heat, so the Willow Chickadee can afford to rush around during the short winter days looking for spiders.

Willow Chickadee ★ Finland ★ February

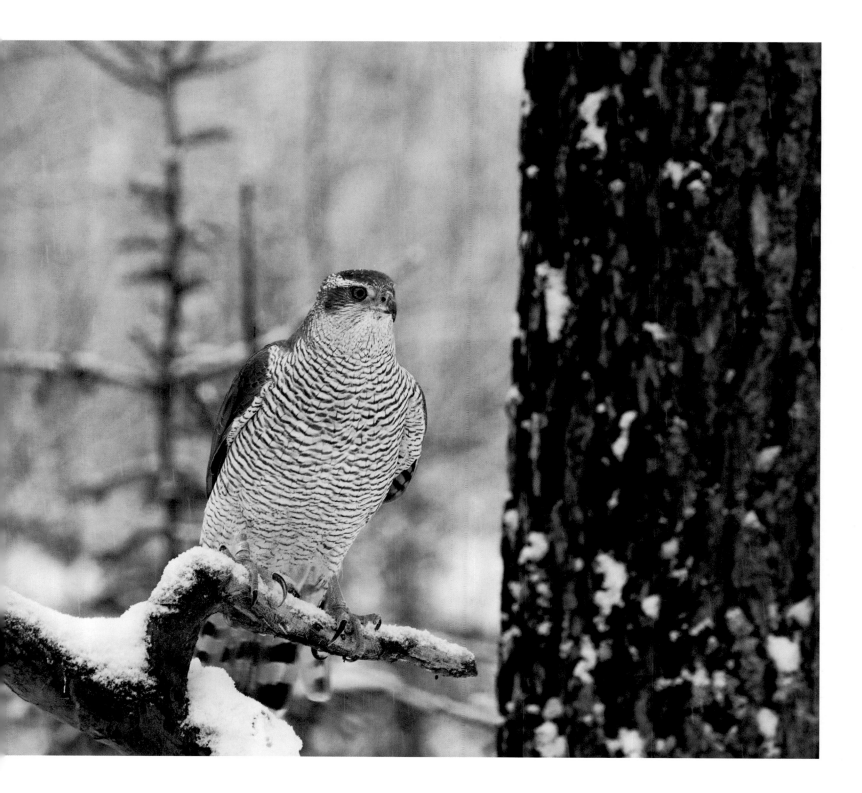

Culling. Goshawks occur all over Europe. Essentially, it is a bird of substantial woodland with old, tall trees, and there is no doubt it has a key role to play in the wild. Even so, goshawk numbers are declining in several areas, including the Nordic and Baltic countries.

Each year, thousands of Asiatic pheasants are released in Sweden. Unfortunately, modern life gives modern men few opportunities to prove their manhood, so shooting lead into birds bred for the purpose is considered to be a virile pursuit. As it happens, the goshawk manages to catch one or two of these virtually tame game birds, so the Swedish authorities still endorse the culling of this raptor. When an important, disappearing, indigenous bird like the goshawk is legally killed to save an alien, "artificial" species, it is definitely time to reexamine our idea of nature conservation.

Northern Goshawk ∗ Finland ∗ January

Tough. The Kestrel is by far the most common falcon in Europe. It is a tough little bird that has a diet of voles and mice, similar to the much larger and heavier Buzzard, and is often seen perched on roadside posts in the open countryside keeping an eye out for prey. Like many birds in agricultural areas, the Kestrel is disappearing throughout Europe, partly as a result of pest control and the clearing of hedgerows, overgrown ditches, and other marginal environments where its prey thrive. Where specially made nesting boxes have been put up, however, the Kestrel has managed to increase dramatically in numbers.

Kestrel * Spain * April

Happy return. Woodpeckers are a globally threatened group. Most of them are highly specialized, which means they are reluctant to change habitats and so are highly vulnerable to habitat degradation. Besides wetlands, forests may be the single most threatened habitat in the world today.

Fortunately, there are still some woodpecker species that are doing well. Grey-headed Woodpecker populations, which were previously declining throughout Europe, are currently stable and a few are even on the increase. This is good news, although the reasons behind it are obscure and are unlikely to have anything to do with habitat conservation.

Grey-headed Woodpecker ∗ Finland ∗ July

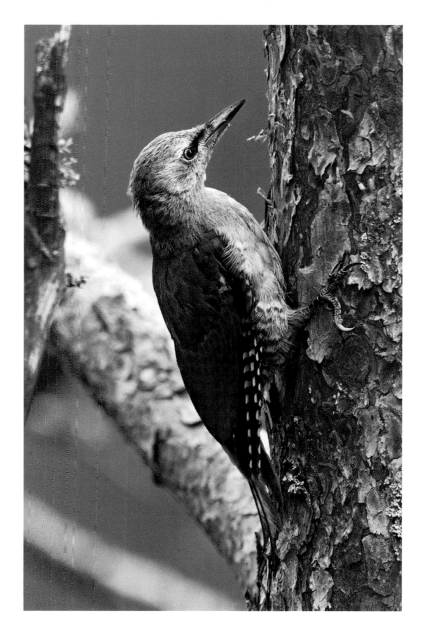

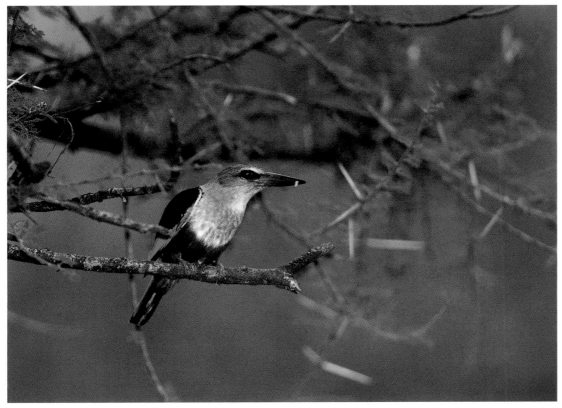

Fishing on land. The Kingfisher, one of 90 members of the kingfisher family found worldwide, is common in the British Isles and can regularly be observed flying along rivers in search of vantage points from which to look for fish. Several other members of the kingfisher family do not live on fish, however, and many are found in entirely different types of habitat. In New Guinea, for example, there is a sturdy species that walks on the ground, shifting the soil with its thick beak as it searches for various small animals. Like many other birds of the family, the Grey-headed Kingfisher uses basically the same technique as the British Kingfisher—the only difference is that it does not dive into water but onto the surface of dry land, where it catches insects, lizards, and other small creatures.

Grey-headed Kingfisher ∗ Tanzania ∗ January

Metamorphosis. The Bohemian Waxwing is a secretive bird, breeding throughout the northern taiga from Norway and eastwards through Siberia and Alaska to Hudson Bay. During the winter it migrates to the south, feeding on hawthorn and rowan berries. From being a typical wilderness species, the waxwing transforms into a familiar garden visitor.

Bohemian Waxwing ∗ Finland ∗ March

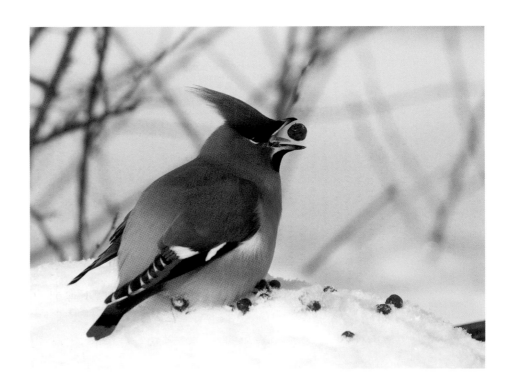

Forest green. A bird's appearance often communicates something about the kind of environment it is adapted to, and sometimes about what kind of life it leads. Many sandy-colored birds are, for example, found in the desert, while light-colored or white birds often live in polar regions. Meanwhile, the Green Woodpecker is green because it is more likely to forage on the ground than other woodpeckers, preferring grassy meadows.

In forests across the world there are birds with green and yellow hues. The bright yellow Golden Oriole is one such species, and becomes almost invisible in foliage where the sunlight falls between the leaves to create a dappled effect. The same is true of the Green Jay—the bird pictured here is showing off its colorful plumage before taking off into the dense vegetation where it spends most of its time.

Green Jay ∗ Texas ∗ April

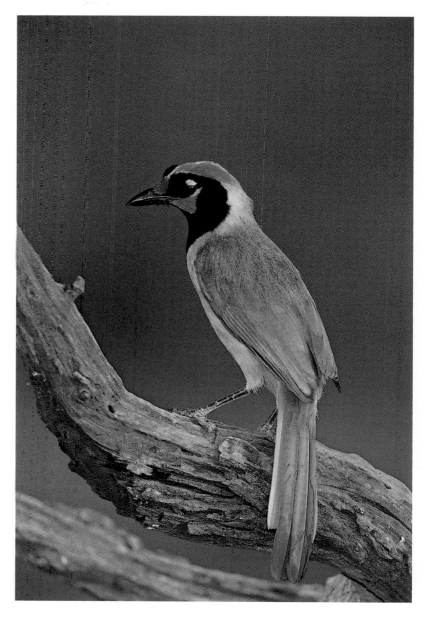

Overleaf. **The ocean giveth.** The sea is rich in food, and the cold polar waters are no exception. Here, there are large populations of birds that eat fish, shrimps, and crustaceans, including auks in the north and penguins in the south. These species come ashore only during the breeding season, when large numbers gather within a relatively small perimeter. There are many ocean wanderers in these regions, but few species that actually live on land in the Arctic and Antarctic. The barren, rocky islands here simply do not offer enough food to feed large, land-based populations.

This is why the Brown Skua lives indirectly off the sea. This hefty bird has no scruples, and will steal penguin eggs or newly hatched young before the eyes of their desperate parents or grab fish straight out of their bills.

Brown Skua and King Penguins ∗ South Georgia ∗ December

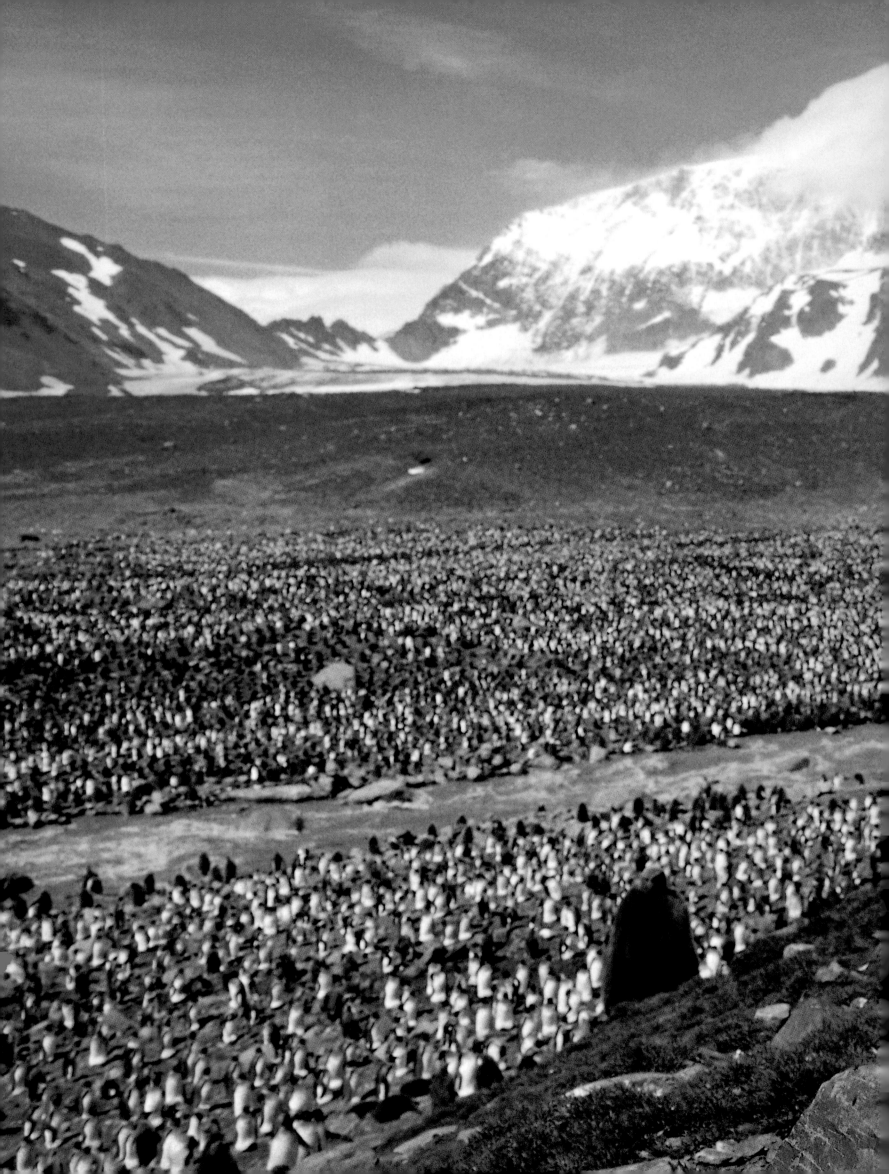

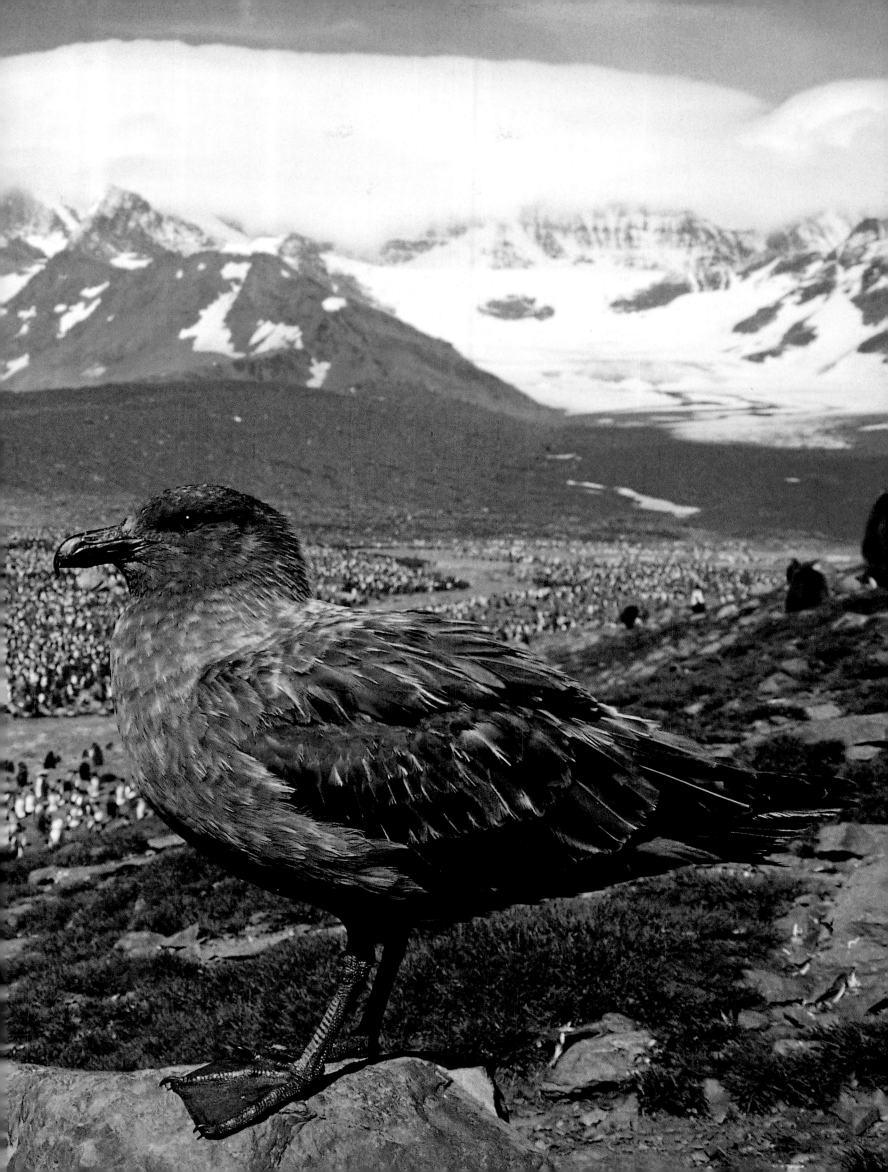

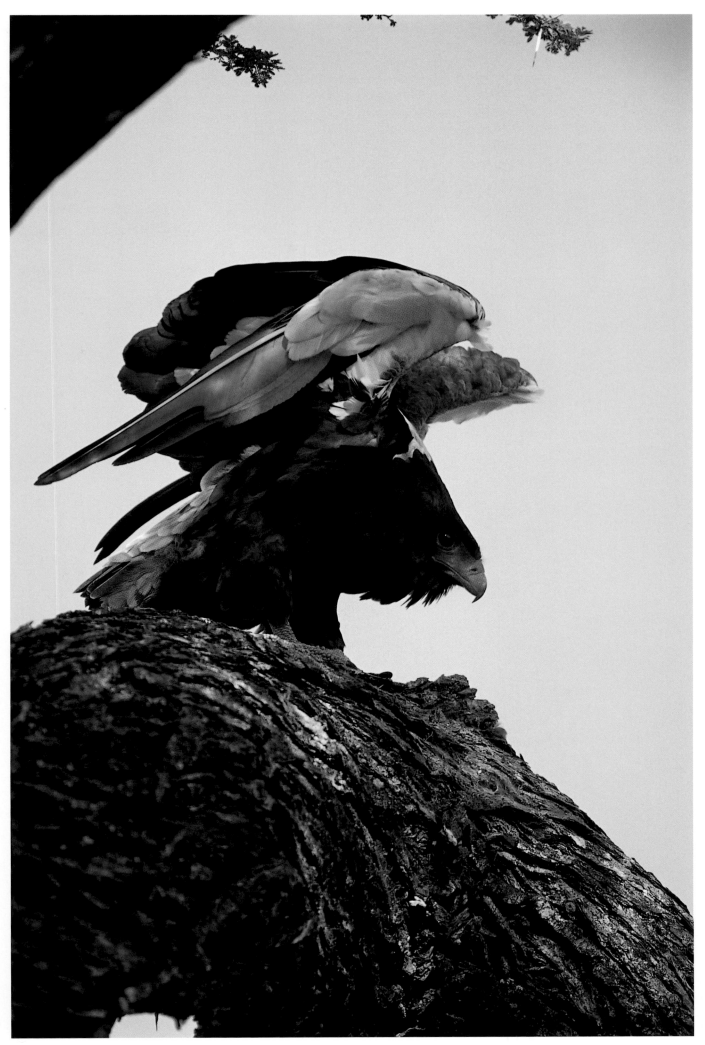

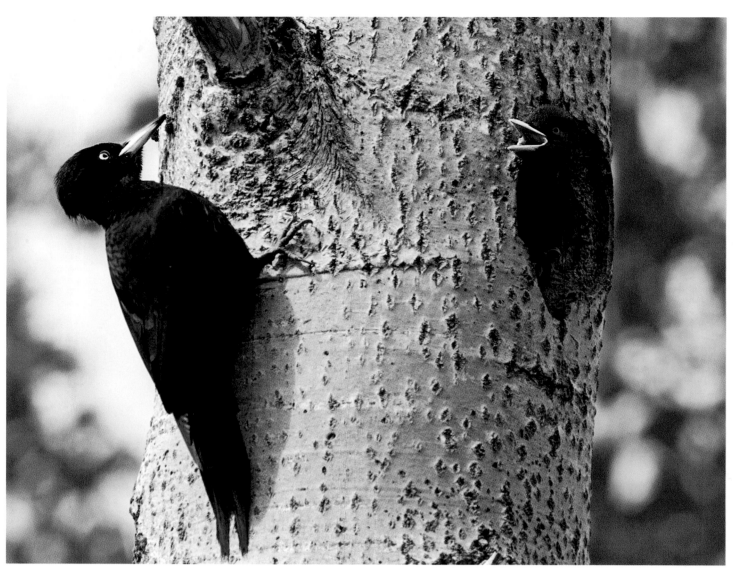

The builder. The Black Woodpecker is Europe's largest woodpecker, an impressive bird that makes a drumming sound like a machine gun. In common with other woodpeckers, it likes to drill its nest in aspen trees, which have soft wood, and also builds a new nest every year. This means that old woodpecker holes make readily available housing for less discerning lodgers. Birds as varied as goldeneyes, stock doves, and Tengmalm's Owls like to move into abandoned Black Woodpecker holes, which may be used by species such as these for several years.

Black Woodpecker ✳ Sweden ✳ June

Wish list. To the uninitiated it may seem surprising, but different birds have a different status among naturalists. Birdwatchers traveling to Africa, for example, will put the Bateleur at the top of their list of species to see. Part of the attraction of this bird is its unusual outline in flight and its stumped tail feathers.

Another important factor relating to a bird's status is its habitat and habits. The Bateleur is found in rather open landscapes with deciduous forests and savanna. It spends much of its time in the air and is said to be able to travel 250 miles (400 km) in a day, which is why it is spotted so often. Once seen, the Bateleur is an unusual bird that you will remember and will want to see again.

Bateleur ✳ Tanzania ✳ February

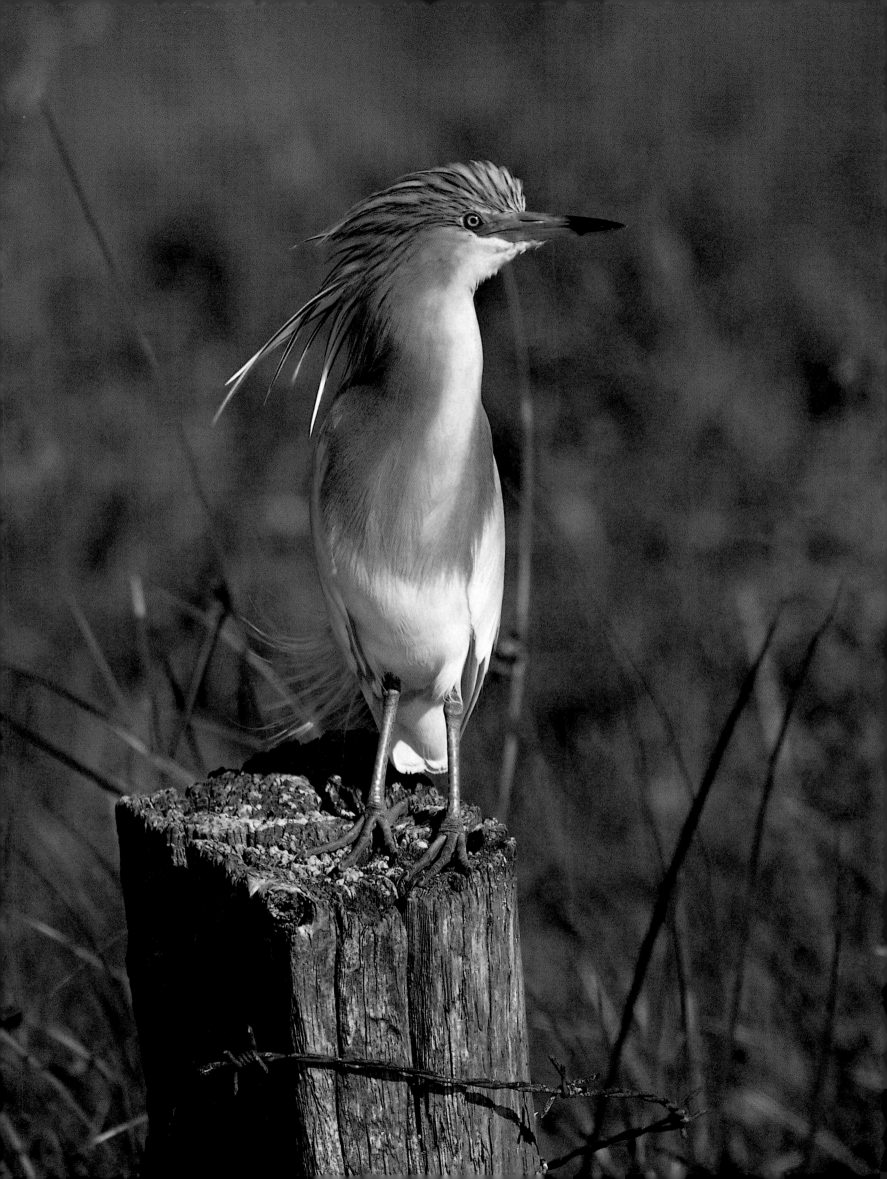

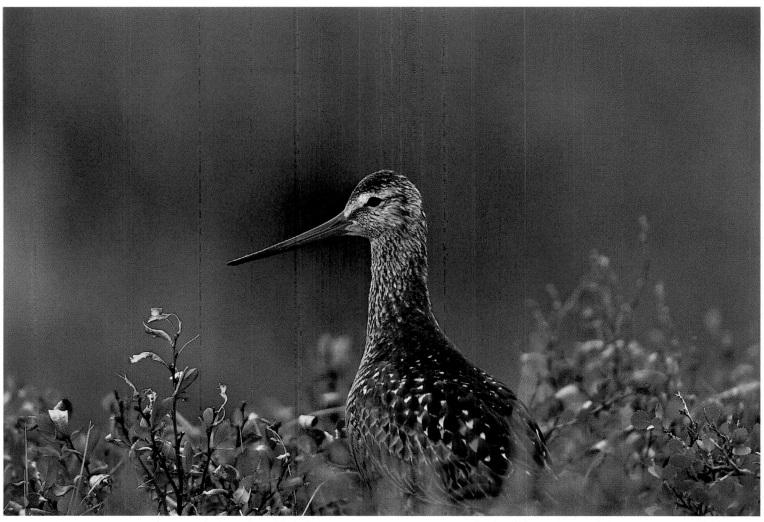

New habitats. Abundant wetlands, made up of a mosaic of rushes, pools, watercourses, marshes, and bogs, were once common. As a result, a large number of birds and other animals became adapted to the different niches that are found in wetland habitats. The Squacco Heron is one such example.

Over the past few centuries, however, agriculture has changed the landscape considerably. The relatively small areas of land that were cultivated first have since been extended through deforestation and wetland drainage. This has, not surprisingly, had a very negative impact on herons and many other wetland species. Despite this, some of the species—including the Squacco Heron—have managed to adapt to the new habitat niches offered by manmade irrigation projects. Rice is a crop that requires vast amounts of water, and foraging Squacco Herons, Black-winged Stilts, and other birds often visit rice paddies.

Squacco Heron * Spain * April

Stable environment. Bird species have not appeared out of nowhere, but exist in particular environments because these offer favorable living conditions to which the species become adapted. A large number of sandpipers, snipes, plovers, and curlews are, for example, so well adapted to the northern taiga and tundra that they would not exist without these habitats.

The Hudsonian Godwit's tundra habitat has changed little over the millennia, and it would be reasonable to think that it was the existence of this environment that promoted the bird to a separate species. As a result, the Hudsonian Godwit is entirely dependent on the tundra remaining un-touched, a status that, unfortunately, is likely to change in the foreseeable future.

Hudsonian Godwit * Manitoba, Canada * June

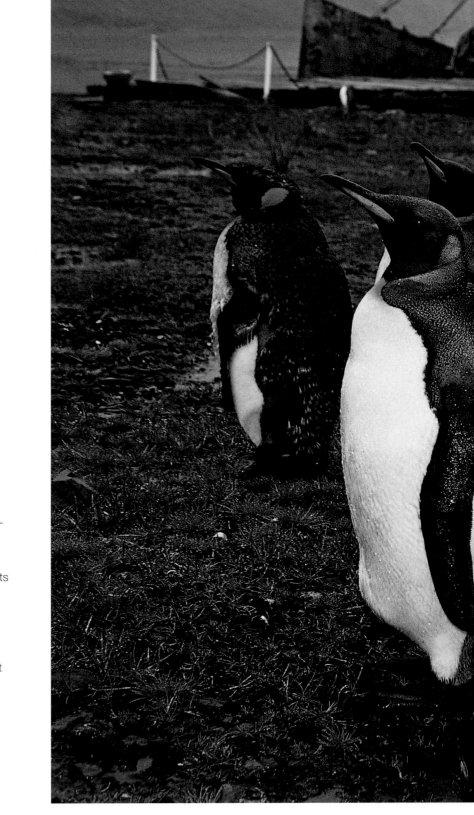

Impressive. You can say what you want about human accomplishments, but as environmental bad guys we are definitely outstanding. One proof of this impressive feat is the amount of unspoiled land that still exists in the world— virtually none! We are not just talking here about Europe, the United States, and other industrialized areas, but also the vast Siberian forests, the once impenetrable rain forests of the Amazon, the Arctic tundra, and the summits of the Himalaya. Traces of ruthless human exploitation can be found everywhere—not even the Antarctic penguins can escape human waste in the form of discarded plastic, leaking oil, and all kinds of rusting iron structures. Today, it is not enough just to keep our own front yards clean—we need to clean up the whole world!

King Penguins ★ South Georgia ★ December

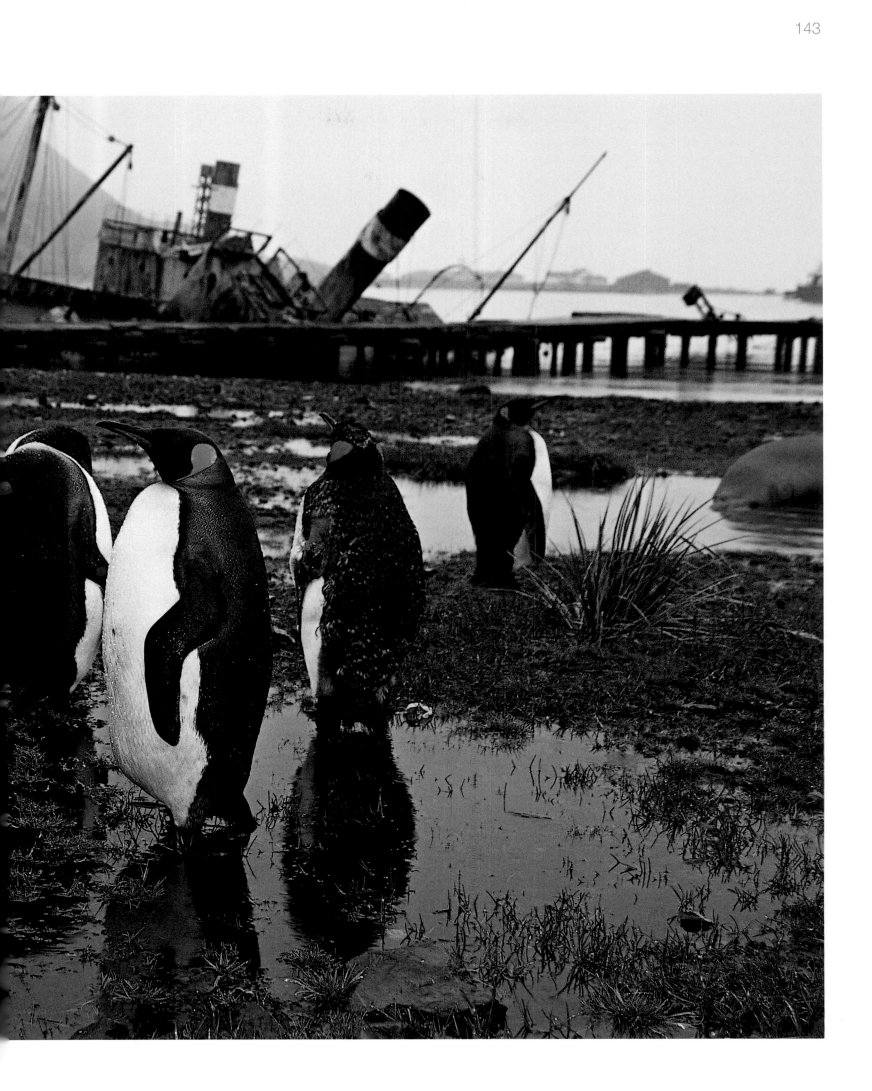

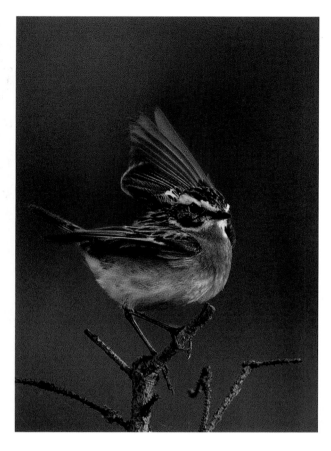

Winter. The Whinchat is declining in half of European countries, including the United Kingdom. In contrast, its close relative the Stonechat is increasing in nearly half of Europe, again including the United Kingdom. This marked difference is partly due to the divergent breeding habitats of the two species. The Whinchat relies more
on seasonal herbaceous plants and tall grasses on farmland, which have declined with the adoption of modern farming practices, while the Stonechat frequents less cultivated areas with permanent vegetation in the form of bushes. In addition, the migratory Whinchat is also likely to suffer from the heavy use of pesticides in its wintering areas in tropical Africa. This species exemplifies the need for international conservation, as not only does it require healthy breeding grounds, but its winter habitats are equally important too.

Whinchat ∗ Sweden ∗ July

Staging posts. While both breeding and wintering areas are important for the survival of birds, migrants also need suitable staging posts along their migration routes. This is especially important to the Whimbrel and other waders, many of which travel extremely long distances between their breeding grounds in the arctic and their overwintering areas in the tropics. When these birds get to their Arctic breeding grounds it may still be winter, so they must arrive in excellent condition. This is why it is essential that they have access to high-quality staging posts with plenty of food along the way.

Whimbrel ∗ Manitoba, Canada ∗ June

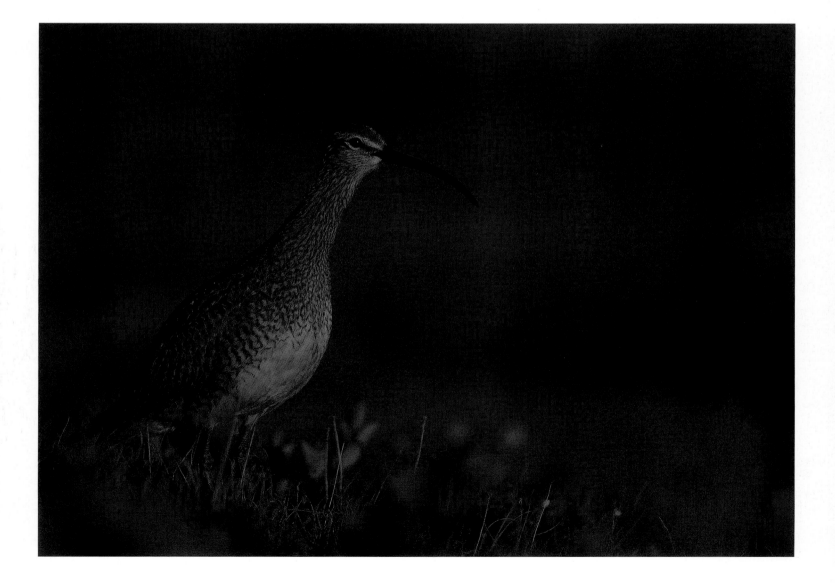

Liberal. With a diet consisting of small invertebrates such as insects and worms, the mew gull is, among other members of its family, one of the least dependent on fish. It may tolerate a herring or two and might even take a young bird or an egg if given the chance, but it is just as good at finding food on land as in the water. Because of the bird's opportunist feeding behavior, its habitat is extremely varied. You may find it along a rocky or sandy shoreline, or equally by an inland lake in an agricultural district or in the forest. During lemming migrations in particular, Mew Gulls may be abundant around tundra tarns—if you venture out on an inhospitable bog this may, in fact, be the only bird you encounter.

Mew Gull ∗ Sweden ∗ April

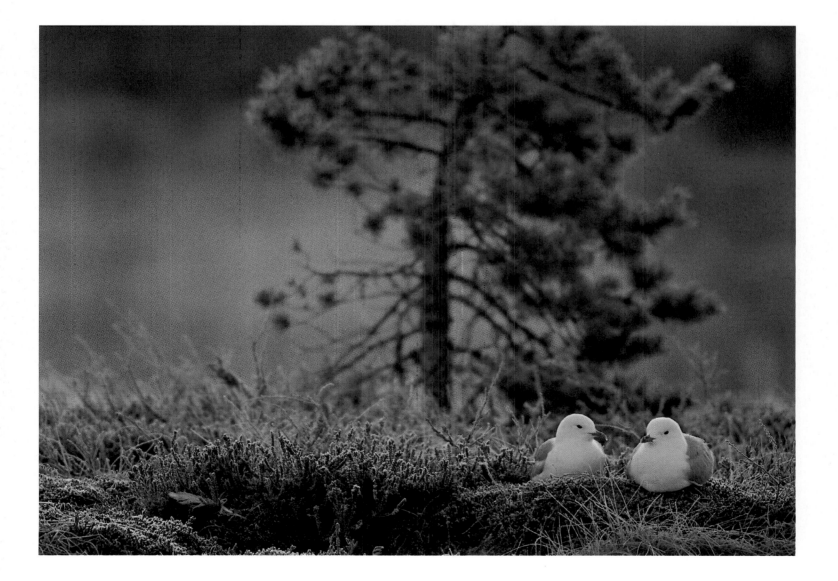

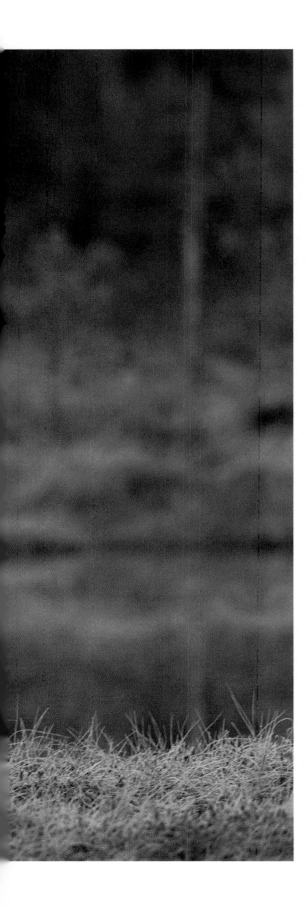

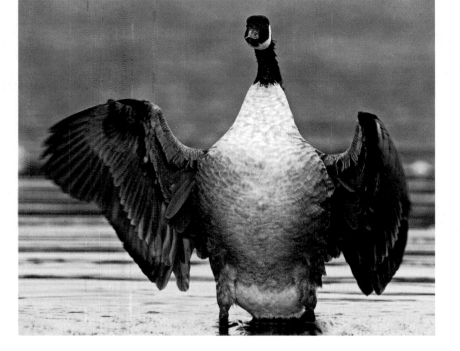

Tampering with fauna. The most common goose in North America is the Canada Goose, which can be found as far south as the southern United States. The species was first introduced into England in the seventeenth century, but it was not until the early twentieth century that it was brought to the Nordic countries for hunting.

Unfortunately, the introduction of new species and nature conservation do not always go together. On the contrary, it is very common for this kind of tampering with fauna to lead to unwanted results—all around the world, a negative impact on the environment has, in fact, been common after new species have been introduced. Local wildlife is wiped out, the hunting of indigenous species is intensified in order to protect the newcomers, and native flora is also damaged. In Sweden, the Canada Goose has caused problems for farmers by ruining their crops, and it has affected the general public by soiling their bathing beaches. While the species is wonderful in its native forests in North America, it doesn't belong in Europe.

Canada Goose * Sweden * April **Canada Goose** * New York * September

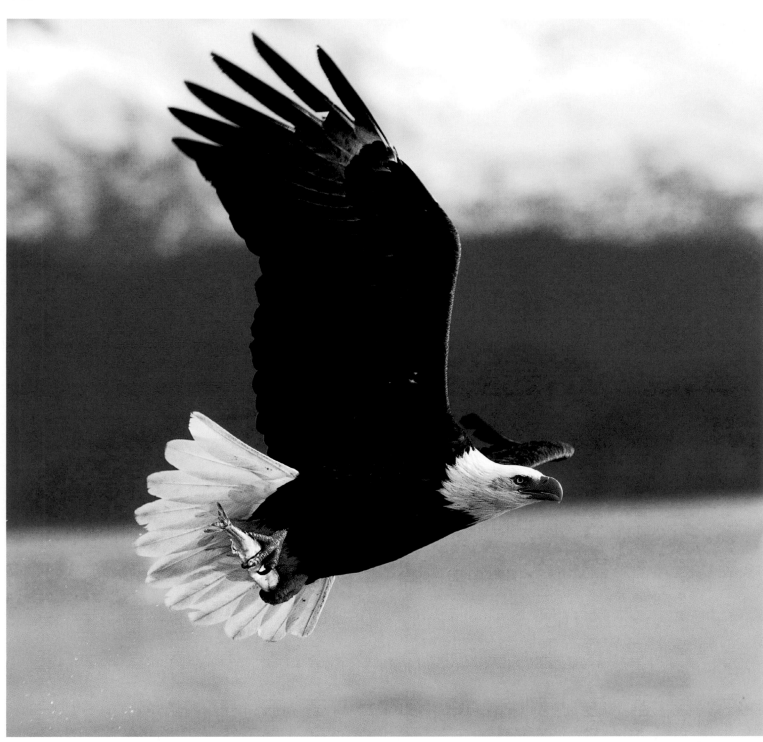

National emblem. With its majestic physique and brilliant hunting technique, it is easy to see why the Bald Eagle has inspired such admiration that it was adopted as America's national emblem. However, admiration alone has not been enough to protect the bird. During the first half of the twentieth century, Bald Eagles in Alaska had a price on their head, and as many as 150,000 birds may have been killed during this period. In the 1960s and 1970s, the species suffered from poisoning by DDT and other pesticides, and numbers fell markedly in many of the southern states. The trend is now turning and the Bald Eagle is returning in many places, but the total population of this endangered species is still no more than 150,000 individuals.

Bald Eagle ∗ Alaska ∗ January

Inquisitive. Some birds are not only not tame but downright pushy. One example is the Striated Caracara of the Falkland Islands, once persecuted by local farmers but now protected. The juveniles in particular are extremely forward, and the species is so notorious among local people that they have christened it "Johnny Rook."

If you take a nap on the ground, you might wake up with Johnny Rook sitting on your right foot. If you are careless enough to leave your bag open, you can count on one turning up and robbing you of something. Not only do these birds steal food, but they have also been seen hopping off with camera lenses and other useful items in their bill.

Striated Caracara (juvenile) ∗ Falkland Islands ∗ December

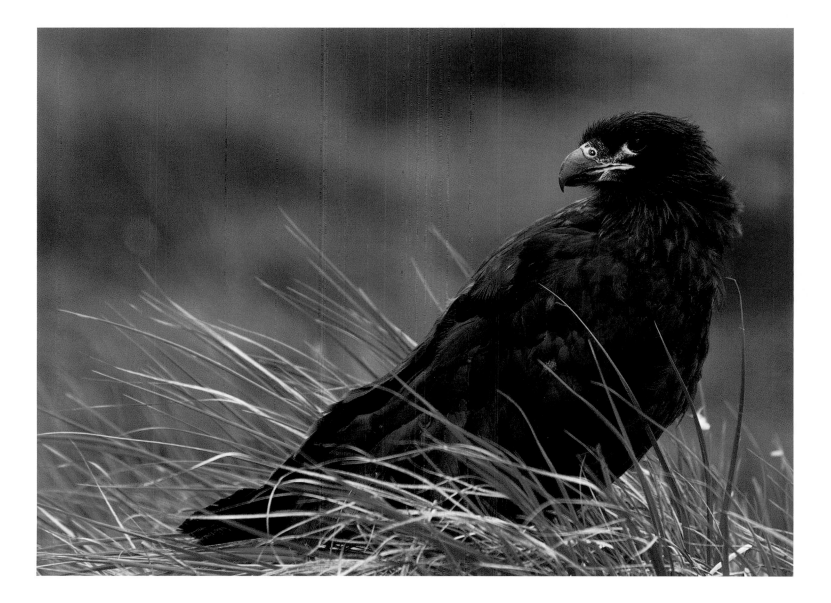

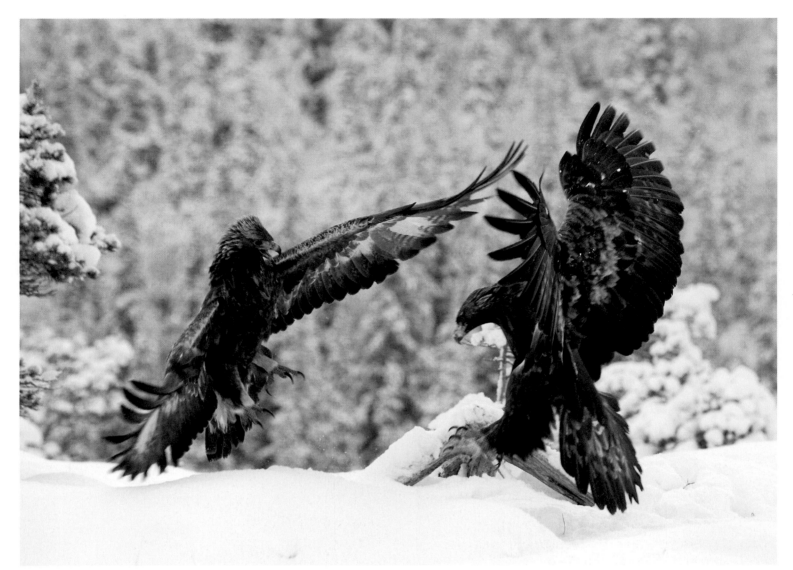

If the persecution ends. The Golden Eagle ranges over most of the northern hemisphere, and as such it is the most widely distributed of all eagles. In many ways it is also the archetypal eagle—agile, fast, strong, and more athletic than most, with long wings, a long tail, and a very heavy build. Not surprisingly, it is called the golden, royal, or rock eagle in most languages.

Golden Eagles are currently found mostly in mountainous and wilderness areas. This is not because lowland or farmland prey does not suit them, but because they have withdrawn to these marginal regions after centuries of human persecution. This situation has now changed in many places, however, and recent experience has shown that if left in peace, even this king of the wild will settle down in a populated, farmed valley.

Golden Eagle ⋆ Finland ⋆ February

Housing shortage. The Black Woodpecker's nesting hole is large, and after some time the trunk will be severely weakened. Once this has happened, blizzards in the fall will sooner or later snap the tree in half at the level of the woodpecker's entrance. Does this mean that it is ruined forever? Not at all! The stumps will soon be colonized by such species as the Ural Owl, which favors just such a deep, sheltered indentation.

A healthy Black Woodpecker population is thus a precondition for maintaining healthy populations of many other forest bird species across Europe. As ever, there is a snag to this in the form of man: Modern forestry is so efficient that many stumps and other woodpecker trees are being felled. As a result, the low availability of nesting holes has now become acute in the forests. Luckily, not only small birds appreciate manmade nests in the form of nesting boxes—the Ural Owl is happy to settle down in one too.

Ural Owl (juvenile) ⋆ Sweden ⋆ June

Breeding

IN MANY PARTS of the world, birds coming together for the breeding season make a significant impact on the landscape. In the Arctic and Antarctic regions, for example, the contrast between winter and spring is striking, as previously deserted coastlines suddenly teem with thousands of birds.

Our own perception of the intensity of spring is largely due to the activities of returning migrant birds and their lively song. When *Silent Spring* was published in 1962, Rachel Carson was right to sound the alarm about declining bird numbers, and this still holds true, but anyone thinking that spring really is silent should take a walk in the woods on a May morning. At such times the birdsong is deafening, so loud that it is almost comical, with chaffinches, flycatchers, willow warblers, and chickadees never tiring of trying to outdo one another. All the while, males are fighting or offering suitable nesting places to females, the females themselves are flying back and forth with sticks for the nest, and all are mating—there is constant activity everywhere.

Breeding is a very energy-consuming affair, which is why it is extremely important for birds to find the partner that suits them best and is most likely to contribute to a successful result both in terms of genetic material and work effort. It is especially strenuous for the female. Just producing eggs is so energy-depleting that female Spotted Redshanks, Dotterels, and phalaropes have no energy left for anything else—it is all left to the males.

It is important for the females to find out what kind of bird the potential partner is: who is he; what does he want; and what is he able to contribute? To impress females, male Barn Swallows use their elongated tail streamers. These cost a lot of energy to produce and to look after, and they certainly make the journey to South Africa and back more strenuous (which is why young Barn Swallows have much shorter tail streamers). As a result, only healthy, strong males are able to wear this distinguishing mark. The longer the tail streamers are, the more popular the male is on the mating market, because they are proof of his fitness and condition.

In many species both partners contribute to the rearing of offspring. A female Chinstrap Penguin, for example, must be able to rely on her partner to play his part during incubation. Without his cooperation it would be impossible to raise two fluffy chicks in the harsh Antarctic climate.

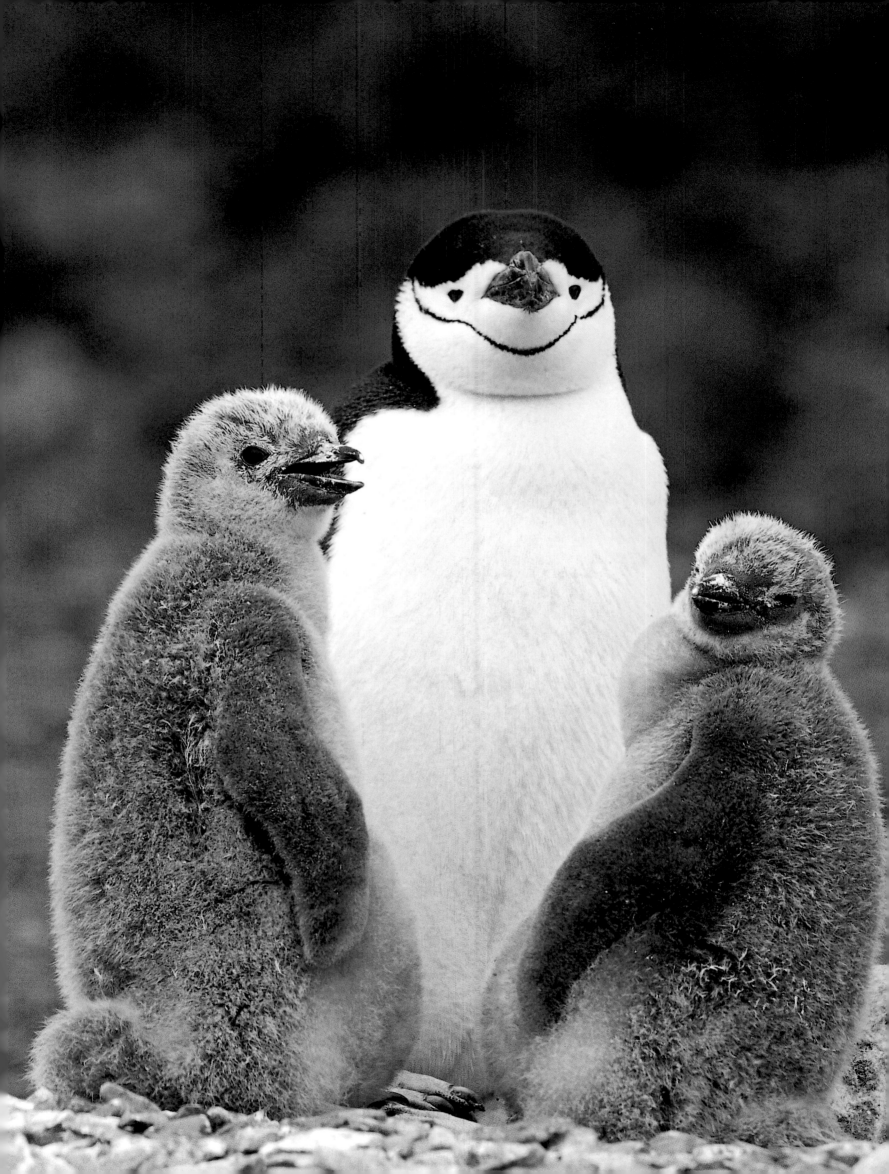

Signal. Many birds signal their availability and suitability for breeding by changing into their display plumage. In the Great White Egret, the lore, or naked tissue between the bill and the eye, is normally a pale greenish yellow. However, just before the breeding season it acquires a very different, bright pastel green luster. This fresh green hue signals the bird's good health as well as a boundless willingness to mate.

Great White Egret ⋆ Florida ⋆ April

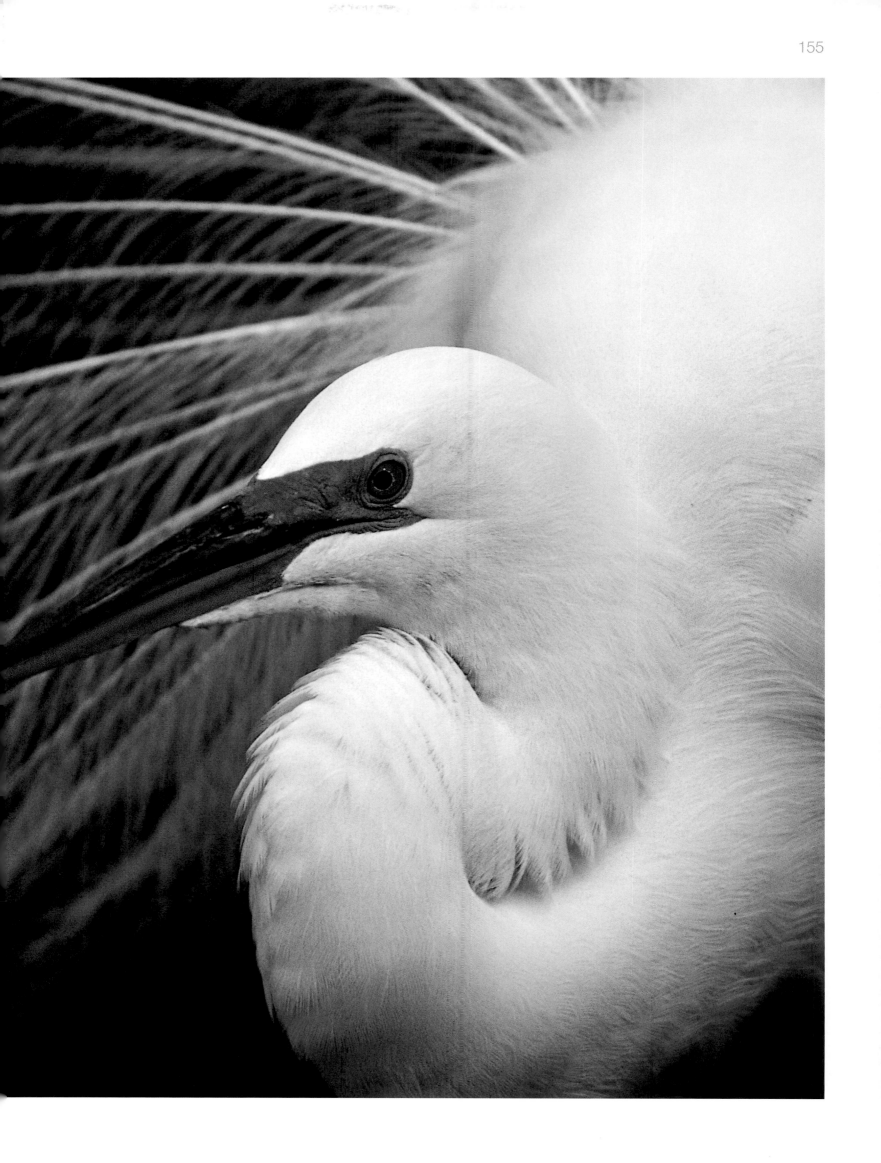

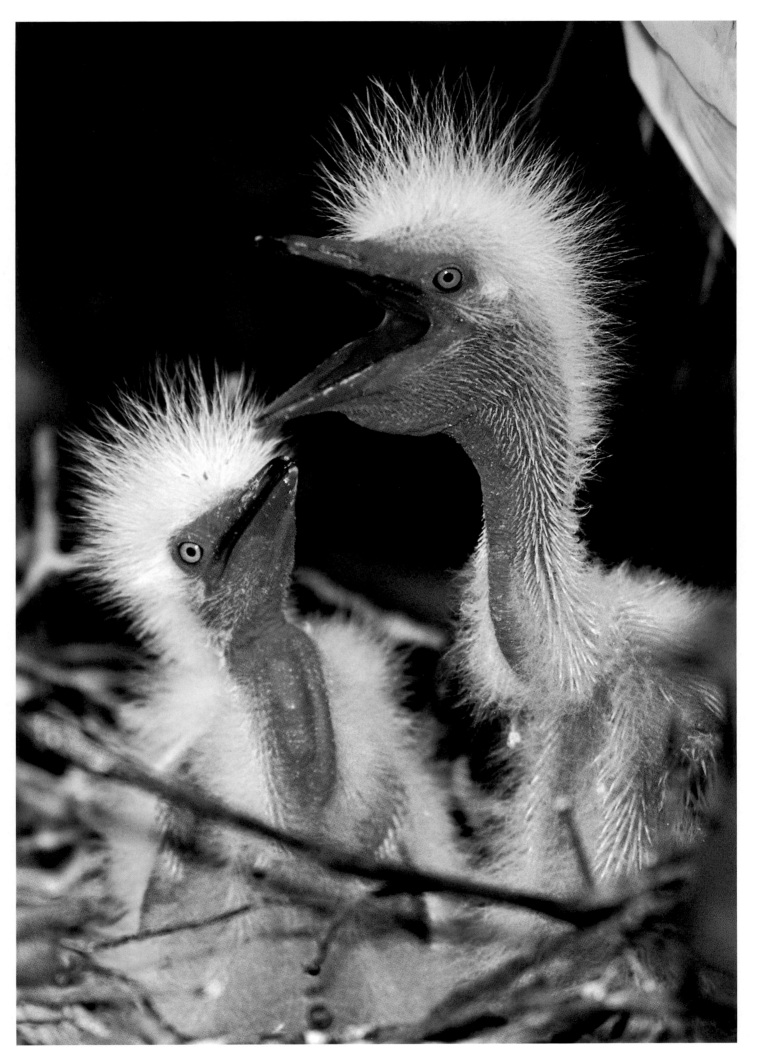

The result. We are so used to birds and other animals producing offspring we tend to take it for granted. But many things must tally before it can happen: two birds need to agree on a nesting place; build a nest; mate when the female (and the male) is fertile; lay eggs; incubate them with great care; and then feed the chicks. All this goes on without the aid of verbal communication and such questions as "Who is picking the kids up today?" and "Was it 4:15 or 4:30?"

Great White Egret (juveniles) ∗ Florida ∗ April

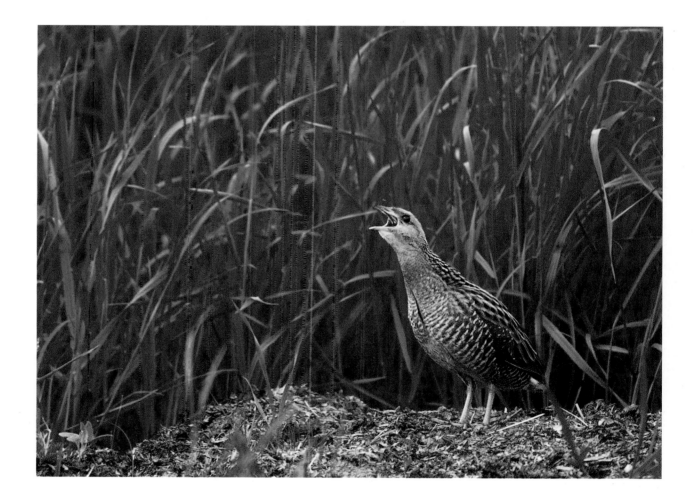

Advertising. Many birds sing melodiously or in some other way that is special. This is not to please us humans, but has a more practical function: attracting a female and claiming territory. The female determines a male's general suitability as a husband and father from his song, the qualities of which differ in importance depending on the species. The Corncrake's song, for example, is a simple two-syllable croaking that sounds throughout summer nights, and is distinguished by its volume and the stamina of the vocalist rather than style.

Corncrake ∗ Finland ∗ June

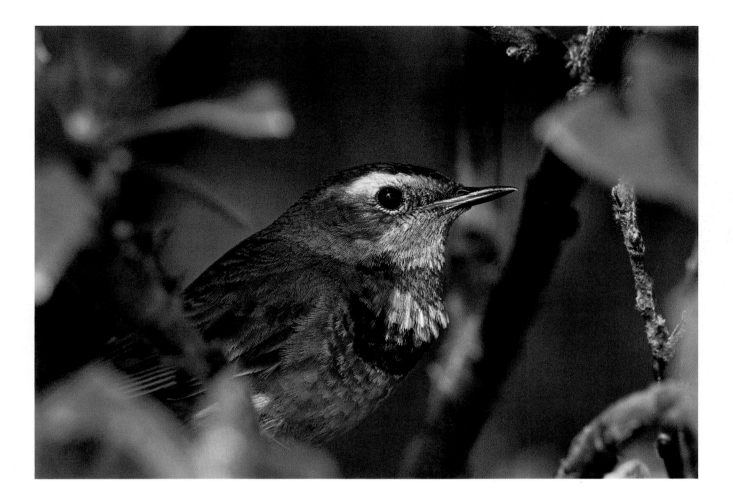

A master. Among the warblers there is a special elite unit of singers, including species such as the Icterine Warbler and the Marsh Warbler. Bluethroats also number in this group, with their varied, complex, and very melodious song, sometimes copying other species. Its varied and creative song distinguishes a successful Bluethroat—just performing the standard repertoire is not enough, and only a true innovator will attract a female.

Bluethroat ⋆ Sweden ⋆ June

Testosterone. Male birds are usually more colorful and ornate than the females. This is governed by testosterone, which is normally a male hormone. Among the phalaropes, however, the females are more colorful and more active in claiming territory and initiating mating. This reverse process occurs because the females have high levels of testosterone—so much, in fact, that when they begin to fight the males prefer to disappear into the undergrowth.

Red-necked Phalarope (female) ⋆ Norway ⋆ July

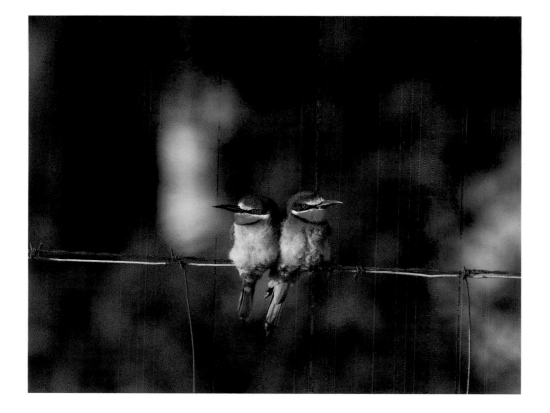

Helpers. Some species have helpers, which are often unrelated birds that assist nesting pairs in bringing up their young. For example, a helper assists 20 percent of nesting bee-eaters. But why is this?

Birds probably study the behavior of their own species, and it seems likely that a helper is simply showing off, thereby increasing its likelihood of winning a partner in the future. Helpers are most common in species that breed in colonies, where they have the greatest chance of being observed.

Bee-eaters * Spain * March

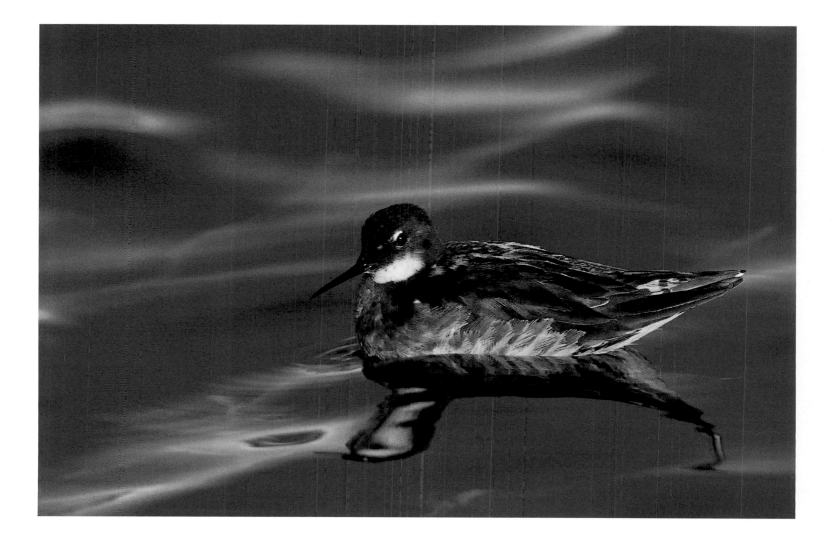

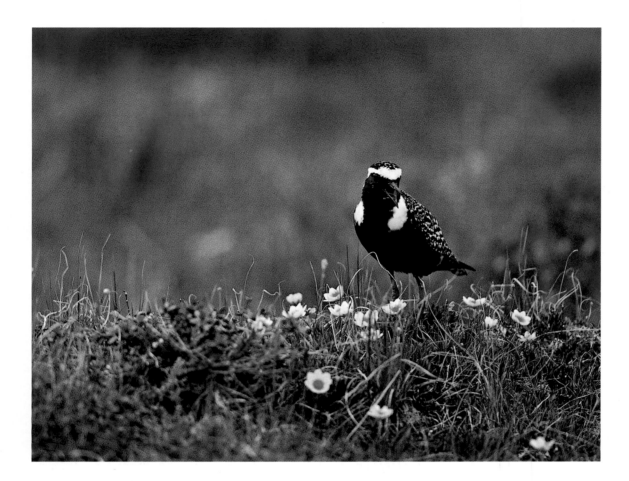

Free from crows. Waders leave their nests exposed on the ground and trust that the mottled camouflage pattern of the eggs will prevent detection. This also applies to other ground-nesting birds, although there are many examples of alternative strategies: Some birds cover their eggs with down or vegetation when leaving the nest unattended, while others build their nests under a tuft of grass or a bush.

Anyone who has walked in the Scandinavian fjelds or across the tundra of Siberia or Canada may have noticed that it is much easier to spot birds' nests there than on open ground further south. But why are the nests in temperate areas much better hidden than those in the tundra? The reason must be crows.

Crows are numerous, are always around, and will eat just about anything. They prey on chicks and eggs, but cannot live on this diet alone. In order to breed successfully on the tundra, crows would need to start their breeding season in good enough time for their chicks to hatch just as the waders lay their eggs. But around the time of the year that they would have to begin laying their eggs there is hardly anything for the crows to eat. This means crows can't breed, so the tundra is free from crows during the waders' breeding season.

American Golden Plover ∗ Manitoba, Canada ∗ June

American Golden Plover eggs ∗ Manitoba, Canada ∗ June

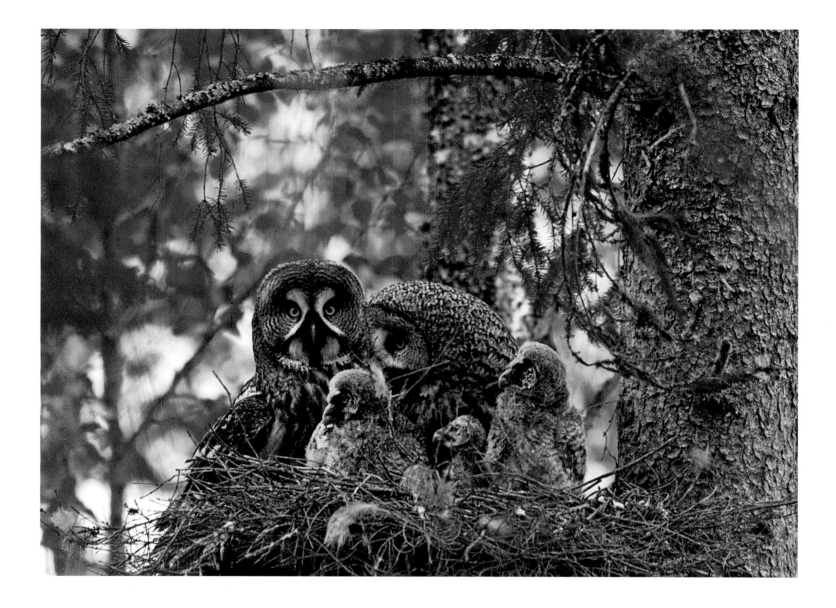

One after the other. Many female birds lay all their eggs before they begin incubation. In species where the chicks leave the nest immediately after hatching, such as ducks, it is especially important that all the chicks hatch at the same time.

Owls and raptors do things the other way around. Instead, they start incubation as soon as they have laid the first egg in order to make sure that the chicks will be of different sizes. The point is to create an unequal brood where one chick is the strongest and another weakest. The biggest chick is the dominant and feeds first, and so it continues down to the last chick. If the female has got it right and laid an optimal number of eggs, there will be enough food for all her chicks and all of them will live until they fledge. However, if there is not enough food to feed the whole brood, one or all of the weakest will die while one or several of the oldest will make it. This may seem cruel, but it would be just as cruel if the parents divided the scarce food fairly so that all the chicks starved to death. "Unfair is fair" sounds like a quote from *Animal Farm*, but it is the harsh reality of life in the wild. Nature does not ask what is cruel or fair, only what is practical.

Great Gray Owl ⋆ Sweden ⋆ June

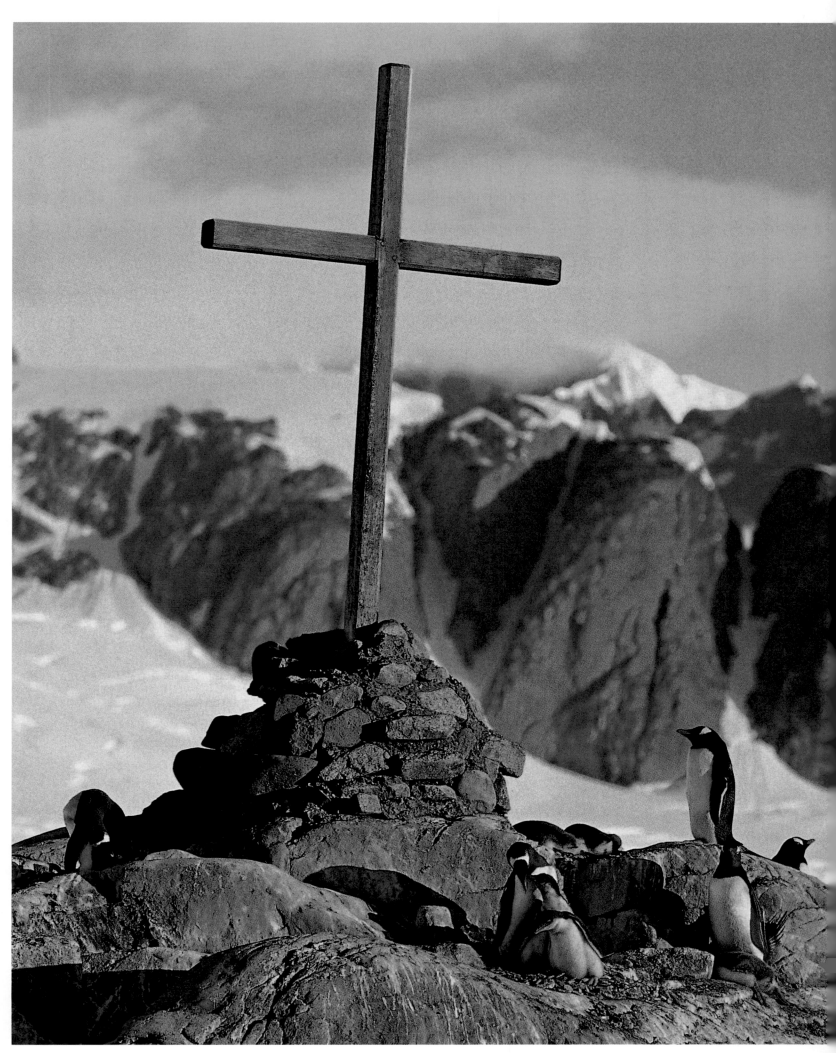

Warmer. In Antarctica, grass is spreading to areas that used to be covered in snow and ice. While this may be of some use to golfers, it is disconcerting news for environmentalists and is yet another sign of global warming caused by car exhaust fumes, fossil fuel emissions, and other ill effects of modern energy consumption. There used to be only very small patches of grass in Antarctica in the summer, but now it survives the winter and spreads during the warmer months. It has not been this warm on the continent for 10,000 years. Species that live here, like the Gentoo Penguin, are extremely specialized, and so any changes in their breeding environment constitute a serious threat to their survival.

Gentoo Penguins ∗ Antarctica ∗ January

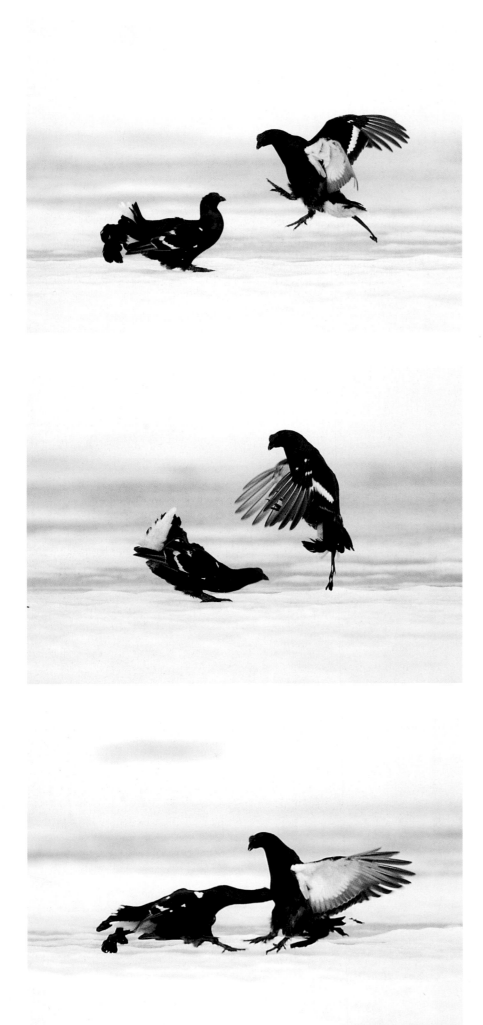

Big and strong. The only male attribute that impresses a Black Grouse hen is raw strength. But why are the females so interested in ensuring that the fathers of their offspring are the biggest and strongest cock birds? After all, they are never there to defend or protect the young, which are brought up by the hen alone.

The answer is that if a grouse cock is big and strong, the hen might expect him to be in all-round peak condition. Such a bird will have no disabilities, a good immune system, a high resistance to hunger and cold, and a keen level of alertness. By choosing such a mate the hen is simply making sure that her offspring will inherit the best possible qualities.

Black Grouse * border between Russia and Finland * April

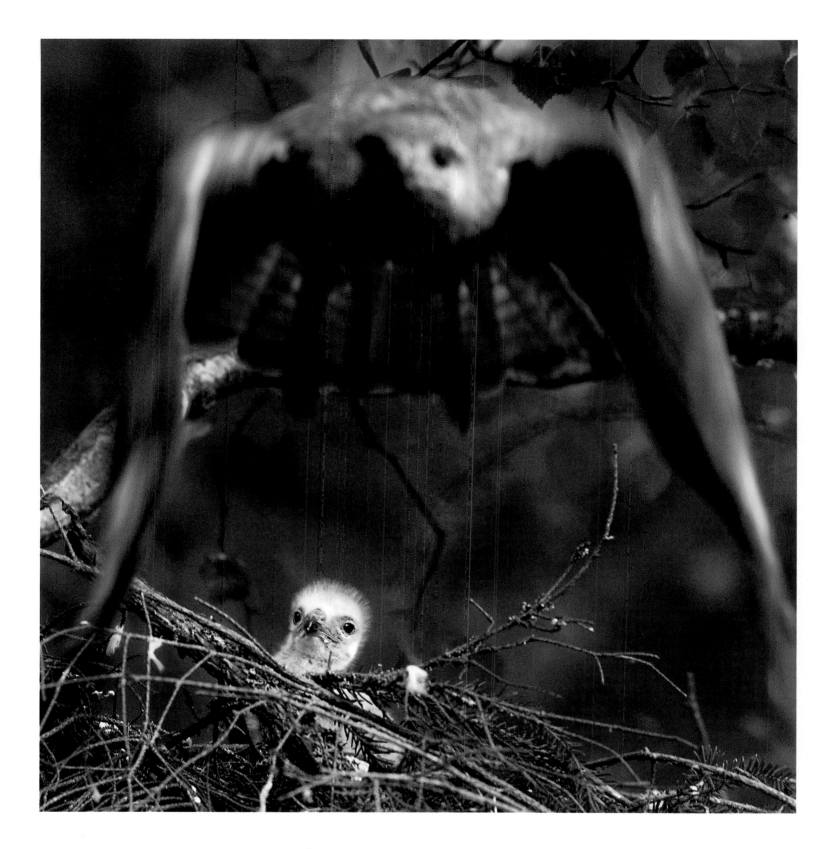

Staying in the nest. The newly hatched offspring of passerines, raptors, and many other birds are naked and helpless, requiring constant care in the form of warmth, shelter, and food during the period they spend in the nest. Almost the only functions that are activated in these altricial chicks are mouth gaping and the digestive system. The young birds will not abandon the nest until they are ready to fly. Because bringing up a brood is such a daunting task, the parents normally help each other. The Buzzard chick is giving its mother a long look as she leaves the nest, and can only sit and wait for the next delicacy to appear.

Buzzard ∗ Finland ∗ June

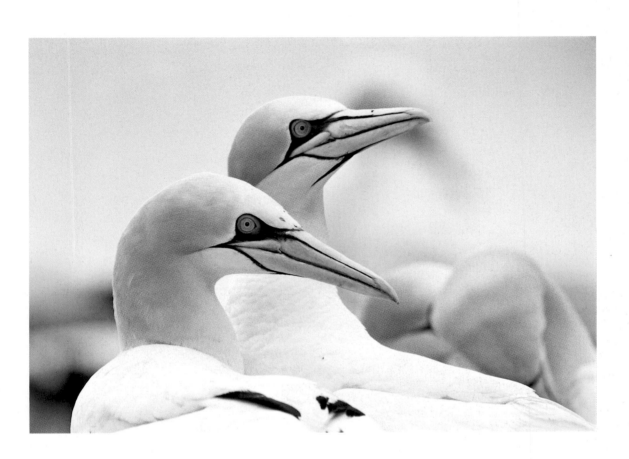

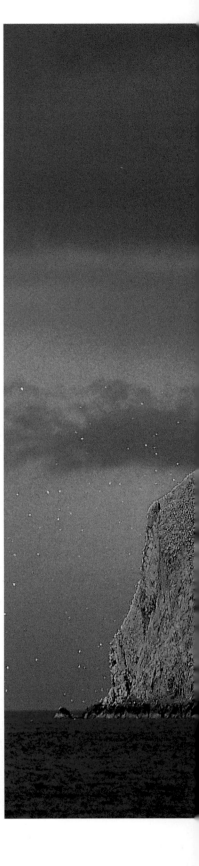

One egg. The Northern Gannet lays only one egg. Why is this? Doesn't it need to lay more to ensure maximum survival rates? In fact, each species and each individual female will produce only as many eggs as she can cope with. The aim of a gannet pair is to bring up one offspring every year, the idea being that after 10 years there are 10 living adult offspring. If they should try to produce two eggs, they would end up with fewer living offspring because there would not be enough food to feed both. Some of the young would starve to death while others would be weakened and fall prey to disease or predators.

Breeding is hard work, and it may also be that the recuperation time after laying two eggs is too short, so that in the next season the female lays her egg later than normal and the young don't have enough time to finish developing before the onset of winter. So by laying just one egg, the Northern Gannet is indeed ensuring maximum survival rates of her offspring.

Northern Gannet ∗ Bass Rock, Scotland ∗ July

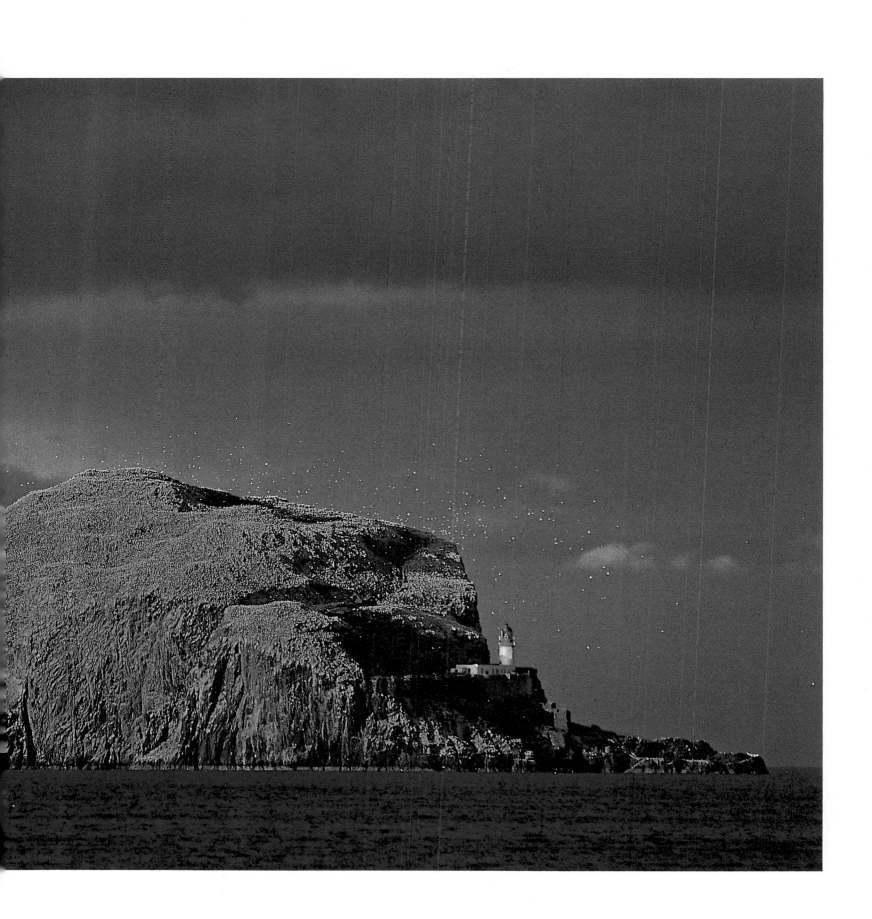

Overleaf. **The voice.** Young brown penguins wander around the colony together in gangs. So how can parents and chicks find each other among the thousand or so birds? The answer is that they use their voices. Penguins are conditioned to the sound of their parents' voices right from the time they are inside the egg.

King Penguins * South Georgia * December

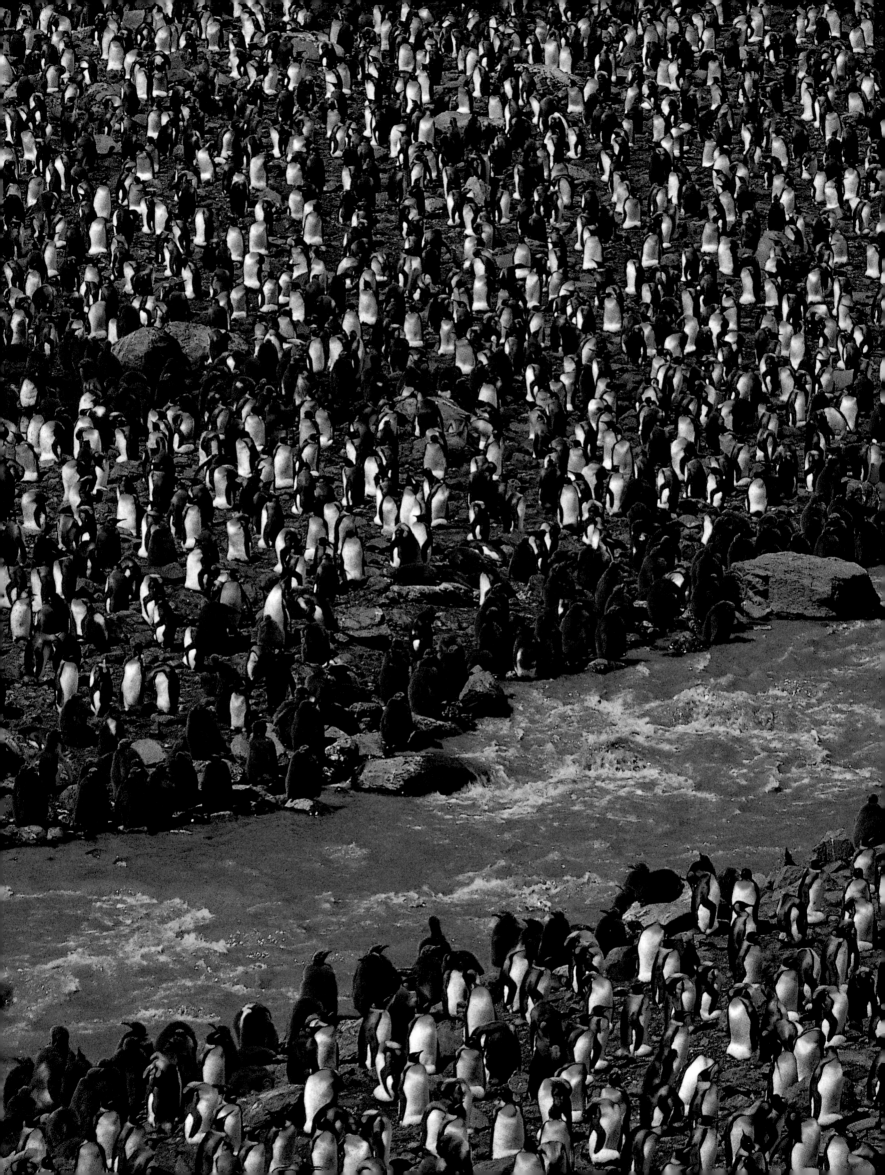

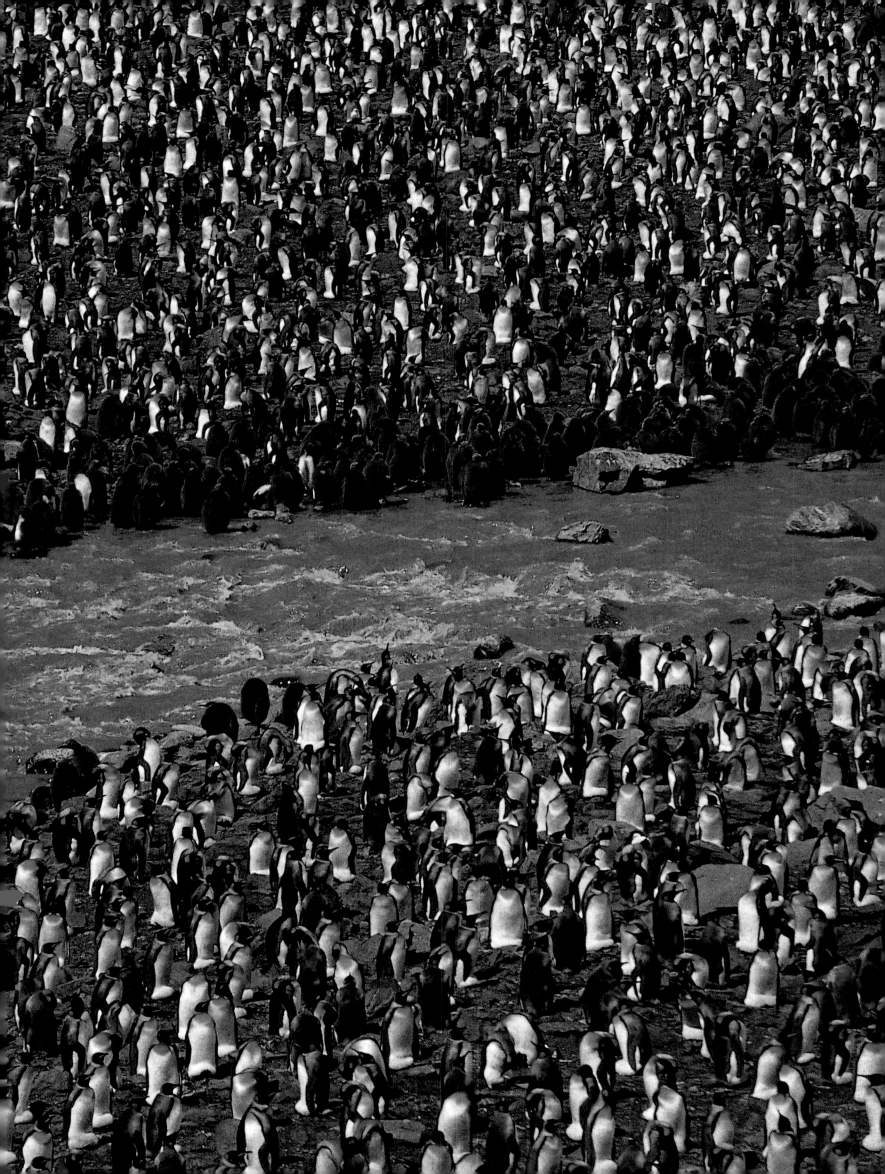

Signaling system. In order for birds to succeed in the complex process of breeding, a detailed signaling system is needed. The male and female must be able to understand each other's intentions and trust each other. The male Great Blue Heron performs a number of ceremonies. He stretches, clatters his bill, and offers a branch to the female. New ways to propose marriage may work for humans, but they are of no interest to birds. On the contrary, it is essential that the mating routine is followed precisely; if not, the female will not accept the male.

Great Blue Heron * Florida * November

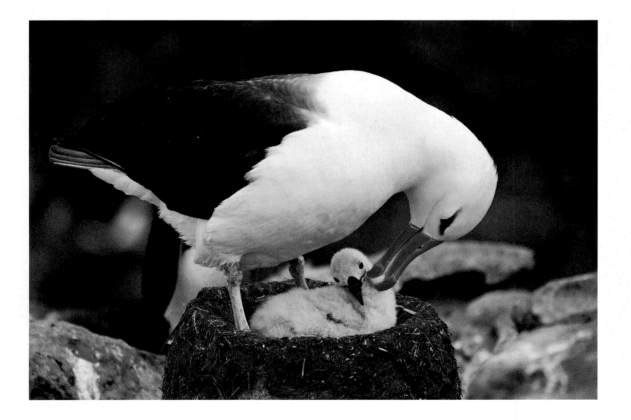

Hard chore. Albatrosses and other related pelagic birds lay only one egg. They often breed in regions with a very harsh climate and fly enormous distances to look for food before they return to the nest to feed their young. The egg of the Black-browed Albatross is incubated for more than two months, and the chick, which is a big baby, is fed for another four months. It is therefore easy to see why breeding is a strenuous affair for this species, and that raising two chicks at the same time would simply be too much. Breeding is even skipped altogether in some years—a clear sign that it can be a hard chore.

Black-browed Albatross * Falkland Islands * December

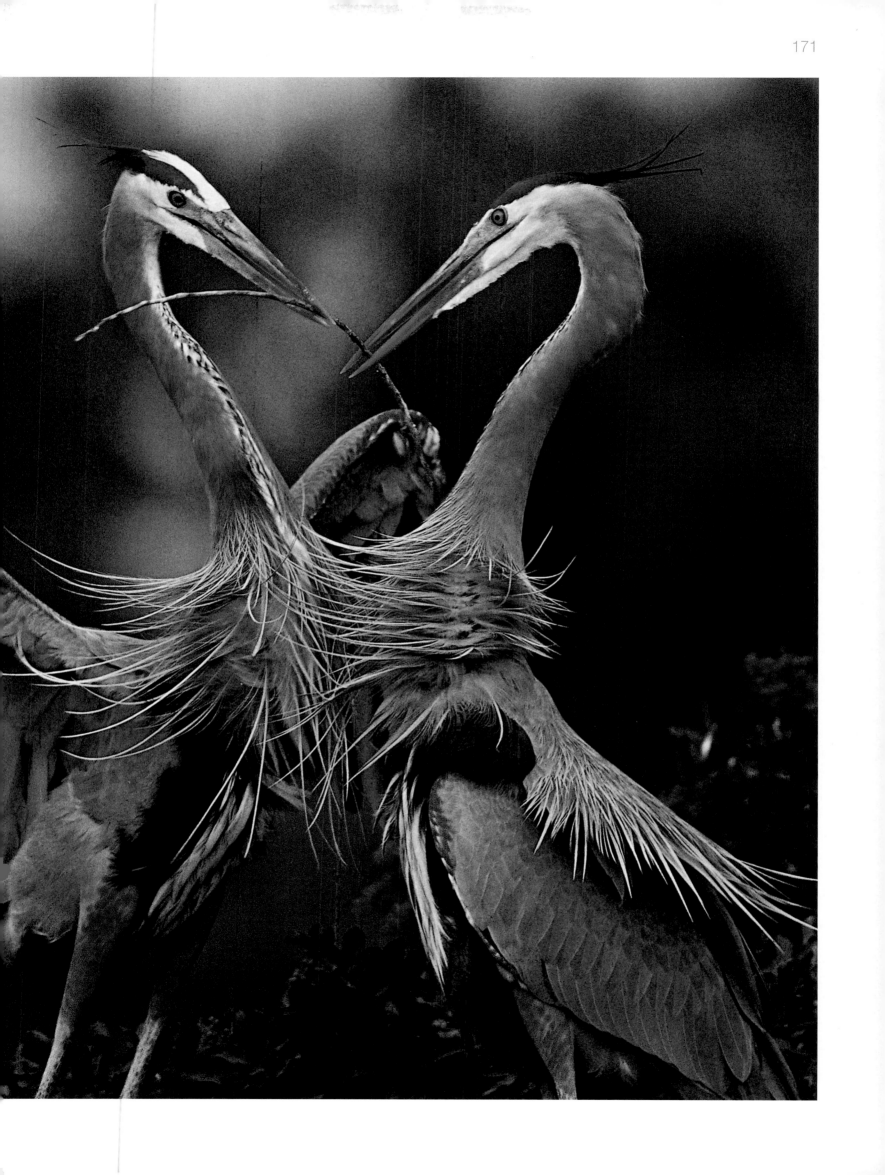

Migration and Distribution

BIRDS ARE GENERALLY defined by their ability to fly, and flying is the very basis of bird migration. Many animals migrate, but not to the same far-reaching extent as birds. Flying is not, however, as energy-efficient a means of travel as swimming, although it does come a close second. The reason why birds migrate more often than fish is that birds have colonized breeding grounds where it is impossible for them to overwinter. Fish seldom experience the vast climate differences that birds do during the course of a year, and can live in the same place in summer as well as in winter.

Flying is thus intimately associated with the wide distribution of birds. Snow Buntings and Sanderlings, which breed further north than any other bird, would never appear in Cape Morris Jesup in northern Greenland unless they were able to leave again once the dark season and cold weather arrive. The remarkable Gray Gull would not breed in the extremely dry and lifeless Atacama Desert of Chile unless it could fly out to the coast to feed every day. Similarly, the sandgrouse would not have colonized Dasht-e-Kavir in Iran, Rub' al Khali in the Arabian Peninsula, or the many other deserts where it is found if it were unable to fly many miles every day to its traditional watering holes.

Flying and migration also enable birds to colonize new breeding grounds quickly. When suitable habitats suddenly appeared in 1961 on the Dutch polders in conjunction with reclamation of the North Sea, for example, several Dotterel pairs immediately bred there, despite the fact that the area is a long way from their normal breeding grounds. They continued to return until 1969, when the area no longer met their needs.

Similarly, habitat restoration at Lake Hornborgasjön, Sweden, led to a return of Black-necked Grebe, such that they increased from five pairs during the 1980s to a record 107 pairs in 1997.

Hordes of migrating birds pass over land each year, and as suitable new breeding grounds or stopover sites become available they soon discover them. In this way they are able to increase or consolidate their distribution. The Great White Egret breeds in North America, South America, Europe, Africa, Asia, and Australia, a vast area that it has been able to colonize only through its ability to fly.

The flight of birds is nothing short of a miracle. How else would you describe the Whooper Swan's traverse of the skies at an altitude of 25,000ft (8,000m), where temperatures are −40°F (−40°C) and the extremely thin air contains only one-third of the oxygen found at sea level? Or the North American wood-warblers that migrate across the western Atlantic from Nova Scotia in Canada to Guyana on the northern coast of South America in an uninterrupted flight of three to four days? And what about the three-month-old Wheatear, which migrates alone nonstop across the Atlantic from Greenland to Morocco, not only carrying enough fuel for the 2,500-mile (4,000km) flight, but also able to find exactly the right landing place without getting lost?

On April 8, 1996, some 287,000 eiders flew in black and white streaks past Kåseberga in southern Sweden on their way to their breeding grounds around the Baltic. Although this wasn't perhaps a miracle, it was a fantastic display nonetheless.

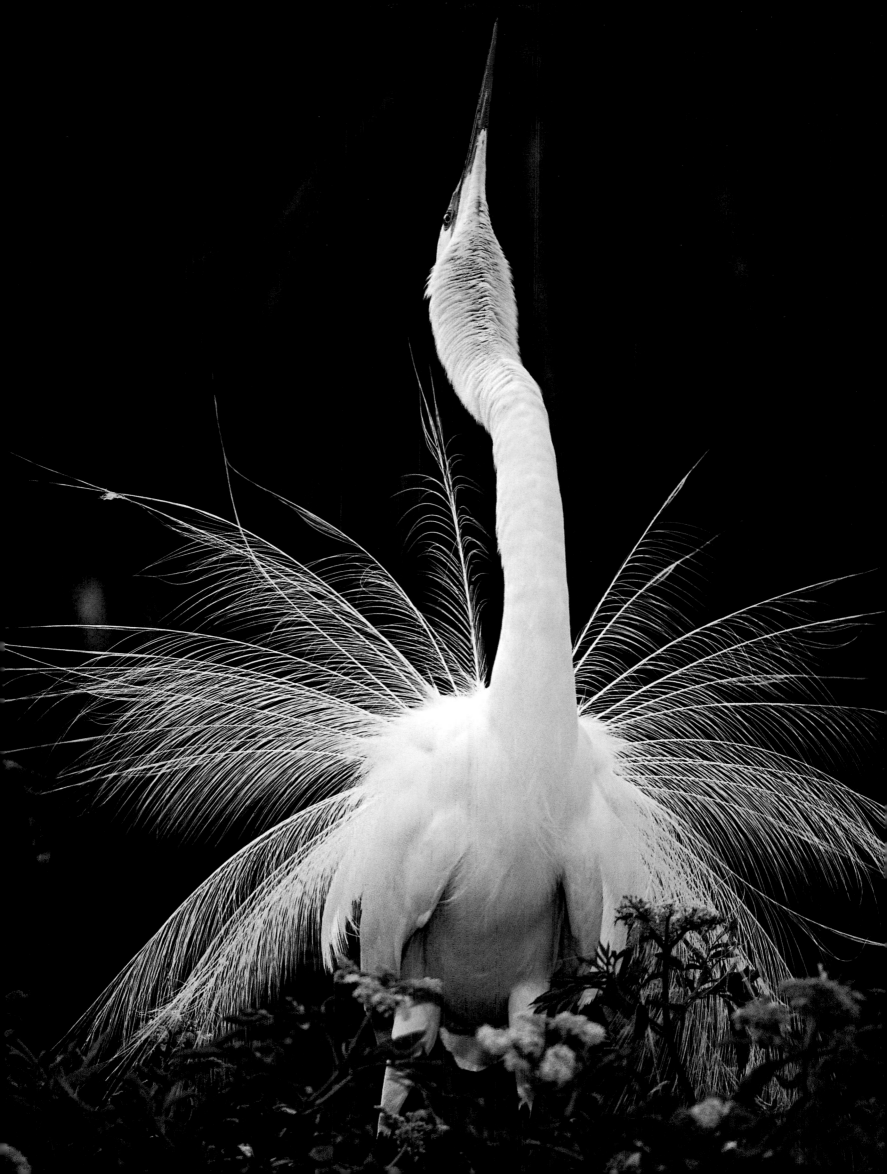

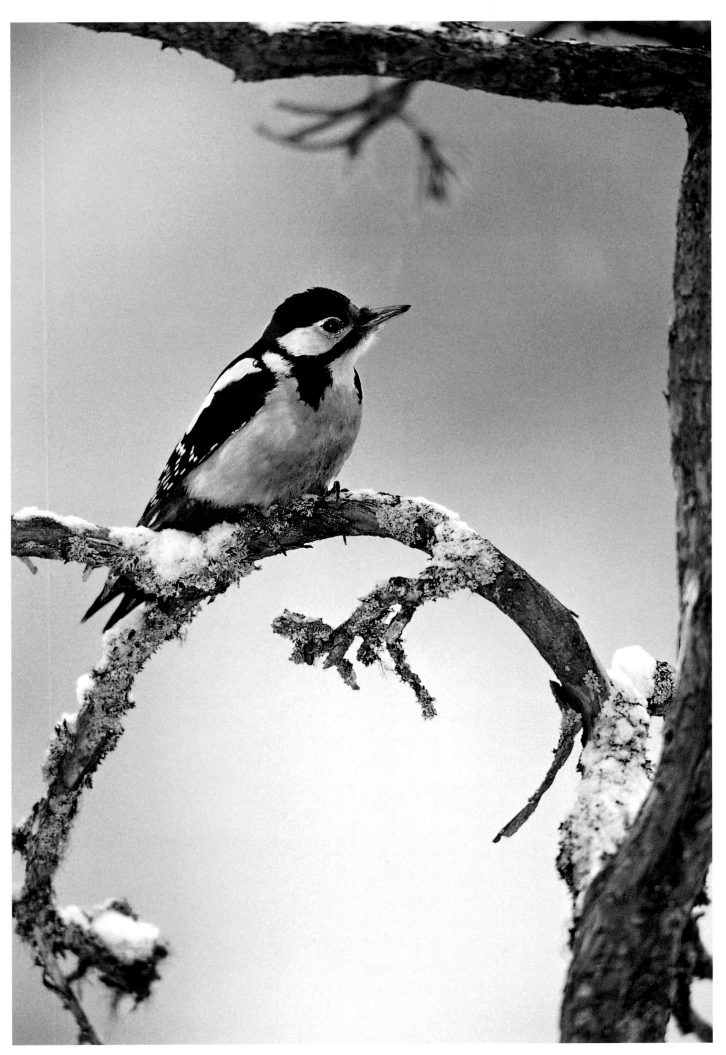

Invasion. Most bird species have regular migration habits, but there is a small group that performs invasion-like migrations. In the fall of some years they remain resident while in others they migrate to a greater or lesser extent depending on food availability. The Great Spotted Woodpecker's staple food during the winter is pine and, especially, spruce seed. The supply of cones varies from year to year and the woodpecker risks starvation when there is a shortage. Consequently, the birds move south in some years while in others they do not migrate at all.

Great Spotted Woodpecker ∗ Finland ∗ March

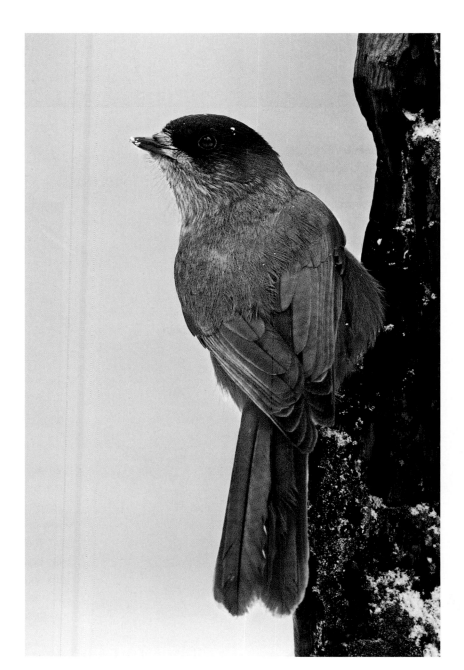

We refuse to move. The Siberian Jay employs one of the most interesting of the various migration strategies: it does not migrate at all. This species lives in the northern coniferous forests, where winters are harsh and the snow lies thick on the ground. How can this be more appealing than a few months in the Congo basin? The answer is hoarding.

During the fall, the Siberian Jay hides away anything it can find: seeds, berries, and other plant material. This intrepid bird is perhaps man's best friend in the forest, and few can resist the temptation to share their food with it, so that bits of cheese, meatballs, and sausage find their way to its stores. It can keep track of some 5,000 hiding places scattered around its territory, so survives quite happily through a strategy of stockpiling.

Siberian Jay ∗ Finland ∗ February

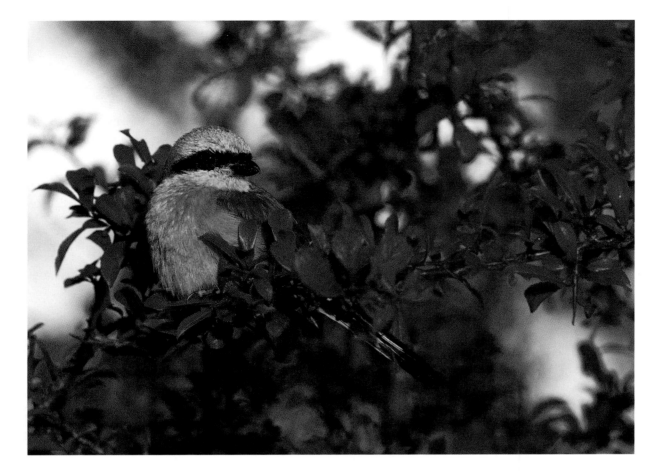

Southeast. While most migrating European birds head southwest, there is a group that complicates things by moving southeast. Though members of this somewhat small, exclusive group breed in most parts of Europe, they mainly spend the winter in East Africa.

The Red-backed Shrike is one such southeast migrant. It can be found throughout most of Europe south to northern Spain, but these birds all migrate via the Balkans as they cross the Mediterranean to their wintering areas south of the Equator.

Red-backed Shrike * Sweden * June

Winter guests from the south. Even the youngest child knows that many of our birds migrate south during the winter. But winter arrives in the southern hemisphere too—during our summer—so why don't tropical swallows fly north for their winter?

The Lesser Striped Swallow's breeding grounds lie close to the Equator, ranging from Ethiopia in the north to South Africa in the south. This means that the winter here is mild and the air full of insects, so there is no reason for the birds to set out on a long, dangerous journey northward to Europe.

Lesser Striped Swallow * Tanzania * January

Nocturnal migrants. Most long-distance migrants, including passerines such as warblers, chats, and flycatchers, migrate during the night. This may have something to do with making the best of their time, allowing them to eat during the day and fly at night.

One special group is the waders, which usually migrate at night but sometimes fly during the day too. Many breed along the coast of the Arctic Ocean and overwinter in the tropics, so cover incredible distances on their journeys. Flying nonstop for several days at an altitude of 18,000ft (6,000m), where there is only half the oxygen found at sea level, would be dangerous to humans, but these amazing migrants do it with seemingly little effort. The Stilt Sandpiper is one such bird, breeding in the far north of Canada and overwintering 7,000 miles (12,000km) away south of the Equator in South America. It undertakes the journey twice a year—an incredible feat.

Stilt Sandpiper * Manitoba, Canada * June

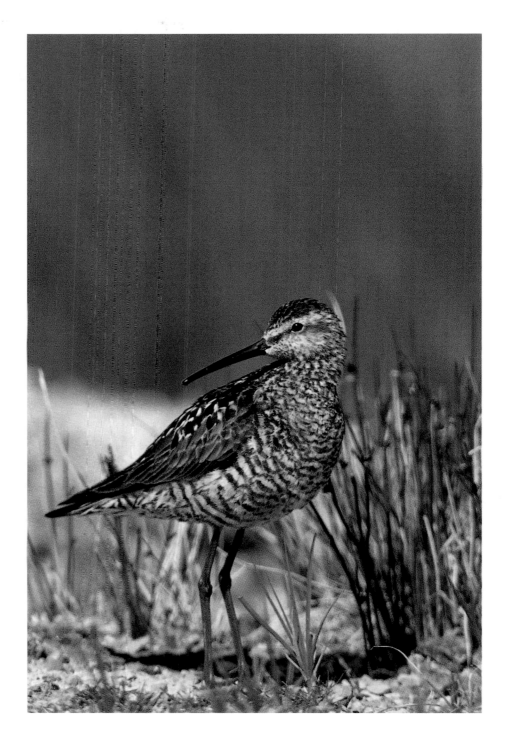

Overleaf. **Flocking.** Many species spend their entire lives in flocks. A good example is the Kittiwake, easily the world's most numerous gull. These birds breed in dense colonies of several thousand pairs on cramped cliffs around the North Sea, the North Atlantic, and the Arctic Ocean. Migration to wintering grounds is undertaken collectively in sparse or dense flight formations.

Kittiwakes * Iceland * July

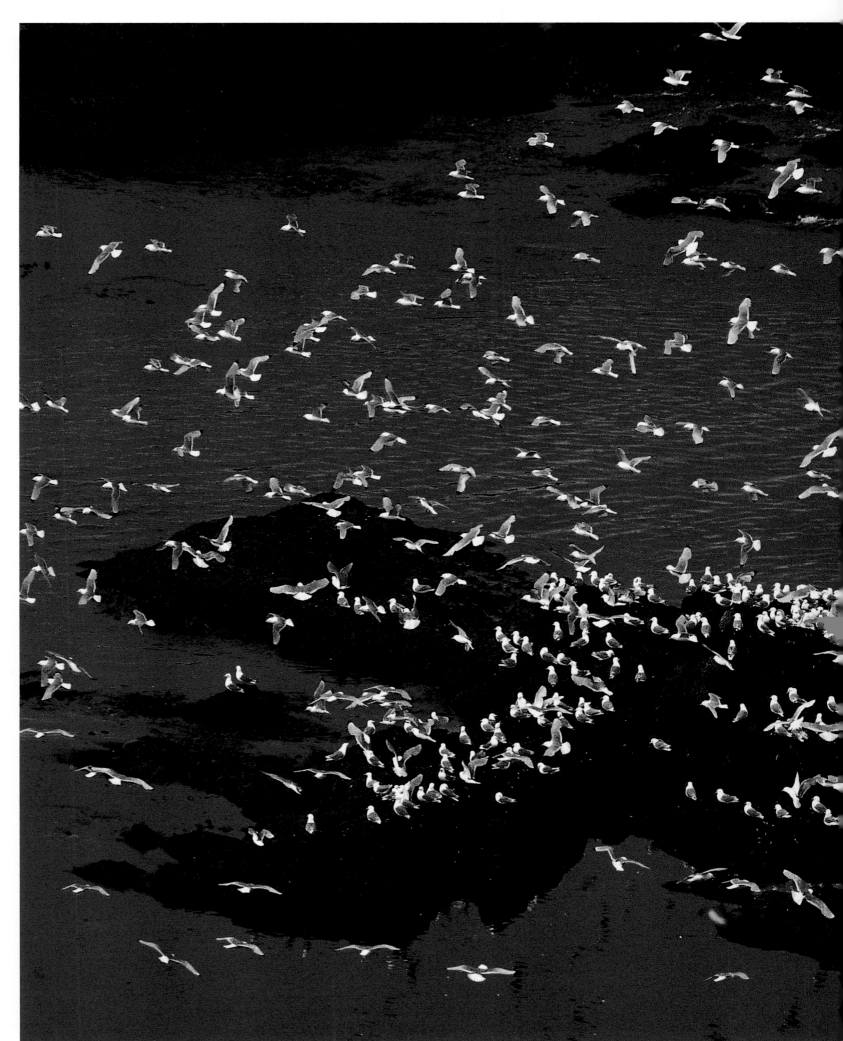

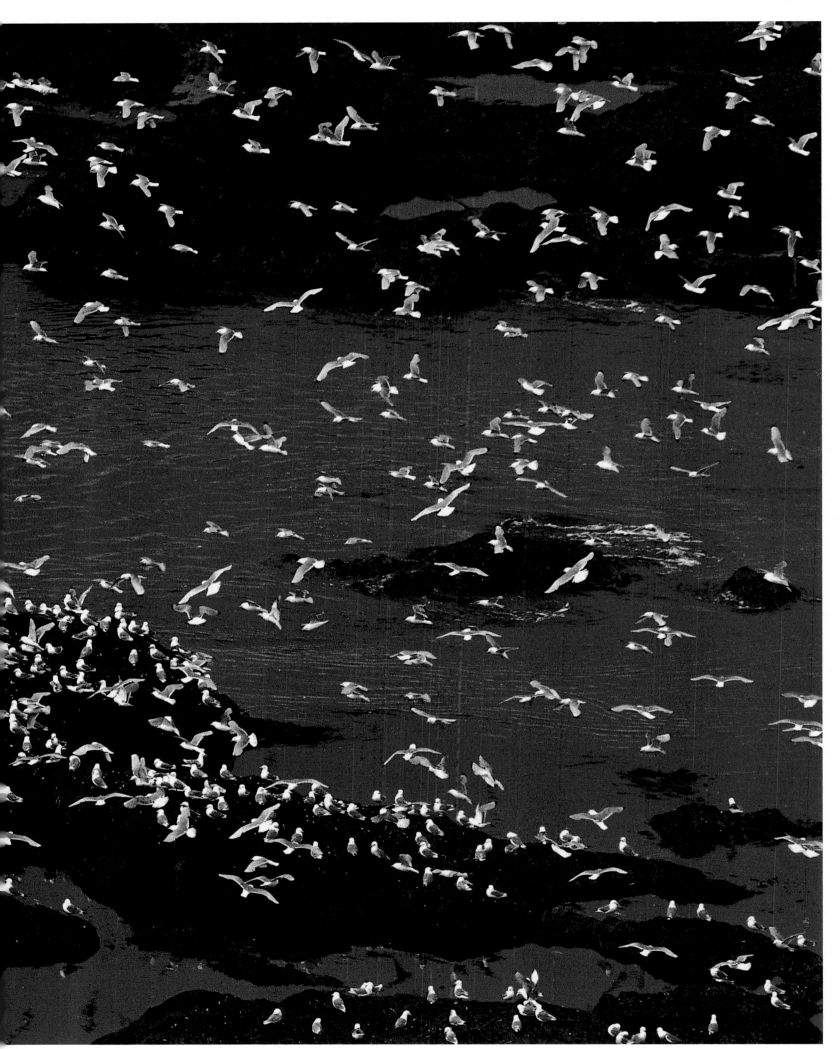

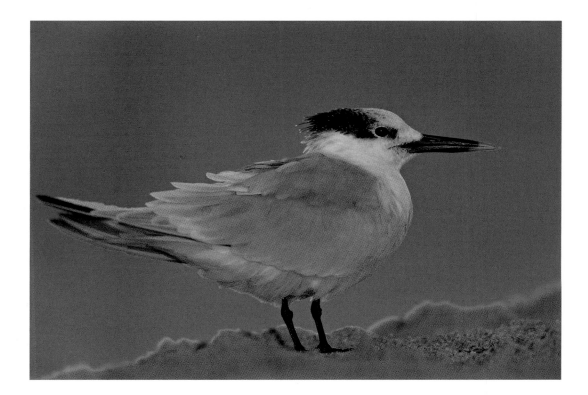

Tied to the coast. The Sandwich Tern is extremely attached to the coast the whole year round, and is so set in its ways that even birds breeding in the Baltic refuse to cross land. During their fall migration, these birds pass the southern part of Sweden, and continue through the Kattegat and around Skagen at the northern tip of Denmark, before following the west coast of Europe south to their winter areas between Mauritania and South Africa.

The Sandwich Tern would never condescend to wetting its feet along the shores of a swampy lake.

Sandwich Tern * Spain * March

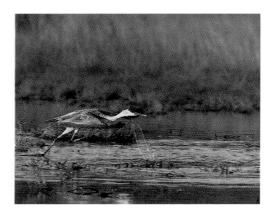
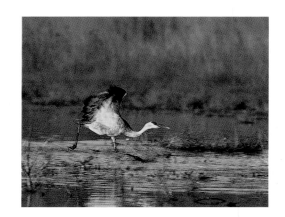
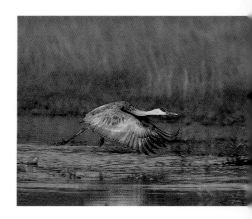

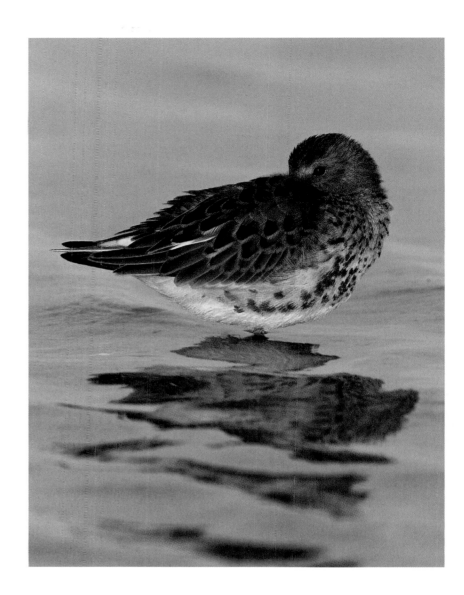

Circumpolar. Several northerly waders breed in the circumpolar region around the Arctic Ocean, including the Dunlin. This exceptionally wide breeding range means that the Dunlin is a common migrant along virtually all coasts in the northern hemisphere. It overwinters along most coasts from the Equator to 50°N in North America, which is on a level with Vancouver Island, and in Europe as far north as 58°N, level with the north of Scotland.

Dunlin ∗ Sweden ∗ September

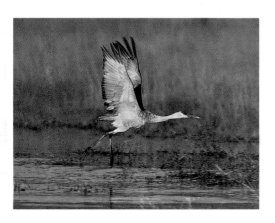

Diurnal migrant. Cranes migrate during the day, taking advantage of thermal air currents that are generated over ground warmed by the sun. Their wide wings are especially suitable for soaring on these thermals, but their shape, in conjunction with the size of the birds, makes takeoff rather difficult. The bird has to run on its long legs to gain momentum before it can lift into the air.

Sandhill Crane ∗ New Mexico ∗ November

Storm. The importance of wind and weather conditions to migration cannot be overestimated. An especially exciting occurrence takes place along the coast of Skagerrak and Kattegat, when pelagic species arrive in conjunction with westerly gales in the fall. These are birds that, outside the breeding season, stay out at sea, and include shearwaters, fulmars, storm petrels, and gannets.

Auks also belong to the group. The Atlantic Puffin will occasionally appear along Sweden's west coast during fall and winter storms in much harsher conditions than on a calm, sun-heated summer rock.

Atlantic Puffin * Iceland * July

Migrating on a broad front. The Redshank breeds all over Europe and winters in several locations in southern Europe, the Middle East, and Africa. Along its migration route it stops off at large or small wetlands along the coast as well as inland. This is why the species does not follow any specifically defined routes, but instead migrates on a broad front. If you were to follow its fall migration on a radar screen, you would see a large "blip" moving in a south-westerly direction across Europe.

Redshank * Sweden * June

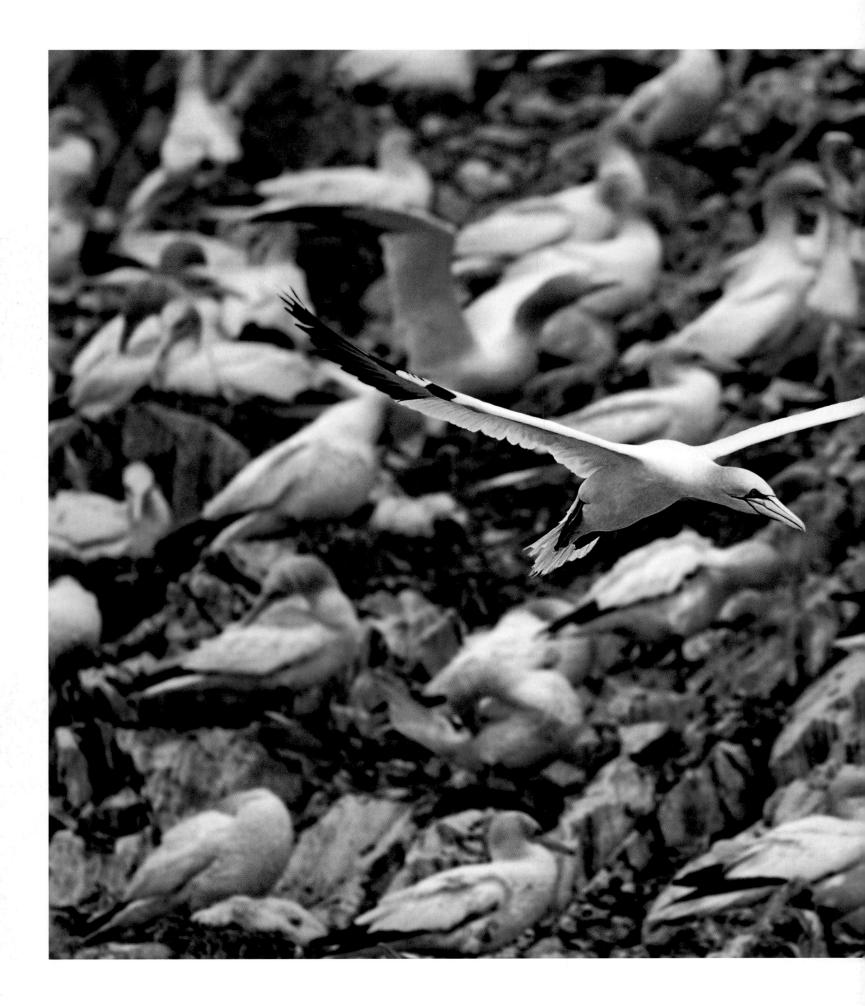

On the move. Closely related species with seemingly similar habits may have entirely different migration patterns depending on food resources. Birds in colder latitudes naturally migrate more often than others.

Out of the world's nine species of gannet and booby, eight do not migrate. The ninth, the Northern Gannet, occurs much further from the Equator than the others, its northernmost colonies being found in northern parts of Norway. Even though some 160,000 Northern Gannets winter around the North Sea, many migrate much further afield, some reaching the coast of Senegal.

Northern Gannet ∗ Scotland ∗ July

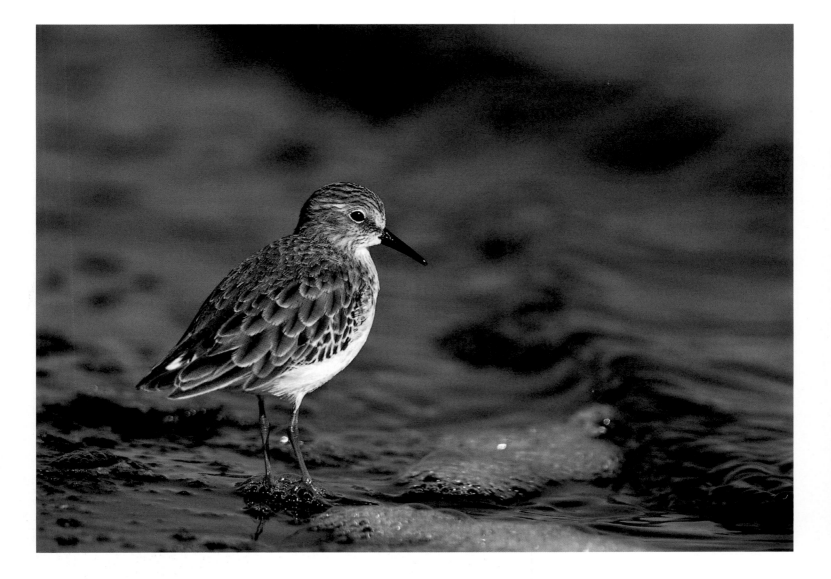

On its own. The young cuckoo migrates to its winter area without the help of adult birds. Because breeding cuckoos lay their eggs in the nests of other birds, their offspring never see their mother or father and so cannot benefit from their knowledge. It is therefore a major accomplishment that a young cuckoo knows where it is going.

This is, however, in no way unique. Among waders, for example, it is the rule rather than the exception that adult birds move first and young birds migrate much later. Summer is short for species breeding in the Arctic, and the young may need extra time to prepare for the long flight. The adult Little Stint in Siberia and the Least Sandpiper in northern Canada, for example, leave their offspring behind as early as in July. In August, the young follow by themselves. They know exactly where to go, which direction to fly in, where to find staging posts, and when they have reached their final destination.

Least Sandpiper ★ Florida ★ February

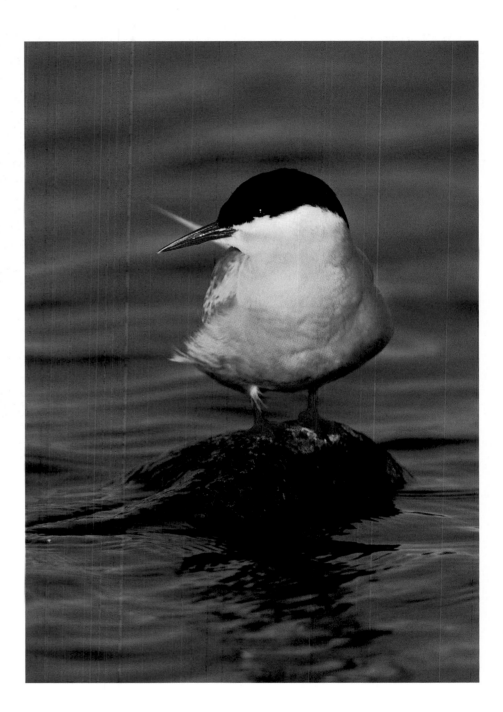

Exposure to the sun. The Arctic Tern breeds at Spitsbergen, Franz Josef Land, and Ellesmere Island in northern Canada, the northernmost coastlines on Earth. Incredibly, they often overwinter along the southern-most shore in the world, in the Antarctic. This means that these tiny birds, weighing just over 3.5oz (100g), make the longest migration in the world—10,000 miles (17,000km) one way—an impressive example of the capacity of birds.

This also means the Arctic Tern is ex-posed to more hours of daylight than any other organism in the world, because it lives with the midnight sun for most of the year.

Arctic Tern ∗ Spitsbergen ∗ July

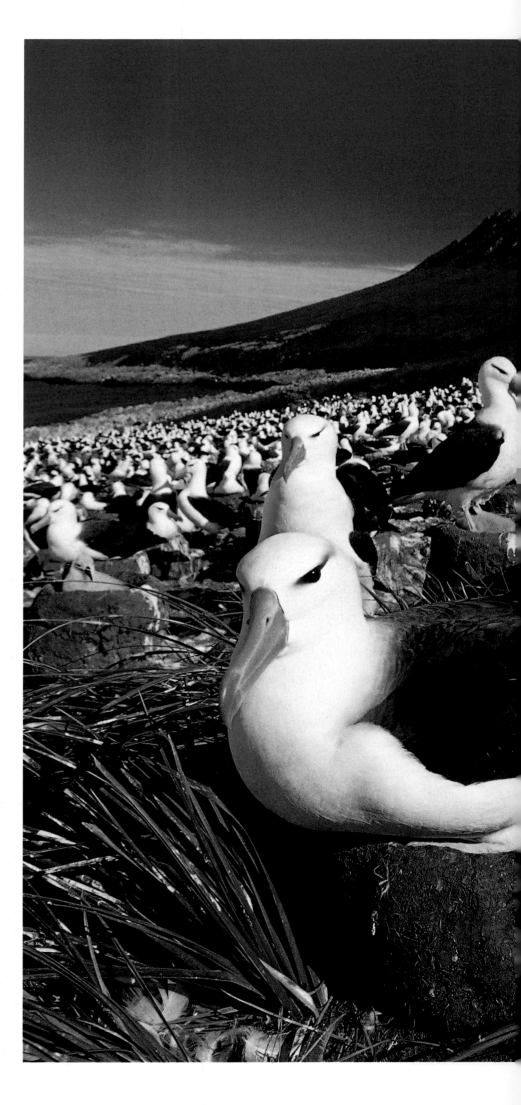

Unwilling. There is a small group of birds that breed in the southern hemisphere and overwinter in the northern hemisphere during our summer. These are ocean birds and include the Great Shearwater and Sooty Shearwater. These migrants head north along the coast of the western North Atlantic in the northern spring, and then follow the coast of the eastern North Atlantic south in the northern fall on their way back to their breeding grounds in the Falkland Islands.

Large colonies of Black-browed Albatross, which fly faster than shearwaters, can be found in the Falkland Islands but the species is extremely rare in the North Atlantic. Why is this so? The fact is that these large birds are so specialized at exploiting gale-force winds for dynamic soaring they are very unwilling to fly actively. Their migratory route would take them across the Equator, where it is always calm, so they simply prefer not to make the energy-sapping journey.

Notwithstanding immense colonies in the Falkland Islands, it is thus exceptional in the North Atlantic. Among the albatrosses this species is perhaps the one that suffers most from long-line fishing and overfishing— the drop in their numbers is striking. It is therefore un- likely that it will become a more frequent visitor to North Atlantic waters in the future.

Black-browed Albatross ★ Falkland Islands ★ December

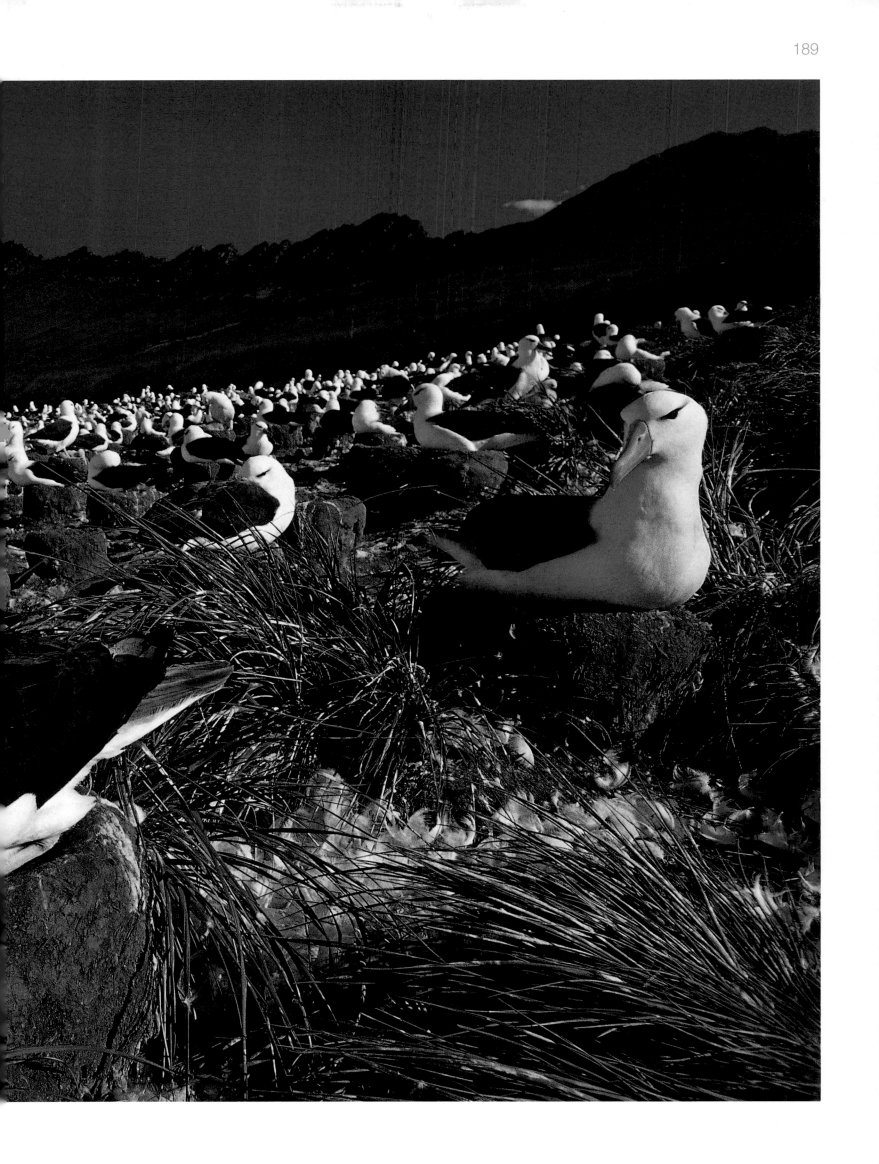

Narrow specialization. Birds are normally more or less restricted when it comes to the choice and extent of their breeding range. The Eurasian Cuckoo, however, knows no limits. It breeds right across Europe and well into Asia, and can be found in all kinds of environments, from the bird haven of Doñana in southern Spain to the alpine fjeld regions of Lapland. Two factors contribute to this.

First, cuckoos don't have to worry about feeding their young because the host bird does this for them. Consequently, they can lay their eggs in a wide range of habitats. A female cuckoo in Spain, for example, can confidently lay her eggs in a melodious warbler's nest, knowing that the hosts will supply her offspring with the right amount of food. A female cuckoo in Britain, meanwhile, may lay her eggs in a Reed Warbler's nest without having to worry about the supply of insects in the reeds, and a Lapland cuckoo can lay her eggs in a Meadow Pipit's nest without wondering about the kind of insects the pipits will find on the barren tundra.

Second, the wide distribution of the cuckoo is due to the fact that the species has claimed a special food niche that it shares with no other species and that is available in all habitats. This magic food is the hairy caterpillar, which other birds avoid because to them it is poisonous.

Eurasian Cuckoo with caterpillar ∗ Sweden ∗ May

Eurasian Cuckoo with caterpillar ∗ Spain ∗ April

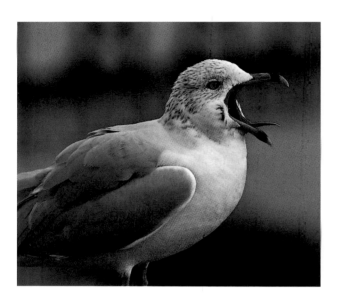

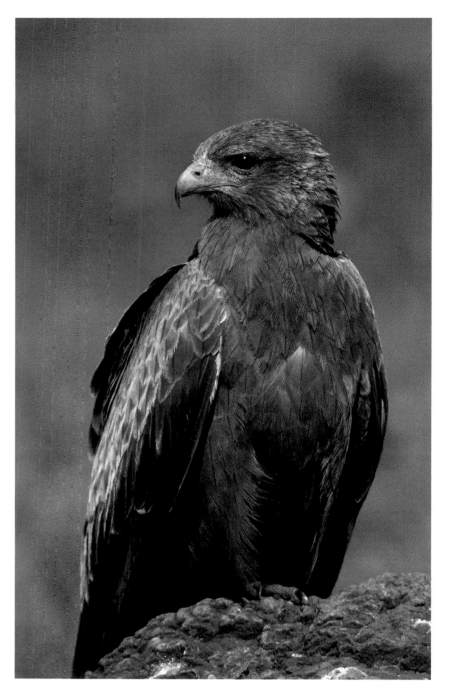

Numerous. The Ring-billed Gull breeds all over North America and is a common bird with an estimated population of 1.5 to two million pairs, or more than three million individuals. Each pair lays an average of three eggs, of which, say, half develop into chicks that survive until the winter. This means that there will be 2.25 million juveniles at this stage, making a total of 5.25 million birds. Out of the previous year's 2.25 million juveniles, perhaps 25 percent will also still be around, or just more than 0.5 million birds, raising the total number of Ring-billed Gulls to 5.75 million. In addition, not all adult birds breed. Healthy species do contain a certain number of "floating" stock, in this case perhaps 0.25 million. This would result in a grand total winter population of six million birds—not really that many for a "common" species.

Ring-billed Gull ⋆ California ⋆ January

Taxonomy. One of the world's most widely distributed raptors is the Black Kite, which is found in Africa, Europe, Asia, and Australia. In a few years' time, its area of distribution may be half what it is today, but without a decrease in population. How is this possible?

There are two varieties of Black Kite. In the north (Europe and the former Soviet Union), the subspecies *migrans* and *lineatus* breed. These are migrants that overwinter in the tropics and are distinguished by their dark bill. Various subspecies that do not migrate are found in the south (for example, *parasitus* in Tanzania), and these are distinguished by their yellow bill and lighter brown plumage.

Taxonomic studies in the future may determine that these two groups are actually separate species—the Black Kite in the north and the "Tawny Kite" in the south. If this were to prove the case, the Black Kite's range would effectively be cut in half.

Black Kite ⋆ Tanzania ⋆ January

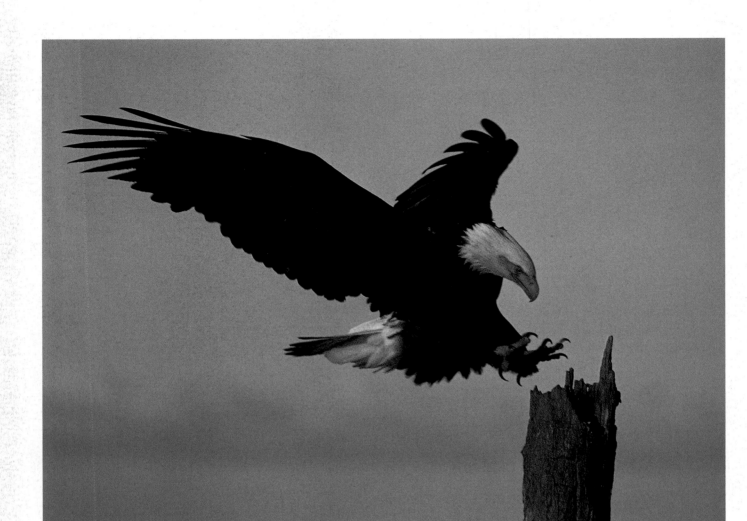

Allopatric. Closely related species may breed allopatrically. It sounds stranger than it is. A basic evolutionary thesis states that competing species do not occur in the same area, either because one will be driven out or because both seek to avoid competition. An example of such species is the White-tailed Eagle, which breeds all over Europe and northern Asia, and the Bald Eagle, which breeds in most parts of North America. These two species exploit the same niche in their respective ecosystems, both breeding in the same way, hunting the same type of prey, and occupying similar habitats. The White-tailed Eagle and the Bald Eagle are living lives that are too similar for them to coexist in the same location, but because of these similarities they breed allopatrically, like two pieces in a puzzle.

Bald Eagle * Alaska * March **White-tailed Eagle** * Norway * November

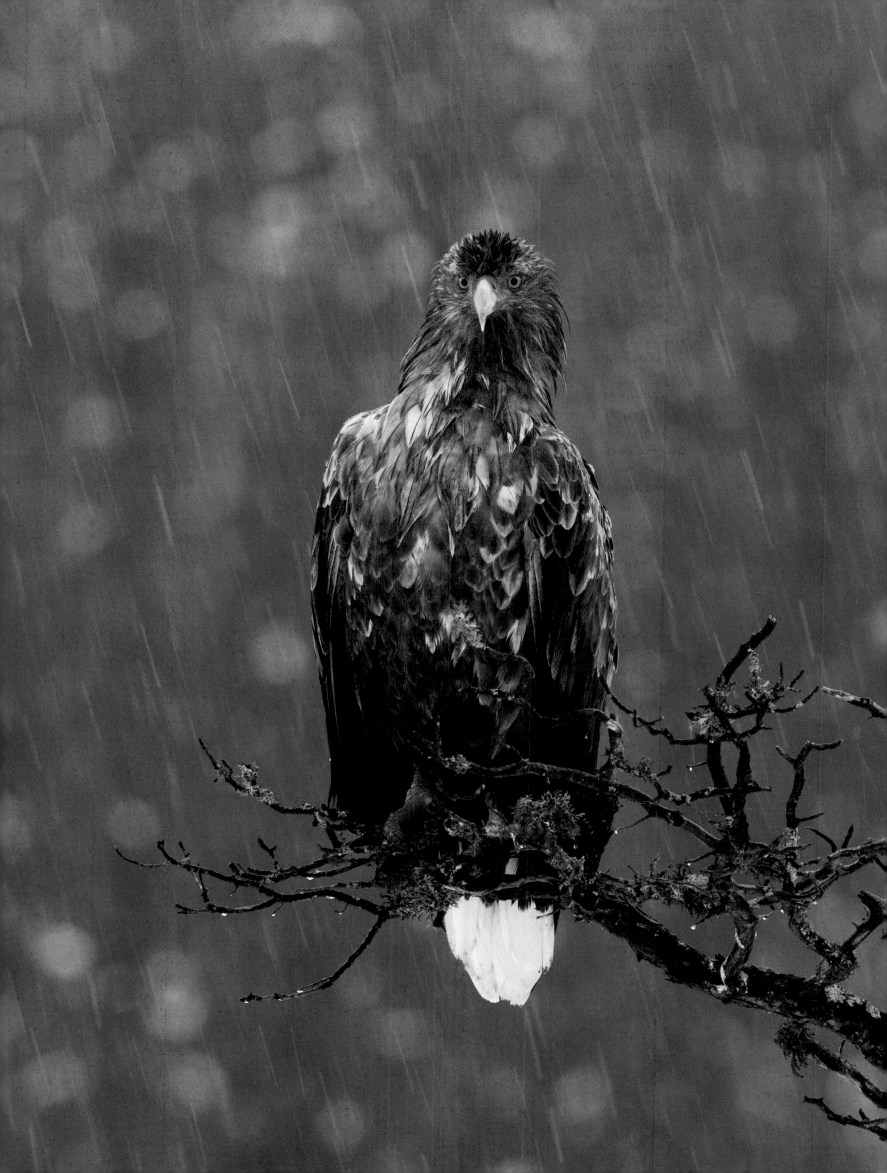

Sympatric. Some closely related species breed sympatrically, meaning they occupy the same geographical area. The Red-throated Loon and the Pacific Loon, for example, breed side by side over much of northern Canada. These closely related species tolerate each other because they do not breed in the same type of environment. The Red-throated Loon prefers small lakes and pools, often those that are part of a large system of bogs, and they will fly between different lakes to catch fish. The Pacific Loon, on the other hand, is found in large, deep lakes that support enough food alone to supply the whole family. The habitats of these two species are so different they do not have to compete and so can breed sympatrically, close to each other.

Red-throated Loon ∗ Sweden ∗ May **Pacific Loon** ∗ Manitoba, Canada ∗June

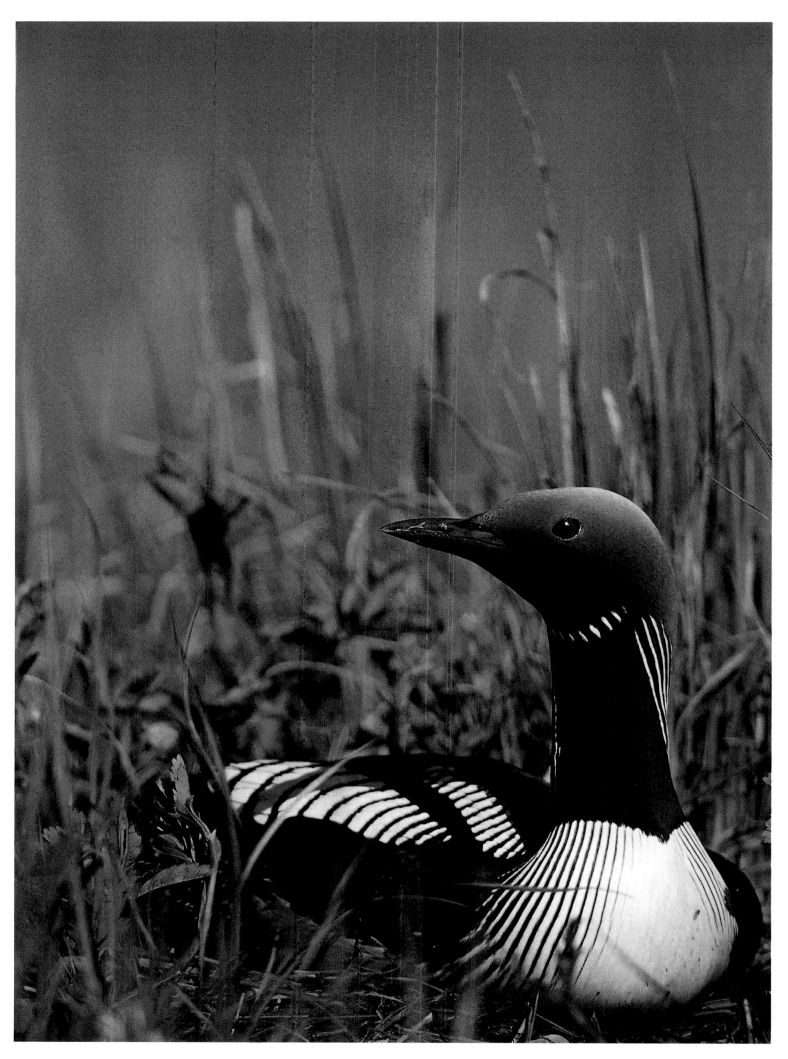

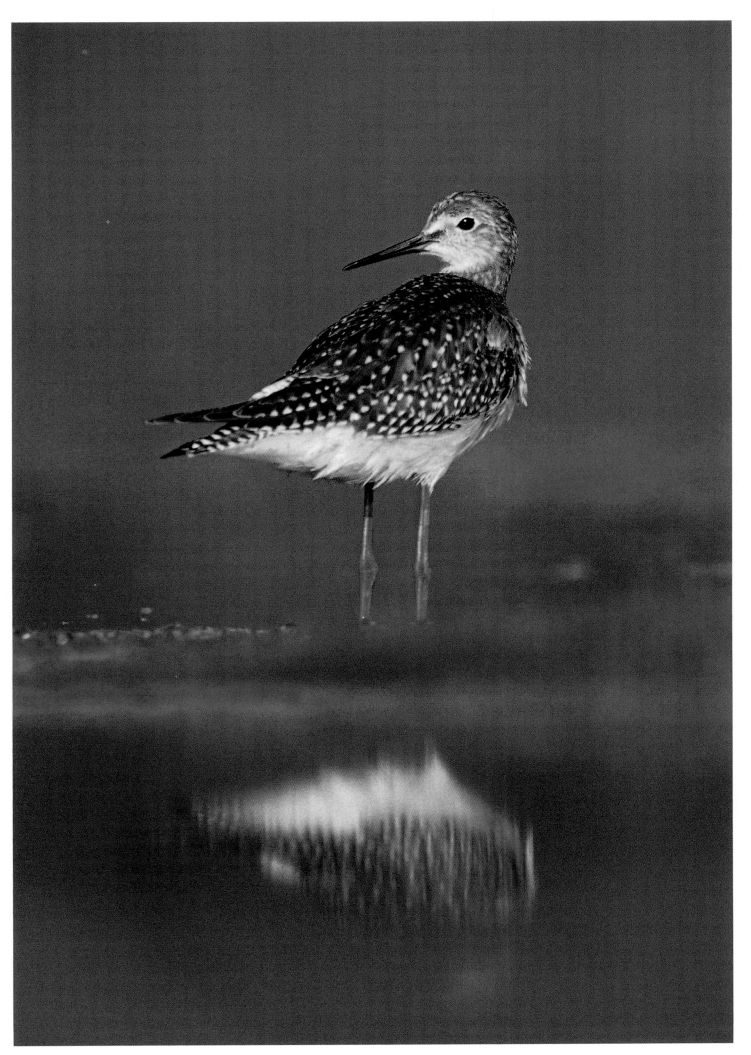

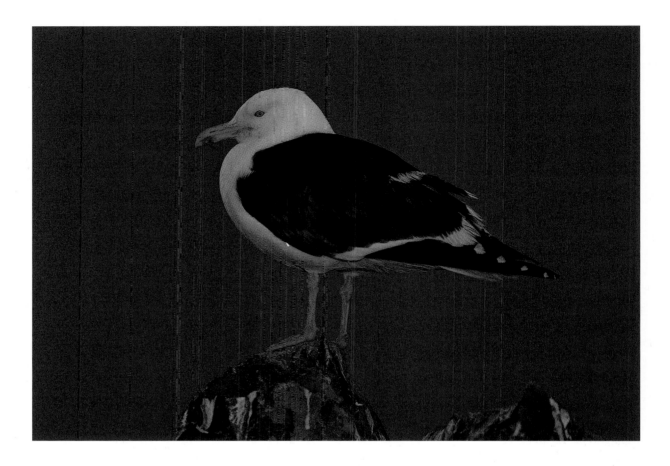

Analogous. When it comes to northern habitats in particular—especially the conifer belt and tundra—North America is in many ways a compact version of Eurasia. In northern North America, there are many specific species that share similar distributions, migration patterns, and wintering areas with species in Europe.

The Lesser Yellowlegs, for example, breed from Alaska eastward across Canada at the same latitudes as the Eurasian Greenshank. Lesser Yellowlegs overwinter along the east coast of the United States southward all the way to Cape Horn at the extreme tip of South America, while Eurasian Greenshanks overwinter along the west coast of Europe to Cape Agulhas at the most southerly tip of Africa. The similarities are striking.

Lesser Yellowlegs * New York * September

Flexible. Most widely distributed species breed in relatively homogenous climate zones. Greenshanks, for example, are found in a vast area that stretches from the Pacific across northern Russia and west into Scotland. However, they will never breed in latitudes north of northern Norway or south of Belgium, so are restricted to a somewhat narrow band.

The Kelp Gull also breeds over a wide range, from South America across Africa to New Zealand. But this gull differs in that it is virtually unique in its north–south distribution, occurring from the sunny Equator to the icy shores of the Antarctic Peninsula. A breeding ground can even be found around the desert lakes of Madagascar, making you realize just how flexible and special this species is.

Kelp Gull * Antarctica * January

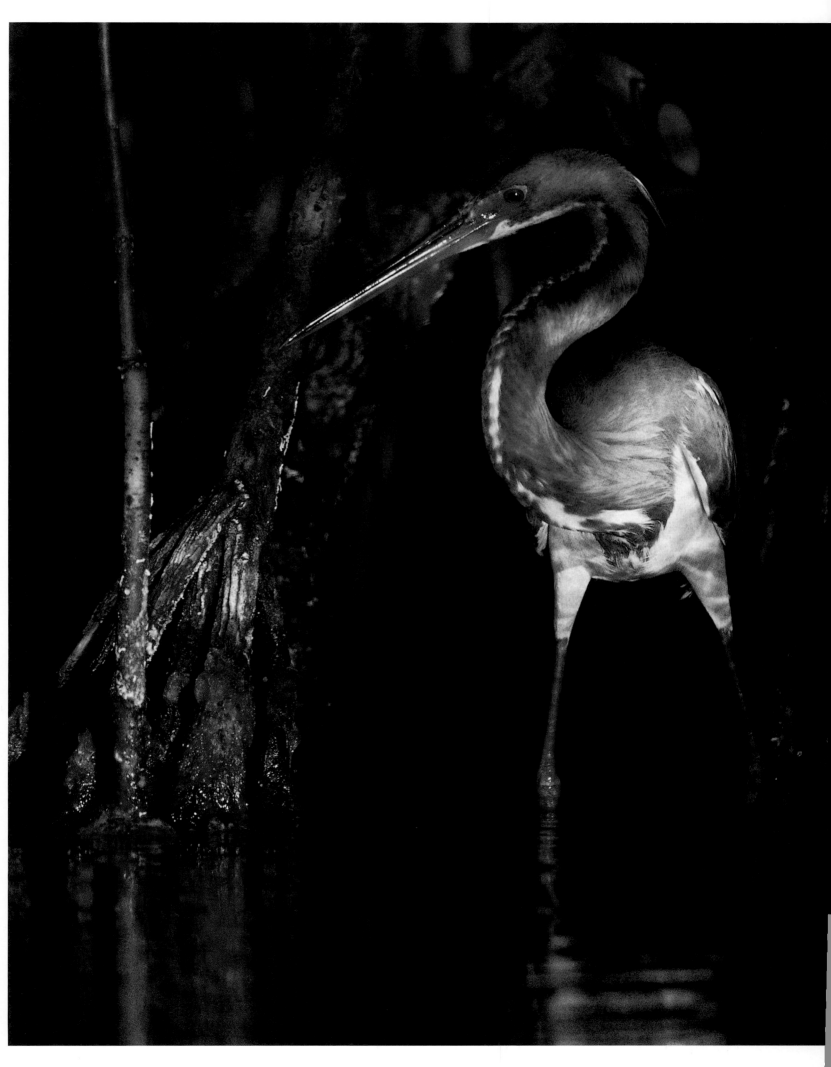

Habitat. The distribution of a species depends on several factors, one of the most important being the particular habitat it is adapted to. The Tricolored Heron is a tropical and subtropical bird found mainly in South and Central America. It is a coastal species that occurs chiefly in mangrove swamps, water-logged forests, and salt marshes that provide access to muddy tidal shorelines. In North America, the species is therefore most common in Louisiana and Florida, though it can be found further north along a large stretch of the eastern coast of the United States—simply as far north as it can find a suitable habitat.

Tricolored Heron ★ Florida ★ January

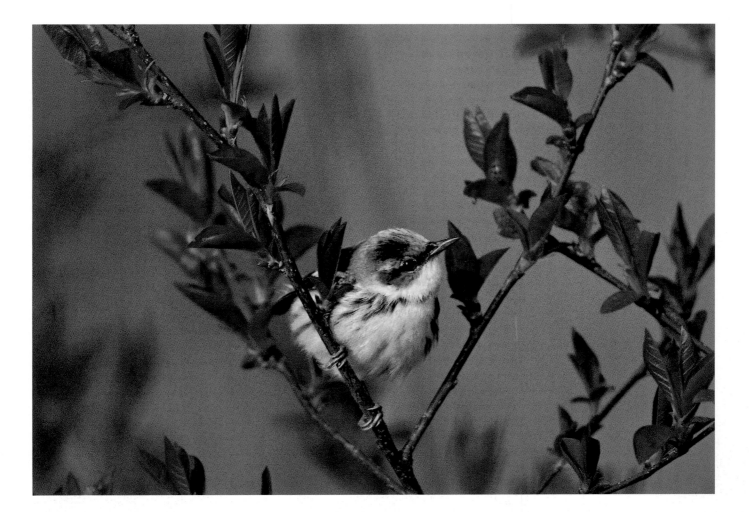

American "warbler". Many of the more melodious
birdsongs heard in spring belong to a family that
was named after this special trait—the warblers.
Willow Warblers and Garden Warblers—tiny birds
that often take shelter under vegetation and are
more usually heard than seen—are two examples.

When European emigrants first arrived in North
America, they encountered both foreign landscapes
and foreign birdlife. But some things reminded them
of springtime back home, such as the sonorous,
hard-to-spot passerines that flew around catching
insects in the treetops and bushes. Back in England
birds like this were called warblers, so this is the
name they were given in the new country too.
But things were not as they seemed. The Cerulean
Warbler is in no way related to the European warb-
ler, but is in fact more closely related to the Reed
Bunting and other members of its family.

Cerulean Warbler * Ontario, Canada * May

African winner. The Black-shouldered Kite is a sought-after
beauty in the Cork Oak forests of Portugal's Estremadura
region. Although it is now found at the top of the wish list of
every birdwatcher that travels to Iberia, it did not arrive there
until the end of the 1960s. The species normally breeds in the
tropics and has a wide distribution across sub-Saharan Africa
and southern Asia.

Once the Black-shouldered Kite had established itself in
the Iberian Peninsula, it slowly began to spread north. Since
the mid-1990s, a handful of pairs have been found breeding in
France. Although the species is not, strictly speaking, a migrant,
a vagrant bird was spotted in Denmark on March 29, 1998,
and another in southwestern Sweden on April 26, 2004.

Despite the fact that the species is common in tropical
Africa, it is rare in Morocco, and so why it has colonized Europe
is a bit of a mystery. In Spain it has enjoyed a certain amount
of protection in the past few years, which makes it one of the
most fascinating winners of the European fauna.

Black-shouldered Kite * Tanzania * February

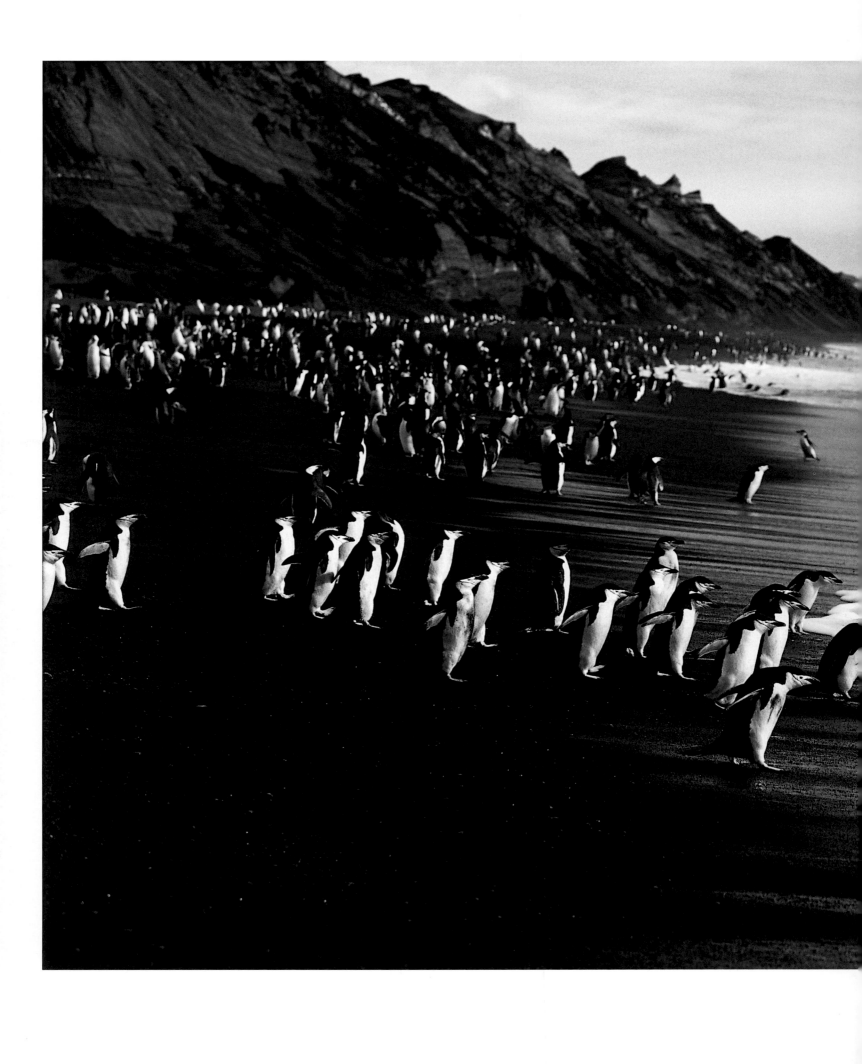

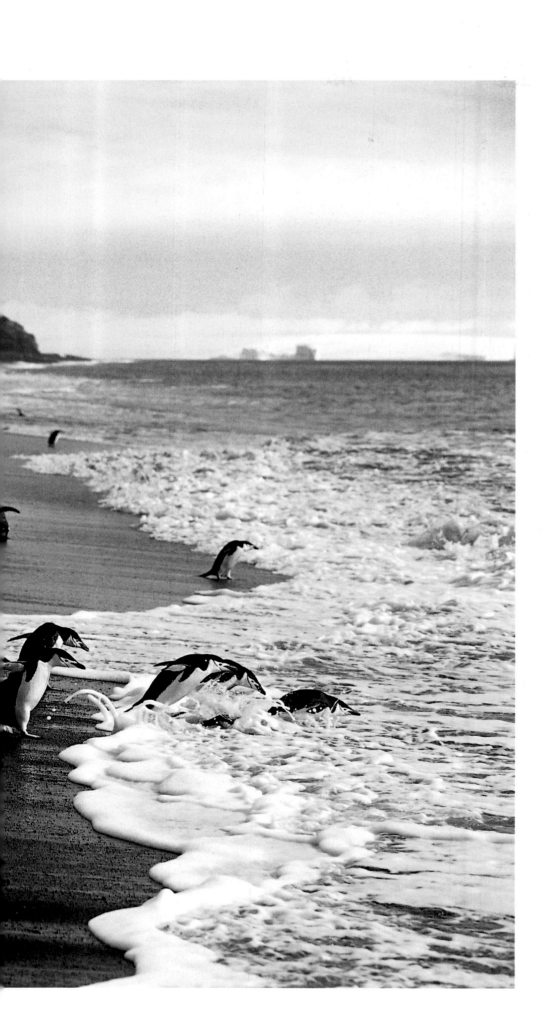

Polar Bears. Auks in the northern hemisphere and penguins in the southern hemisphere are generally somewhat similar. They are both black and white colonial breeders that feed on a diet of fish and crustaceans. The one important difference between them, however, is that auks can fly while penguins cannot. Why is this the case?

The answer is simple: There are no polar bears in Antarctica. Penguins lost their ability to fly a long time ago because they were not threatened by predators when they came ashore to breed. Auks, on the other hand, need to be able to fly off when polar bears or polar foxes stray into their colony.

Because penguins cannot fly, their weight is not important, which means they are much larger than auks and therefore better adapted to the cold. But the absence of polar bears does not mean an absence of danger altogether. Instead, penguins face danger mainly from the sea, especially in the form of the leopard seal. This is why they enter the sea one after the other, in much the same way that some birds fly together in flocks. They may take a long time to get started, but once one penguin is in the water the rest will soon follow.

Chinstrap Penguins ∗ Antarctica ∗ January

Epilogue

SOME OF THE information provided in the previous pages of this book may give the impression that birds can think, but they cannot. At least not if by "think" you mean the ability to plan, have intentions, make informed choices, understand context, and draw conclusions. Birds have none of these qualities. If you were to interview a bird about why it preens, it would not be able to reply: "To keep off vermin and to save energy during flight." It simply does not see the connection. Similarly, if you asked a female gannet why she lays only one egg, she would not be able to say: "Because if I raise two chicks I will not be fit and ready for the next breeding season."

Instead, birds act on instinct. They do what they do simply because it "feels right," not because they are able to understand the consequences of their actions. The closest we humans get to this state is when a newborn baby searches for its mother's breast for the first time. The child has no intentions, because it has no way of knowing what will happen when it feeds. Birds are the same: They have no intentions, make no informed choices, and carry out no planning. It is simply not the way their brains work.

While birds cannot think as such, they deal with every situation as if they are doing just this. Over several thousand generations they have evolved into a kind of automaton that is so sophisticated that if you push the right buttons (seasons, weather conditions, nutritional status, and so on) it will perform amazing feats. The three-month-old Lesser Whitethroat, for example, does not know where the Mediterranean is situated, or even that it exists, yet it still manages to cross it. It has never heard of the Sudan before, yet not only does find its way there but it "realizes" it has reached its wintering area and stays there.

This then begs the question: wouldn't it be impossible for a bird species to be successful without being able to think? The answer lies with plants. Does a whitebeam think to grow its dark red berries for thrushes and waxwings to eat, so its seeds are distributed and new whitebeams can see the light of day? And what about the common dandelion, a flower that is so successful gardeners roll their eyes at the mere mention of it. Does it think? If whitebeams and dandelions flourish without intention, so too can the Lesser Whitethroat.

The Green Heron does not realize how elegant it looks, or why, but we do.

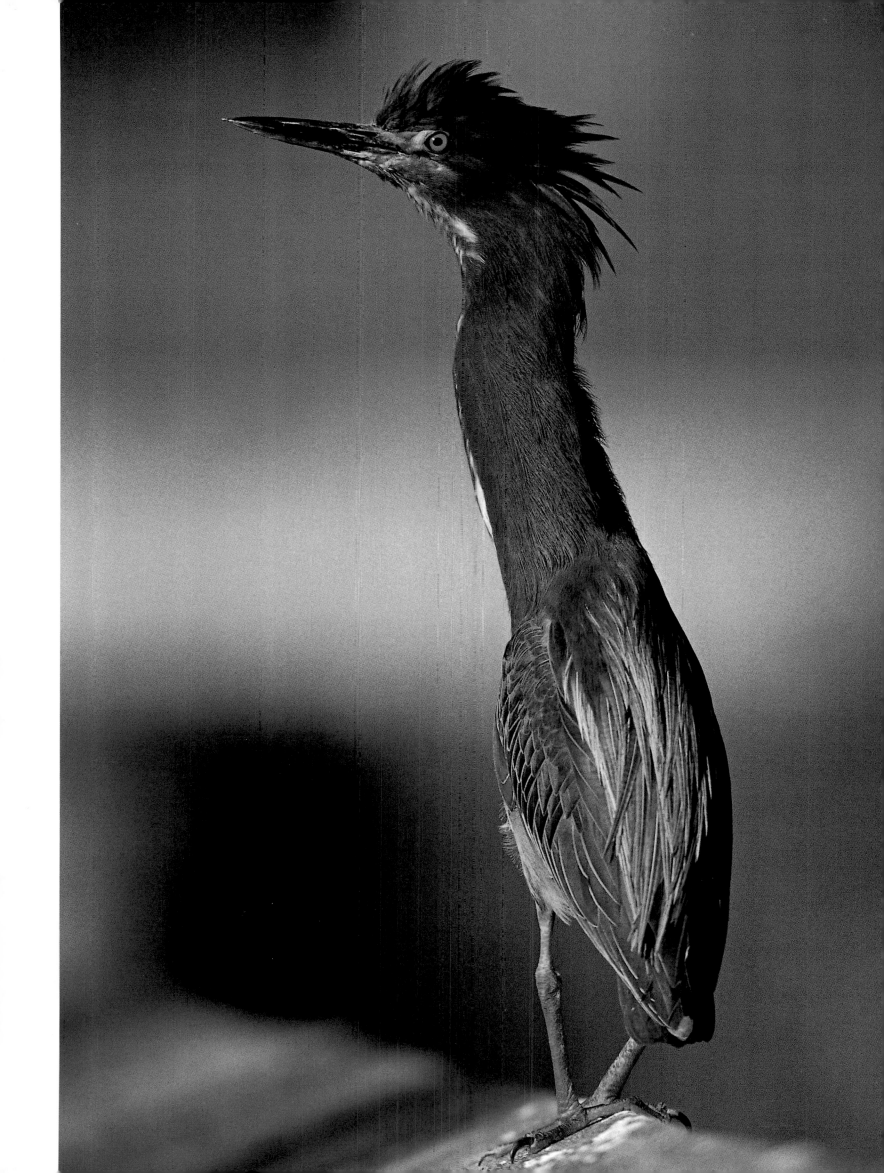

Photographer's Acknowledgments and Comments

With a few exceptions, the photographs in this book were taken between 2001 and 2005, the majority during the latter half of that period.

Strength comes in numbers, and I am indebted to more people than I can remember: Arthur Morris in Florida, who generously shared tips on good places in the U.S. and whose three-day workshops I strongly recommend; Doug, Gail, and Ted Cheeseman in California, who run the best eco safaris I know; Lauri Sippu, Lassi Rautiainen, Hannu Hautala, and Petteri Törmänen, who lent me their hides in Finland; Ove Stefansson in Boden and Juha Vitalo at Lappeenranta, who introduced me to some owls; the generous Ford dealer and bird lover in Texas, Roel Ramirez; Ole Martin Dahle, whose White-tailed Eagle tours along Norway's Atlantic coast are simply the best; and Rolf Segerstedt in Umeå, along with other Swedish, American, and Finnish birdwatchers, who have kindly shared their knowledge. Thanks also go to Joakim and the rest of the staff at Scandinavian Photo; to Lasse at Kamerateknik, who was always there when my camera equipment needed emergency repairs; to Maria and Charlotta at Go West in Gothenburg, who had to make too many last-minute changes; and, not least, to Sven Persson, Ulf Malm, and the others at Photonatura.

When taking pictures of birds, fast, reliable cameras and long, sharp lenses are a great asset. For the slides—which constitute about half of the pictures in this book—I used Canon's analog top-of-the range models EOS1V and EOS3. My preferred film was Kodak Ektachrome 100 VS, with its saturated colors. In 2003, I began to take digital photos with a Canon EOS 1Ds, and when the exceptionally fast and ideal bird-shooting camera EOS 1 D Mark II was released in mid-May 2004, I completely switched over to digital photography.

There is basically no alternative to using long lenses when photographing birds, so during my first two or three years I used Canon's "backbreaker," the 600/4, normally with a 1.4x converter (for a focal length of 840mm) and occasionally a 2x converter (1200mm). A few years back I went over to using the lighter 500/4 L IS USM as a "standard" lens. It also has the advantage of being light enough to hold by hand, at least for a few minutes at a time. Other lenses I have used for this book include the Canon 100-400/4-5.6 L IS USM, the 70-200/2.8 L IS USM (often together with a converter), and the 24-70/2.8 L USM, and for birds in flight I have now added the super-light telephoto 400/4 DO IS USM lens.

Most of the pictures were taken during nature walks. In some cases—for example, the picture of the Golden Eagle and some of the White-tailed Eagle shots—I attracted the birds with carrion and used a fixed hide. The picture of a buzzard leaving its nest to fetch food, unaware that it was flying toward the photographer, was taken from a brand-new tree hide provided by Lauri Sippu, where I spent a few days and nights during the wet summer of 2004. (The other buzzard pictures are from my own garden in the south of Sweden.) I also used my car as a hide for many of the shots, and in some cases a portable tent hide.

We live in a time when an increasing number of pictures that appear in the media have been manipulated with the help of computers—animals and birds photographed in captivity can now be pasted into a natural background. Therefore, I would like to point out here that none of the birds in this book were photographed in captivity, and nor has any bird been removed or added with the aid of a computer.

While working on this book I had the opportunity, for the first time in 30 years, to return to my family's original home region in northern Finland, which my mother was forced to leave during the war. My part of this book is therefore dedicated to my mother who, soon after arrival in her new country, learnt what it meant not to be born a Swede. It is also dedicated to the new, sober friends I met and got to know more than 15 years ago—an international community that pays as little attention to national borders as do birds. Not only did you probably save my life, but also my soul!

Brutus Östling
March 2005

List of species